PACIFIC PARALLELS

ARTISTS AND THE LANDSCAPE IN NEW ZEALAND

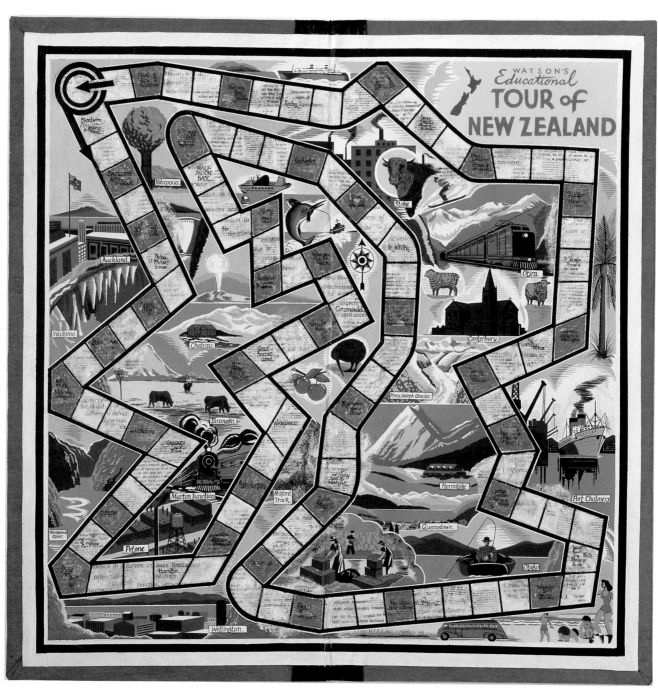

Ruth Watson, *Tour of New Zealand,* 1989. Acrylic and mixed media on canvas on board, 1300 x 1340 mm. (51 x 51¾ inches). Private collection.

PACIFIC PARALLELS

ARTISTS AND THE LANDSCAPE IN NEW ZEALAND

Charles C. Eldredge

with Jim Barr and Mary Barr

THE NEW ZEALAND – UNITED STATES ARTS FOUNDATION

SAN DIEGO MUSEUM OF ART

Distributed by the University of Washington Press
Seattle and London

The United States tour circulated by The Trust for Museum Exhibitions, Washington, D.C.

This book is published on the occasion of the exhibition *Pacific Parallels: Artists and the Landscape in New Zealand,* organized by The New Zealand – United States Arts Foundation.

Library of Congress Card Catalog Number 91-60445.
ISBN 0-295-97106-1

Publication production coordinated by David W. Hewitt, Head of Publications and Sales, San Diego Museum of Art.

Edited by Fronia W. Simpson, San Francisco, California.

Designed by David Alcorn Museum Publications, Mill Valley, California.

Printed and bound in Japan.

Cover:
Christopher Perkins,
Taranaki, 1931.
Oil on canvas, 505 x 912 mm.
(19⅞ x 35⅞ inches).
Auckland City Art Gallery Collection. Purchased 1968.

EXHIBITION VENUES

May 5 – June 30, 1991
Dixon Gallery and Gardens, Memphis, Tennessee

August 8 – October 6, 1991
Cedar Rapids Art Museum, Cedar Rapids, Iowa

November 3 – December 29, 1991
Spencer Museum of Art, University of Kansas, Lawrence, Kansas

February 2 – March 29, 1992
Meridian House International, Washington, D.C.

July 4 – August 16, 1992
Mary and Leigh Block Gallery, Northwestern University, Evanston, Illinois

September 12 – October 25, 1992
San Diego Museum of Art, San Diego, California

January 20 – February 28, 1993
Honolulu Academy of Arts, Honolulu, Hawaii

Following the American tour, the exhibition will be shown in New Zealand under the auspices of the National Art Gallery, Wellington.

The New Zealand – United States Arts Foundation gratefully acknowledges the generous support that has made this exhibition possible.

PATRONS
Mobil Corporation
Bell Atlantic Corporation
Federal Express Corporation
 the official carrier of the exhibition

SPONSORS
Ameritech Foundation
MCI Communications Corporation
New Zealand Ministry of External Relations and Trade

CONTRIBUTORS
Fletcher Challenge Limited
The Fletcher Construction Company
David Lloyd Kreeger Foundation
The United States – New Zealand Council

CONTENTS

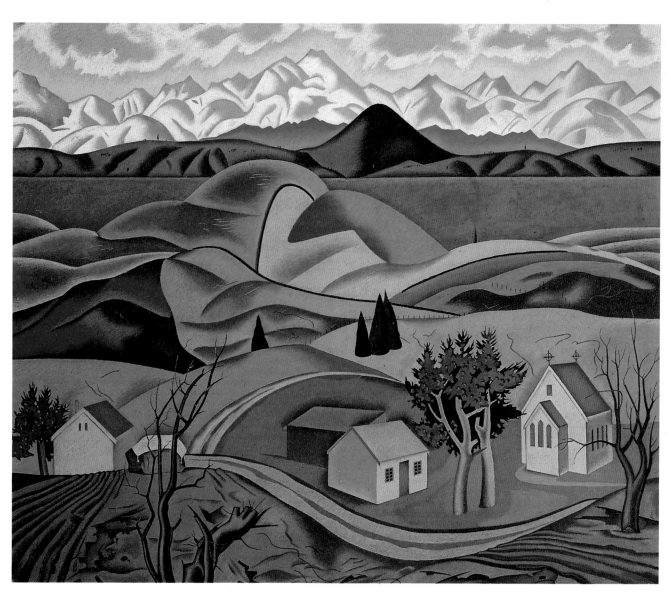

Rita Angus
Central Otago, 1940.
Oil on board, 350 x 548 mm.
(13¾ x 21½ inches).
Auckland City Art Gallery
Collection.
Bequest of Mrs. Joyce Milligan,
in memory of the late
Dr. R. R. D. Milligan, 1987.

PREFACE

There shall be no insistence upon symbolism: let each eye take the tokens, heart interpret, individual tongue make fit respond.

Mary Ursula Bethell

These words by Ursula Bethell are a fitting introduction to this exhibition, which seeks to give Americans a feel for the way in which artists, whether painters or photographers, have responded to the New Zealand landscape over the past one hundred and fifty years. If it is debatable that there is a New Zealand school of landscape art, there is no doubt that those men and women whose work is represented here – and the works range from the clarity of the early artists through the romanticism of the later nineteenth century to the extraordinarily varied work of today – have responded intensely to the land. Their interests are many, but this thematic reference to the mountains, the bush, the towns, rivers, and seacoasts of our country unites these works.

There have been other comprehensive exhibitions of the work of artists whose concern has been with the landscape. *Pacific Parallels* presents a somewhat different perspective because it offers an American view of New Zealand work. We were very fortunate indeed that the distinguished American scholar Dr. Charles C. Eldredge agreed to curate the exhibition, for he brings to it not only his own particular insight and knowledge but also the ability to point to interesting parallels with the way American painters and photographers have responded to their own landscape.

I am happy that this exhibition will show Americans another aspect of New Zealand and New Zealanders and, as well as conveying something of our identity, will emphasize once again how many things our two peoples share, not only our language, a sense of justice, and belief in democracy but also an energetic and lively artistic tradition.

I want to thank all those people and institutions in New Zealand and elsewhere who have so willingly lent us works that make up this exhibition. The response from those we asked has been enormously encouraging, and I am deeply grateful to them and to the National Art Gallery, Wellington, which also coordinated the exhibition for us. I want to pay a special tribute, too, to those institutions whose generous contributions of money and services have made this exhibition possible; without their splendid support we would not have got far. To Mobil Corporation and the New Zealand Ministry of External Relations and Trade, whose initial funding made it possible to plan and go forward with the exhibition; and to the Ameritech Foundation, Bell Atlantic Corporation, Federal Express Corporation (the official carrier of the exhibition), Fletcher Challenge Limited and The Fletcher Construction Company (which together underwrote conservation required to preserve artworks in the exhibition), the David Lloyd Kreeger Foundation, MCI Communications Corporation, and The United States–New Zealand Council, I extend my own deep gratitude as well as that of the Foundation. The museums across the United States that have helped us mount the exhibition have been extraordinarily generous in the time and money they have contributed, and I want to pay an especial tribute to the San Diego Museum of Art, which assumed responsibility for publishing this catalogue. To our distinguished curator, Dr. Charles C. Eldredge, who developed the concept and content of this exhibition, I extend my admiration. He brings a fresh perspective before us. Dr. Eldredge received invaluable assistance from Jim and Mary Barr of Wellington. In a very personal way I want to thank my colleagues on the New Zealand–United States Arts Foundation for their enthusiasm, vision, and sheer hard work. To Christopher Phillips, who chaired the Foundation in its earlier days, until taking up his appointment as United States Ambassador to Brunei, and to Lydia Chamberlin, who took over the chair and carried the show through to its successful entrance on the American scene, I can only say you have been tremendous. What great friends for us New Zealanders to have!

Tim Francis
New Zealand Ambassador
to the United States

September 1990

Peter Peryer, *Bluff,* 1985.
Silver print, 360 x 355 mm.
(14⅛ x 14 inches).
Collection National Art Gallery,
New Zealand.

FOREWORD

As chairperson of the New Zealand–United States Arts Foundation, I am proud to introduce the exhibition *Pacific Parallels: Artists and the Landscape in New Zealand* to American audiences. The Arts Foundation grew out of the desire of a small group of people to celebrate American and New Zealand achievements in the visual arts and to further mutual understanding between the two countries. Since its inception in 1982, the Foundation has arranged cultural exchanges and assisted museums in acquiring art that represents the best of each country's tradition, and in particular to help ensure that the diverse culture of the people of New Zealand is more widely known in the United States.

Although New Zealand is remote geographically, it has long been admired by Americans as a beautiful and friendly country, whose people do not seem foreign to us. Its distinctive heritage and the development and interaction of its varied cultural sources are, however, less familiar. The splendid treasures contained in the *Te Maori* exhibition that toured the United States several years ago introduced many of us to the art of New Zealand's indigenous settlers. Now, in *Pacific Parallels*, we are presented with artists' visions of their land from the middle of the nineteenth century to the present. The works are compelling; the landscape tradition revealed to us is strikingly like our own.

Many devoted people have worked long and hard to bring this exhibition to our shores. I am grateful to Dr. Charles C. Eldredge, the curator of the exhibition, and his collaborators in New Zealand, Jim and Mary Barr, for their outstanding scholarship and dedication. My deepest thanks also to Dr. Jenny Harper and her splendid staff at the National Art Gallery in Wellington for their coordination of the exhibition in New Zealand. They solved many knotty problems; without them the exhibition, quite literally, would never have gotten off the ground.

I earnestly thank all the lenders, whether artists, private collectors, museums, galleries, or other institutions, for graciously providing so many notable works for this tour. We are particularly grateful to the Auckland City Art Gallery for permitting so many treasures to be absent from their walls for such a long time. Such generosity makes it possible for American museum-goers to see the very finest in New Zealand art.

Most of all, I want to thank Ambassador Tim Francis, his able assistant Dr. Lesley Jackman, her predecessor Witi Ihimaera, and others at the New Zealand Embassy in Washington, D.C., who so graciously gave their unflagging support to this exhibition. I am most grateful to our capable Foundation consultants, Patricia L. Fiske and Margy P. Sharpe, and my stalwart colleagues of the New Zealand–United States Arts Foundation for their continuing patience and hard work. Thanks are also due to our co-publisher, the San Diego Museum of Art, and to The Trust for Museum Exhibitions, for circulating the show to its American venues.

Pacific Parallels could not have gone from the dreaming stage to the planning stage without seed money provided by the New Zealand Ministry of External Relations and Trade. Primary support from Mobil Corporation, with generous contributions from our other patrons – the Ameritech Foundation, Bell Atlantic Corporation, and Federal Express Corporation (the official carrier of the exhibition) – and contributions from Fletcher Challenge Limited and The Fletcher Construction Company (which together paid for the conservation required for works of art in the exhibition), the David Lloyd Kreeger Foundation, MCI Communications Corporation, The United States–New Zealand Council, turned our dreams into a reality. Because of these combined efforts – contributions of time, energy, and staff as well as money – I know that *Pacific Parallels* will be an enriching experience for all who see it.

Lydia Chamberlin
Chairperson
The New Zealand–United States
Arts Foundation

December 1990

Acknowledgments

The *Pacific Parallels* exhibition and this book have evolved over the past seven years, as my own familiarity with and respect for the art and artists of New Zealand have deepened. For their generous support of my introductory work in New Zealand in 1983, I am grateful to the Queen Elizabeth II Arts Council, the New Zealand–United States Arts Foundation, and the Fulbright program. They could not have foreseen this outcome, but I hope that it will be as gratifying to them as it has been pleasurable for me. Subsequent research in New Zealand, Australia, Canada, and the United States has been made possible by the continuing generosity of the New Zealand–United States Arts Foundation, and by my "home" institutions, the Smithsonian (until 1988) and the University of Kansas (since 1988), to which I am likewise indebted.

An international venture of this sort is invariably a collaborative one. In that respect, no curator has ever been more fortunate than I in the participation of Jim and Mary Barr of Wellington, whose extraordinary assistance and encouragement helped bring the project to fruition. To the degree that our mutual purposes have been realized, it is thanks to their good judgment and indefatigable support, which at various times have been sorely needed and always provided with unfailing kindness and perception.

The Barrs join with me in thanking a number of other individuals and institutions in two hemispheres, without whose cooperation our project would have been impoverished or impossible. Without the kind participation of lenders in three countries this show could not have been realized, and we are grateful for their generosity in sharing their holdings, which in many cases are national treasures, with a broad new audience. I also appreciate enormously the kindness of the contemporary artists represented in this show, each of whom welcomed me into their homes or workplaces and submitted to lengthy interrogations, contributing to my own continuing education with insight, warmth, and wit; memories of those visits will remain as among the happiest of this whole enterprise. Dealers in New Zealand have been consistently helpful in opening their storerooms and records to us, sharing precious information and personal reminiscence of the burgeoning field. We are especially thankful to Janne Land and Peter McLeavey in Wellington; Gregory Flint, formerly of that city but now relocated in Auckland; Sue Crockford and Rodney Kirk Smith in Auckland, and Kobi Bosshard in Dunedin for their help.

Any art historian learns early that a good librarian is a valuable friend. In this enterprise we have been assisted by expert "friends" at a number of institutions, including: in Auckland, the Auckland City Art Gallery and University of Auckland libraries; in Christchurch, the University of Canterbury Library; in Dunedin, the Hocken Library at the University of Otago; in Canberra, the National Library of Australia; in Lawrence, the Watson Library and the Murphy Library of Art and Architecture, both at the University of Kansas; in Rotorua, the Bathhouse, Rotorua's Art and History Museum; in San Francisco, The Fine Arts Museums of San Francisco library at the M. H. de Young Memorial Museum, the West Coast Office of the Archives of American Art, and the San Francisco Public Library; in Sydney, the Dixson Library and Mitchell Library; in Washington, D.C., the Library of Congress, the Archives of American Art, and the library of the National Museum of American Art and National Portrait Gallery, Smithsonian Institution; and in Wellington, the Alexander Turnbull Library, the Wellington Public Library, the National Library, and the National Art Gallery.

Many individuals have made exceptional contributions to the realization of this book and exhibition. In New Zealand, we recall with special gratitude the kind assistance of: John Coley, director of the Robert McDougall Art Gallery; Prof. Michael Dunn, University of Auckland, who shared his extensive knowledge of New Zealand's art history; Jenny Harper, director, National Art Gallery, Wellington, and her predecessor Luit Bieringa, who early on offered strategic

help in coordinating the exhibition's local arrangements and have consistently abetted progress with fine logistical support; also at the National Art Gallery, Tony Mackle and Jane Vial who ably assisted with research, and Les Maiden who conducted a nationwide photographic campaign to document the works reproduced in this publication; Christopher Johnstone, director, Auckland City Art Gallery, and his colleagues Roger Blackley and Alexa Johnston, who added much to my education about art and the landscape; John McCormack, now director of the Govett-Brewster Art Gallery, New Plymouth, but formerly with the Queen Elizabeth II Arts Council in Wellington, in which capacity he provided expert guidance on my initial foray into the world of New Zealand art; Bill Milbank, director, Sarjeant Gallery, Wanganui; John Perry, director of the art gallery at Rotorua; John Quilter, Wellington, bibliophile and connoisseur, who generously shared extensive knowledge of New Zealand arts and letters; and Elizabeth Wilson, University of Auckland, expert on the work of Edward Fristrom. Special thanks go to Peter Peryer and Erika Parkinson of Auckland, and Clovis Peryer of Dunedin, for their generosity, which is finally beyond recompense; over the past seven years, they have repeatedly opened their homes to me, providing a unique insight to the creative process and giving this northerner a new definition and appreciation for "southern hospitality." Also generous with their assistance were Christina Barton, Dr. James Belich, Ronald Brownson, Walter Cook, Jane Elliott, Judith Fyfe, Rowan Gibbs, Ron Lambert, Joan Livingston, Marian Minson, Anne Porter, Jill Trevelyan, Merylyn Tweedie, Daryl Watt, and Cliff Whiting.

In the United States, numerous colleagues have likewise lent their expertise and enthusiasm to the project, including: Jon Blumb, Spencer Museum of Art, who provided help with photographic needs locally; Steven Brezzo, director of the San Diego Museum of Art, one of the American venues for the exhibition, and his associate David Hewitt, head of publications, who undertook production of this volume; past and present administrators of the New Zealand–United States Arts Foundation, Patricia Fiske and Margy P. Sharpe, both of whom attended to myriad details over the long gestation period with finesse and accuracy; and Dr. Karol Ann Lawson, my former colleague at the National Museum of American Art, who assisted in diverse and challenging research tasks with her usual skill and good humor. Fronia Simpson provided expert editorial guidance, and David Alcorn artfully combined image and text in designing this volume. I also appreciate the kind assistance provided at crucial moments by Andrew Connors, Janann Eldredge, Dr. Paul Karlstrom, Dr. Brian Magnusson, and Dr. Virginia Mecklenburg.

Most particularly, the Barrs and I are grateful to Lydia Chamberlin, chairperson of the New Zealand–United States Arts Foundation, to her predecessor, Ambassador Christopher Phillips, and their colleagues on the Foundation board who have from its inception supported this project with generosity and enthusiasm. Last, but certainly not least, we are forever thankful to H. H. (Tim) Francis, New Zealand's distinguished Ambassador to the United States, for the inspiration and insight which have been essential to the completion of this happy task. He and his past and present colleagues at the New Zealand Embassy in Washington, D.C., have contributed in manifold ways to this venture, and for their countless kindnesses we are all indebted. Both Americans and New Zealanders are fortunate indeed to have in their midst such a knowledgeable and caring emissary for the arts. In addition to his abundant skills at diplomacy, Ambassador Francis is a keen judge of New Zealand's art and artists. We hope that the results of our undertaking will meet his exacting standards.

Charles C. Eldredge

December 1990

TASMAN
SEA

PACIFIC
OCEAN

NORTH
ISLAND

SOUTH
ISLAND

WAIKATO

TARANAKI

WESTLAND

CANTERBURY

OTAGO

Kerikeri
Bay of Islands
Waitangi • • Russell (Kororareka)

• Whangarei

• Whangaparoa

Coromandel
Muriwai • • Motutapu Island
Auckland •

Raglan •
Hamilton •

Rotorua • • Maungapohatu
Mt. Tarawera ▲
Lake Rotomahana
Tolaga Bay
• Taupo
Lake Pouarua • Gisborne

Inglewood
New Plymouth • • Tongariro
Parihaka • ▲ • Towhata Hawkes Bay
Taranaki/Mt. Egmont • Pipiriki • Napier

Wanganui •

• Palmerston North
• Kaitawa

Golden Bay
Takaka • Wellington/Port Nicholson ★

Nelson • • Palliser Bay

Cook Strait

Greymouth • • Wairau

Franz Josef
Glacier ▲
Mt. Cook

• Christchurch

Lake Wakatipu
Milford Sound
• Queenstown
Taieri Plains • Moeraki

• Port Chalmers
• Dunedin

Invercargill •
Bluff •

Foveaux Strait

Stewart Island

PACIFIC PARALLELS

Introduction

From the beginning, the land was a magnet for the European imagination, the destination for daring seafarers and childhood dreamers. In her primeval forests, so remote from the familiar greenswards and hedgerows of England, lurked mystery and romance. To the pious British emigrants who colonized those distant shores, the struggle to tame the land was long and arduous, as the romance was often routed by the harsh realities of the place. To the native population, who before the arrival of white people had developed a distinctive culture in this "undiscovered" place, the European presence was often unwelcome, leading to encounters painful for both communities. Yet the allure of the place continued, drawing to it an ever-increasing tide of settlers who sought to adapt to their new world while duplicating some of the old, until eventually the face of the land and its peoples was irretrievably altered.

America? No, New Zealand.

To many Americans, New Zealand is still terra incognita, a small and distant spot on the globe, known only in the most general sense. From travel promotions, they may be familiar with its scenic splendors, such as the Alps, glaciers, and Milford Sound of the South Island. Anglers around the world are aware of its equally famous trout. Popular exports, from kiwifruit to Kiri Te Kanawa, have been well received internationally. Yet, to most people in the northern hemisphere, the realities of place – today's industrialized, urbanized, bicultural, postcolonial New Zealand, which often belies the stereotype of glossy travel brochures or the silver screen – remain largely unfamiliar, as remote as they were on October 6, 1769, the day before Captain James Cook first sighted New Zealand's eastern coast from the deck of the *Endeavour*.

The culture of the native Maori has long been studied by specialists from many countries. This interest has increased in recent decades as the resurgent culture has flourished. The influential leader Apirana Ngata prescribed the direction the culture should take as early as 1940

in his call for "an emphasis on the continuing individuality of the Maori people, the maintenance of such Maori characteristics and such features of Maori culture as present day circumstances will permit, the inculcation of pride in Maori history and traditions, the retention so far as possible of the old time ceremonial, the continuous attempt to interpret the Maori point of view to the *pakeha* [European] in power."[1] The art of the Maori – especially their extraordinary carvings of wood, stone, and bone – has won the admiration of American collectors and museum audiences, from whalers who returned with South Seas souvenirs in the early nineteenth century to visitors to the major exhibition *Te Maori* that toured the United States in 1984–85.

The Maori, however, had no native tradition of pictorial representation on a plane surface. The convention of "landscape" was an import from Europe, but one that took an early and firm hold among artists in the southern settlements. The history of this genre as developed in New Zealand over the period of pakeha colonization is, however, not well known outside of Australasia. The primary purpose of the present venture, then, is to acquaint a foreign audience with the distinguished achievements of painters and photographers working in New Zealand over the past century and a half or so. This introduction is not intended as a general history of art in New Zealand; likewise, it does not pretend to be a comprehensive survey of the phenomenon that might, however loosely, be defined as landscape art. Rather, I have chosen to focus on the work of a relative handful of artists, sixteen men and women whose productions range from the early topographic delineations and scenic views of New Zealand to contemporary interpretations, including maps and even abstractions. The latter stretches any traditional definition of "landscape" yet seems as peculiarly and potently evocative of place as their more traditional predecessors.

The works included in this publication – as well as many others that could not be included in the exhibition – offer provocative parallels to pictorial traditions

▼

13

Note: Images discussed in the text that are reproduced in the Plates section are indicated by the ▼ symbol following their reference. The Plates begin on page 68.

Notes to the text begin on page 57.

in the United States and other former British colonies. In the text that follows those points of tangency are purposely emphasized, not, I hope, at the expense of accuracy but with the intent to highlight the frequent parallelism in view and attitude. When I first toured New Zealand's galleries, private collections, and artists' studios in 1983, I had simultaneously and paradoxically the repeated impressions of discovery and familiarity; this reaction has recurred in my subsequent visits and research. In the immortal words of one American philosopher, it was a case of "déjà vu all over again" (Yogi Berra).

In no way is this observation intended to derogate the local practices and traditions, nor does it suggest dependence on or imitation of American models by New Zealand landscape artists. (There may of course be individual instances of that appropriation in New Zealand as elsewhere, particularly in the modern era, but that situation does not especially interest me here.) More perplexing and compelling was the sense of coincidence in image and even intent among painters and photographers working in arenas widely separated by geography yet sharing a common derivation from European tradition. Barbara Novak has described a similar phenomenon (albeit in a different context); relating America's art to Europe's was, she wrote, "a complicated problem, compounded of artistic influences and of nature itself, stretching across geographical and national barriers, and breaking time barriers as well. In the study of the origins of any art, this is often true. But in America" – or, one might add, in New Zealand – "it would seem to be acutely relevant, since each of these influences, by virtue of America's distance from Europe seems sharply defined. In approaching this problem, composed as it is of philosophical as well as visual solutions to the problems of painting nature, we must take into account not only influence, but an idea to which … we should increasingly devote our comparative studies – affinity."[2]

The question of affinities provided the secondary motivation and emphasis in this undertaking. Literary critics have long

and fruitfully utilized the methodology of comparative study to illuminate both the particular and the universal. This approach has been true of New Zealand's literature no less than others, as seen, for instance, in William New's telling examination of the development of the short story in New Zealand and Canada.[3] But in considerations of American art, the question of comparison has until recently been relatively rare and generally relegated to considerations of stylistic influence, often to the American artist's detriment (e.g., the "inferiority" of colonial portraits vis-à-vis examples from London and Continental centers of fashion, or the "derivative" nature of American Impressionism in comparison to French precedents). In this study, I am less interested in narrow issues of style, imitative or not, than in how generically similar experiences – such as the encounter with wilderness and its conquest, or the renascent nationalism of the generation between world wars – shaped artistic response in New Zealand and the United States.

Ann Davis's pioneering comparison of painting traditions in Canada and the United States offers a useful guide. It was predicated on the notion that "the propinquity of the two countries and their mutual relative isolation from European art sources would suggest that interesting

parallels should exist." As her ensuing study of ten painters demonstrated, "both broad areas of harmony and a number of important differences may be detected in the Canadian and American *oeuvres*."[4]

In the case of New Zealand and the United States, there is also propinquity, although it is more cultural than geographical. Nevertheless, the parallels are strong and tempting to one trying to make sense of either the northern or the southern experience. As in the Canadian-American example, however, the differences between the two societies and their arts may ultimately be as illuminating as their affinities, and one must approach the pairing with an awareness of its limitations.

The New Zealand historian Jock Phillips recently described the comparative history as "an experimental mode. By examining two societies with similar environmental and cultural conditions, one can seek to narrow down the factors which might have produced differing results." He acknowledged that "the performance has often been made more difficult by the fact that no two past societies were ever exactly identical, so that one can never be totally certain which are the determinative differences. History is never an exact science." Despite that caveat, Phillips concluded

that "in the case of New Zealand/United States ... the comparison appears unduly promising."[5]

In undertaking this investigation, I consciously ignore Mark Twain's warning, expressed to a Christchurch interviewer nearly a century ago. Pressed for a pithy quote on New Zealand and New Zealanders, Twain demurred, explaining that "the man who attempts to describe a country which he sees for the first time after a brief visit to it, and before he has time to digest, as I may put it, what he has gleaned regarding it, is wrong."[6] After a number of visits and the opportunity "to digest," I hope the following observations will provide American readers and viewers with a pleasurable introduction to a rich and unfamiliar field, and by comparison, explicit or implicit, a useful lens through which to review and reconsider their own artistic traditions.

Cliff Whiting, *Te Wehenga o Rangi Raua ko Papa,* 1969–76. Mural. National Library of New Zealand, Wellington.

Richard Killeen, *Born Alive in New Zealand (for Samuel)*, 1985 (detail). Alkyd on aluminim (11 units). Collection of Richard Killeen and Margareta Chance.

CHAPTER 1

Discovering New Zealand

During 1990, the sesquicentennial of the Treaty of Waitangi – the British accord with Maori chiefs, from which event New Zealand dates its nationhood – American tourists were urged to "discover New Zealand." Perhaps unknown to tourism officials and advertising copywriters, Americans had been doing just that for more than 150 years. In 1840 a large panoramic painting of New Zealand's Bay of Islands had drawn excited crowds to a New York gallery, where they marveled at the "natural beauties … [of] New Zealand, so little known, but so particularly deserving attention."[1] Nine years later that triumph of showmanship was repeated in Boston with another popular panorama of a round-the-world whaling voyage that culminated in the Bay of Islands with "romantic scenery; ships at anchor; fanciful canoes – natives and missionaries."[2] But even before those exhibitions, reports from the distant islands in the South Pacific had excited Americans' imagination.

In July 1771 Captain James Cook steered his ship, the *Endeavour,* to a safe anchorage in an English port, concluding an epic three-year voyage to the Pacific Ocean. The expedition – the first of his three legendary journeys to that far quarter of the globe – was a triumph in all respects. Cook had searched for and proved there was no massive southern continent, the *Terra Australis Non Cognita,* whose existence had been posited by Ptolemy as early as circa A.D. 150. He had as well been the first European to discover Australia and chart its eastern coast; he was also the first to discover the east coast of New Zealand (whose western shore had only once previously been touched by Europeans, in Abel Tasman's voyage of 1642–43). Cook circumnavigated the islands, charting all of New Zealand's coasts and providing the names for features by which they are still known today.

Cook's compatriots were enormously excited by his achievements. They greeted reports of the voyage – the captain's own narrative and several by his shipmates; the scientific and ethnographic specimens gathered by the naturalists Sir Joseph Banks and Daniel Solander; and the illustrations by expedition artists (Fig. 1) – with the same rapt attention a later age would give Neil Armstrong's first words from the moon. Like the astronauts', Cook's bold expedition forever changed the view of the world – and not for the English alone.

Benjamin Franklin, among the most cosmopolitan of American colonials, was inspired by the captain's account of New Zealand and its native Maoris, whom Cook described as a particularly "brave and generous race." Within weeks of Cook's return, Franklin proposed to benefit "those poor people, who, however distant from us, are in truth related to us," by undertaking a charitable "Voyage by Subscription to Convey the Conveniences of Life … to Those Remote Regions, Which Are Destitute of Them." Unlike most European expeditions, which he saw as "undertaken with views of profit or of plunder, or to gratify resentments," Franklin was determined "not to cheat them, not to rob them, not to seize their lands, or enslave their persons; but merely to do them good, and enable them as far as in our power lies, to live as comfortably as ourselves."[3]

Captain Cook's achievements in the Pacific and his accounts of the islanders' natural virtues continued to stir imagination well into the nineteenth century. In 1828, for instance, as Johann Wolfgang von Goethe was reflecting on that "something more or less wrong among us old Europeans" whose lives and relations are "too artificial and complicated," he longed for a romantic escape to distant shores. "Often one cannot help wishing," he said, "that one had been born upon one of the South Sea Islands, so as to have thoroughly enjoyed human existence in all its purity, without any adulteration."[4]

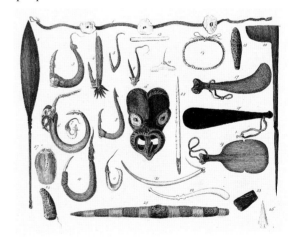

Fig. 1. **Sydney Parkinson,** *Various kinds of Instruments Utensils &c, of the Inhabitants of New Zealand, with some Ornaments &c, of the People of Terra del Fuego & New Holland.* Engraving by Thomas Chambers in Parkinson, *Journal of a Voyage to the South Seas …* (London, 1773), plate XXVI.

▼
17

Americans, too, continued to be captivated by the southern seas. From the 1790s, when the Nantucket captain Eber Bunker first hunted in that region, becoming the "father of Australian and New Zealand whaling," that part of the world was familiar to American whalers who plied the southern Pacific in pursuit of their harvest. In New Zealand's beautiful Bay of Islands, many of them found a safe and congenial haven for their vessels, easily accessible to the rich Vasquez Ground, lying to the northeast, and Middle Ground, to the west in the Tasman Sea. Upon their return to the United States, many of them brought souvenirs of the South Seas, including an impressive carved model of a Maori war canoe now in Nantucket's Whaling Museum (Fig. 2).[5]

In 1836 legislators in the House of Representatives were urged by Jeremiah N. Reynolds to further American exploration of the South Seas, primarily with commercial ambitions in mind; and shortly thereafter, Reynolds's admirer, Edgar Allan Poe, dispatched the fictional hero of *The Narrative of Arthur Gordon Pym* (1838) to the southern latitudes on an allegorical quest for an Antarctic utopia. In 1841 Herman Melville sailed from New Bedford for a southern Pacific sojourn that lasted three and a half years and provided the exotic material for numerous tales, most famously *Moby Dick* (1851), which owes some of its inspiration to the precedent of Pym's narrative.

Later in the century, in southern oceans and on southern islands, Americans and Europeans continued to seek adventure or escape, profit, romance or utopia, the motivation and discoveries varying with each sojourner. In 1890 John La Farge, the artist who epitomized "the American Renaissance," with his friend, the historian and author Henry Adams, embarked on a year-long journey to the South Seas,

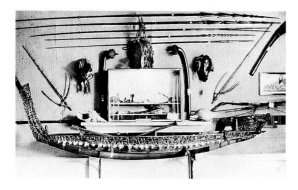

Fig. 2. *Model of Maori War Canoe* (foreground; shown with other Pacific artifacts). Carved wood, before 1850. From the collection of the Nantucket Historical Association.

and, like many before them, the two men were enthralled by nature and the culture of Polynesia. In Samoa, they visited the author Robert Louis Stevenson, one among a growing number of northerners who had taken residence there. In Tahiti, which they left in June 1891, they just missed meeting with perhaps the most famous of all northern transplants to the South Seas, Paul Gauguin, who arrived there about a week later.

In the twentieth century American interest in the general notion of the South Pacific continued to be lively, alternately inspired by pioneering aviators, of whom Amelia Earhart may have been the best known but certainly not the only one; by air and sea battles of World War II, during which years many American servicemen were first introduced to New Zealand during R & R stays; by the burgeoning media and travel industries, which in the postwar decades made the exotic familiar, especially when direct air service from California "turned the Pacific into a pond"; and by books and the theater, most notably James Michener's *Tales of the South Pacific*, which won him immortality when it was translated to the musical stage by Rodgers and Hammerstein.

More than a century before *South Pacific* landed on Broadway, New Yorkers had other opportunities to discover that distant precinct at Frederick Catherwood's Panorama, also on Broadway. In an era before Cinerama, painted panoramas offered American audiences a favorite form of spectacle, providing both entertainment and education. Like much American culture of our early period, the vogue was rooted in Europe, where such presentations were popular in the late eighteenth century; the first panoramas appeared in the newly formed United States even before 1800.[6] Panoramas – generally long canvases encompassing a wide-angle (often 360°) view of a subject – often required specially built circular facilities, such as the Rotunda, adjacent to the New York City Hall, on which the painter John Vanderlyn lavished a fortune in the late 1810s. That building was designed to house his large (3,000 square feet) panorama of the palace and gardens

at Versailles (1816–19; The Metropolitan Museum of Art, New York), an ambitious project on which Vanderlyn embarked following a lengthy European sojourn. Alas, his painting of a royal, French monument failed to excite his democratic countrymen's interests, in terms of either spectacle or politics, which aggravated the artist's already precarious financial state.[7] In order to continue his operation, Vanderlyn was forced to make large payments for works by the popular English panoramist Robert Burford (1792–1861). By 1829 Vanderlyn's expenditures on the venture brought him to financial ruin and he was evicted from the Rotunda.

In New York, however, as elsewhere, other displays enjoyed greater success, and few more so than Robert Burford's, which were regularly featured at the Panorama constructed in 1838 by his protégé Catherwood. Working from his own sketches as well as from views by other artists, Burford created scenic pastiches that were often punctuated by historic landmarks or individuals. These were initially shown at the Royal Panorama in Leicester Square, London, which Burford managed from 1827 to 1861, and later traveled abroad, earning the artist international acclaim. Some of Burford's greatest successes dealt with exotic subjects drawn from the far reaches of the British Empire, such as a view of the young settlement of Sydney, exhibited in London about 1828, and another of Hobart, Tasmania, shown shortly thereafter.[8] They were followed in 1838 by the panorama of the Bay of Islands, New Zealand. As was his practice, Burford published a *Description* of the New Zealand view in conjunction with its presentation, elucidating the forty-four scenes that composed the panorama. The detailed treatment of the subject in text and explanatory plate suggests that for both the artist and his audience the margins of empire in Australasia were a source of enduring fascination. That the interest was not limited to Britain was indicated by the appearance of Burford's *Bay of Islands Panorama* in New York two years later, accompanied by another explanatory *Description* (Fig. 3).[9]

In his views of Australia and New Zealand, Burford relied on the sketches made by Augustus Earle (1793–1838), whose global travels earned him fame as "the wandering artist."[10] The exhibition of the New Zealand panorama in New York was, figuratively speaking, something of a homecoming (albeit posthumous) for Earle, who was part of a family prominent in American art. Augustus – who early in his career added the final "e" to his surname – was the son of the American portraitist James Earl (1761–1796). James's brother, Ralph Earl (1751–1801), was one of America's most distinctive late-eighteenth-century portrait masters; late in life, Ralph also produced several pastoral views of the Connecticut and Massachusetts landscape, among the first of their genre painted in this country, and a panorama of Niagara Falls.[11]

Although their father had been an officer in the Revolutionary Army, both James and Ralph Earl remained loyalists, which accounts for their long periods of residence in England (Ralph, 1778–85; James, ca. 1784–94) – and for Augustus's birth in London. Augustus Earle always considered himself an Englishman, yet he had strong ties to the United States, and more than just familial ones. As a young man in London, which was still the mecca for many American painters, he associated with several artists, including Washington Allston and John Trumbull. He developed a close friendship with Charles Robert Leslie and Samuel F. B. Morse, fellow students at the Royal Academy, and the trio often hiked and painted together in the countryside, "sometimes meeting an adventure," as Morse recalled.[12] The adventurous Earle traveled to the United States in 1818 and spent the next two years rambling widely through the country, probably revisiting American friends made in London.[13] His

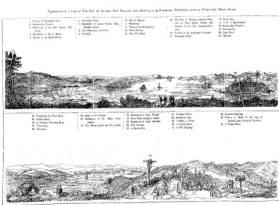

Fig. 3. **Robert Burford** (from drawings by Augustus Earle), *A View of The Bay of Islands, New Zealand.* Explanatory key from *Description of The Bay of Islands, New Zealand, and the Surrounding Country* (New York, 1840).

talents were encouraged – two of his paintings were exhibited at the Pennsylvania Academy of the Fine Arts, Philadelphia, in July 1818 – and in turn he encouraged the efforts of others, most notably the young Thomas Seir Cummings, with whose family Earle resided in New York. Cummings, who later achieved note as a miniature painter and a founder of the National Academy of Design, always remembered warmly the "fair complexioned, flaxen-haired young man" who stimulated his early interests in art, and long retained a group of Earle's sketches as a memento of his visit.[14]

Despite the evident felicity of his American sojourn, the restless Earle left his father's homeland in February 1820, destined for Brazil. Over the next twelve years in the southern latitudes, he found his greatest adventures and inspiration, and, finally, enduring fame. Surpassing the geographical reach even of his early mentor, Benjamin West – the American who became the second president of England's Royal Academy and a master revered in both nations – Earle, the English son of an American painter, is today honored as the "father" of art in the three countries that figured most importantly in his lengthy wanderings: Brazil, Australia, and New Zealand.

In 1832 Earle published *A Narrative of a Nine Months' Residence in New Zealand,* which, like the panoramas based on his sketches, excited considerable interest in Europe and America. It had been a scant two generations since Cook's Pacific voyages of discovery, and as one of the first extended reports of New Zealand to appear since the captain's, Earle's *Narrative* received wide attention in Britain and the United States. Stirred by the book, which he greatly admired, even the stalwart Scot Thomas Carlyle "thought of emigrating to New Zealand, and establishing a Newspaper there."[15]

In the 1820s, when Augustus Earle arrived in the Antipodes, traffic to those far shores was not heavy, and the artist might be counted as the premier tourist of his generation. The romantic allure of the South Seas drew Earle to that region – as

well as the fact that the ship that rescued him from a nine-month stranding on Tristan da Cunha in the South Atlantic was conveniently destined for Tasmania. He arrived at Hobart in January 1825 and moved easily into the local society, just as he subsequently did in Sydney, to which he shortly relocated. By October 1827, however, his wanderlust led him to New Zealand. Predisposed by accounts that portrayed the Maori favorably, Earle was not disappointed in his reception by the natives; despite some unsettling mores – most notably, evidence of cannibalism that Earle discovered firsthand – he found their character and company preferable to those of the British missionaries who had early established themselves in the Bay of Islands. Reversing Benjamin West's famous analogy on first seeing the Apollo Belvedere – "My God, how like it is to a young Mohawk warrior!"[16] – Earle found that the "striking and graceful" natives of New Zealand "invariably reminded me of the fine models of antiquity," and their rituals and demeanor "almost seemed to realize some of the passages of Homer."[17]

As much as with the inhabitants, Earle was stirred by the unspoiled landscape. He described his first view of New Zealand: "After crossing the bar [at the entrance to Hokianga Harbor] … and floating gradually into a beautiful river, we soon lost sight of the sea and were floating up a spacious sheet of water, which became considerably wider after entering it; while majestic hills rose on either side, covered with verdure to their very summits. Looking up the river, we beheld various headlands stretching into the water, and gradually contracting its width, till they became fainter and fainter in the distance, and all was lost in the azure of the horizon."[18] His written description echoes the aesthetic parlance of the late eighteenth century. Readers of the *Narrative* were told that Earle's wide-ranging travels were undertaken "to gratify a refined taste for the picturesque"; later, visitors to the *Bay of Islands Panorama* were prepared by the accompanying *Description* for "every variety of picturesque scenery, from the calm, rich, and romantic, to the wild and sublime."[19]

20

Earle admitted that "the excitement occasioned by contemplating these scenes" could prompt "an ecstasy of delight" in the artist.[20] In such thrall, he drew the "majestic hills," azure horizon, and other scenery in words as well as in watercolors (Fig. 4). These paintings – which later provided the basis for Burford's panorama – conformed to the artistic standards of his day. Earle's generation was heir to the grand tradition of British watercolor, and his views continued the practice of "tinted drawings" that flourished from the late eighteenth century.

Discovery is as much an imaginative process as a unique, physical act, one that can be (and was) repeated from individual to individual, generation to generation. Captain Cook's courageous voyages fixed New Zealand's position on the world map, but its place in the imagination was susceptible to change over time. Augustus Earle's achievements in paint and prose introduced a new northern audience to the southern islands. And the artists who followed in his wake were likewise discoverers, further advancing the familiarity and defining that realm which had once been *non cognitum.*

Watercolors, which Earle favored in his New Zealand views for their portability and subtle effects, were employed there for similar reasons by other early painters, but toward different ends. With increases in commercial trade of native resources – seals and whales, flax and timber[21] – came the need for expanded settlement. In 1838 a group of London capitalists established the New Zealand Company, organized in accordance with the principles of Edward Gibbon Wakefield to advance systematic colonization centered on concentrated agricultural settlements. In September 1839 the company's preliminary expedition arrived at Port Nicholson, the advance party for more than nine thousand emigrants the company would dispatch southward over the next seven years. Among the travelers on that first voyage was Charles Heaphy (1820–1881), who had signed on with the New Zealand Company as an artist and draftsman. Heaphy, like Earle, was from an artistic clan, albeit less noteworthy

than his predecessor's; his elder brother painted portraits and genre pieces, as did his two sisters, all following the professional lead of their father, Thomas Heaphy, a talented but "intractable" watercolorist whose genre subjects one chronicler remembered as "scenes of low life [that] found ardent admirers among the connoisseurs of vulgarity."[22]

Fig. 4. **Augustus Earle,** *Distant View of the Bay of Islands, New Zealand,* 1827(?). Watercolor on paper. Rex Nan Kivell Collection, National Library of Australia, Canberra.

Charles Heaphy brought his father's medium to New Zealand and over the next seven years produced numerous watercolors for the New Zealand Company; in 1842 he also published a *Narrative of a Residence in Various Parts of New Zealand.* As both painter and writer, Heaphy showed skills as a propagandist, in his text exclaiming over the fertile abundance of New Zealand (especially in those areas controlled by the company) and in his watercolors [see pps. 142, 156] celebrating the landscape and the industry of New Zealand's colonists that was rapidly transforming it. The claims of his *Narrative* were often inflated, and the charms of his carefully edited landscape vistas were intended to lure additional settlers to the islands. To judge from the thousands who enlisted in the company's program, he succeeded.

When considered as propaganda or advertisement, Heaphy's art had a utilitarian value – painting with a purpose.[23] Even more obviously useful were the coastal profiles he limned from shipboard, describing the lay of the land and its prominent features. These transcriptions of the coastline array long slices of landscape stacked in layers across the sheet, in what to viewers today look like strikingly modern designs (Fig. 5); however, to their maker, they likely played a role more functional than aesthetic, providing a valuable document for the navigators and surveyors who followed. Subsequent to his employ with the New Zealand Company, Heaphy worked for the

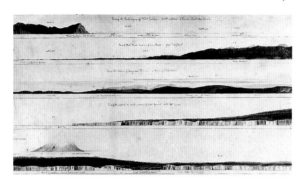

Fig. 5. **Charles Heaphy**, *Coastal Profiles from Mt. Egmont to Queen Charlotte Sound*, ca. 1842. Watercolor on paper. Alexander Turnbull Library.

▼

Auckland Provincial Council's Survey Office, beginning as chief draftsman and ultimately rising to the position of Provincial Surveyor. Many of his topographic views, especially those of his New Zealand Company and Survey Office years, show the surveyor's vision, one that some interpreters defined as the foundation for a native school of painting. Heaphy and other early delineators of the land – surveyors, geologists, botanists, in short, practical, empirical men – had a vision "less befogged than ours with aesthetic preoccupations," wrote R. E. Kennedy in 1948.[24] More recently, Wystan Curnow succinctly characterized their intent as "putting the land on the map."[25]

Today some revisionist critics take the surveyor's vision and his attitude to task. Heaphy has been judged harshly for his involvement with "the drawing, the exploring, the apportioning, the confiscation of the land: all the forms of its expropriation."[26] In an earlier day, however, in New Zealand as in other colonial societies, the surveyor's role was viewed as an important one, he being the first of the white settlers to "know" the new land or, through erudition and calculation, to take its measure. "He thrives on patterns," wrote the historian Don Thomson, "his marks and monuments transforming a wilderness and by his carefully tagged and numbered squares, neat roads, correction lines and small cadastral lots he clothes in certainty, in geometrical designs, man's ancient rights."[27] In societies of the early nineteenth century, enamored of mathematics and the practical, a number of men who are better remembered for achievements in other areas also worked as surveyors; such was the case with Americans, from the surveyor-in-chief for Concord, Massachusetts (Henry David Thoreau), to Whistler's father (George Washington Whistler), and with Charles Heaphy in New Zealand.[28]

Heaphy's charmingly naive early works were long the purview of antiquarians. It was not until the twentieth century that a new audience discovered his work. Beginning in the 1930s, a maturing society's quest for local cultural traditions fueled a new interest in the earlier works of authors, painters, and other artists. In the United States, this search for creativity "on native grounds" (as Alfred Kazin titled his influential study of American letters) led to reappraisals of literary giants (Hawthorne; Melville) as well as painters (Thomas Cole; colonial portraitists, whom James Flexner called "America's Old Masters" in 1939). Entire schools or movements were the beneficiaries of this artistic excavation, such as the folk art and craft traditions, as part of the period's vogue for "Americana." In New Zealand a similar impetus led to the new appreciation of Heaphy, as connoisseurs schooled in the modern vision found new interest in the artistic merits of his creations. By 1940 E. H. McCormick, one of the most important chroniclers of the nation's art, could acclaim Heaphy as an "artist of rare distinction" whose watercolors "meet [the New Zealand Company's] official requirements admirably…. But some – most, indeed – do more than this; they portray experiences of an elusive kind, rarely to be expressed in words…. Throughout the range of Heaphy's work you are aware of a man wrestling with the strange contours and colours of a new environment and, moreover, attempting to define the peculiar quality of each part of New Zealand."[29]

The rising tide of esteem for the pioneer painters in New Zealand benefited a number of Heaphy's contemporaries as well. Such was the case with the Reverend John Kinder, who in 1969 was accorded the singular honor of a monographic chapter in Gordon H. Brown and Hamish Keith's influential survey of New Zealand painting.[30] Elsewhere, Brown observed that Kinder's work ▼ exemplified "a certain line of development within New Zealand painting … towards which American visitors seem to find greater kinship than do Australians or Europeans" and suggested that this appreciation was due

to its similarities to contemporaneous developments among the American luminists, especially the paintings of John Frederick Kensett (Fig. 6).[31] Despite their positions in different hemispheres, an affinity exists between the two artists' works that shows a common commitment to faithful replication of natural fact, realized through exacting discipline. More particularly, they shared a preoccupation with the influential aesthetic theory of the British painter and critic John Ruskin. In America (as the Hudson River artist Worthington Whittredge recalled), Ruskin's *Modern Painters* was "in every landscape painter's hand."[32] It was apparently in Kinder's as well.

Ruskin placed a priority on "seeing truly." "I believe that the sight is more important than the drawing," he proclaimed, "and I would rather teach drawing that my pupils may learn to love nature, than teach the looking at Nature that they may learn to draw."[33] Ruskin's infusion of religious sentiment into the equation of art and nature helped Americans, as Roger Stein noted, "to build a loose but convincing system where art, religion, and nature were inextricably intertwined."[34] To Ruskin's compatriot and exact contemporary, John Kinder, clergyman and landscapist, such a conflation of art, religion, and nature had a strong attraction and helped to shape his views of both art and the world. Furthermore, Ruskin's early appreciation of photography as an aid to faithful observation likely won the attention and admiration of Kinder, who was among the first and finest of New Zealand's photographers. Ruskinians, in New Zealand as in the northern hemisphere, discovered in photography "a medium capable of recording the minute aspects of nature, like the texture of granite or a forest thicket, which resisted treatment with brush or pencil."[35]

Kinder's albumen prints, most of which date from 1862 to 1872, were largely landscapes, detailing the textures of the native bush or the geological forms in the terrain. (Others were portraits, of both European and Maori subjects, or town views and architectural studies.) During his lifetime, Kinder – for whom artistic pursuits were always an avocation, never a professional calling – exhibited his works only occasionally; but in 1873 he submitted two landscape photographs to the exhibition of the Auckland Society of Artists, an act that suggests the equivalent values painting and photography had for him. Sometimes the photographs were taken from the same vantage as his landscape sketches, and they were later used as an aid in finishing his watercolor views. On other occasions, the albumen prints were created as independent works valued for their aesthetic composition, tonal values, and especially their fidelity to the natural subject.

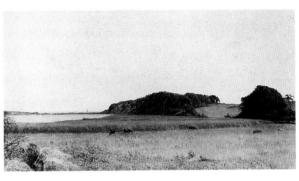

Fig. 6. **John Frederick Kensett**, *An Inlet of Long Island Sound*, ca. 1865. Oil on canvas. Los Angeles County Museum of Art. Gift of Colonel and Mrs. William Keighley.

Kinder's brushwork technique – applying the tints with an extremely fastidious touch – yielded an aura of verisimilitude, of topographical precision.[36] The sense of close observation was often abetted by his notes written on the sheet, specifying details of the view. For instance, one scene in the Taranaki countryside, which is unusually atmospheric in effect, bears the notation that it was painted on "(a rainy day)." Another inscription on a view of the volcanic craters at Pouerua clearly locates the subject and notes, "View taken from the highest point."[37] The degree of specificity and definition, both visual and verbal, is especially pronounced in Kinder's treatments of geological forms. This again suggests his allegiance to Ruskin, who preached the necessity of "truth of earth." By that, Ruskin meant "the faithful representation of the facts and forms of the bare ground, considered as entirely divested of vegetation.... Ground is to the landscape painter what the naked human body is to the historical. The growth of vegetation, the action of water, and even of clouds upon it and around it, are so far subject and subordi-

nate to its forms…. The laws of the organization of the earth are distinct and fixed…. They are in the landscape the foundation of all other truths – the most necessary, therefore, even if they were not in themselves attractive … every abandonment of them by the artist must end in deformity as it begins in falsehood."[38]

Irish-born George O'Brien, Kinder's contemporary in the South Island, arrived in New Zealand from Australia in the early 1860s, but little is known of his background or his training and work prior to his appearance on the Dunedin tax rolls in December 1863.[39] Dunedin remained his home for the balance of his life and, with the nearby hills and harbors of Otago, a favorite subject for his art. If Kinder's North Island landscapes elevated the tradition of topographic specificity to new moral ground, those by O'Brien ultimately seem to have been motivated by different concerns, despite superficial similarities in the use of watercolors and the reliance on precise drawing. Unlike Kinder's limited color range, O'Brien used a more brilliant and varied palette. More significant than technique was O'Brien's choice of motifs, which customarily included references to human presence in the land. While Kinder had depicted various buildings in his landscapes – especially the Anglican churches of Bishop Selwyn – O'Brien, uniquely in his generation, celebrated a local scene transformed by urban growth and modernization. It was he who discovered an industrial Eden.

In O'Brien's watercolors,▼ even in his most rustic scenes, some evidence of people or their handiwork generally appears, perhaps a track through the bush, or a split-rail fence, or cultivated fields neatly patterning the land. Not infrequently,

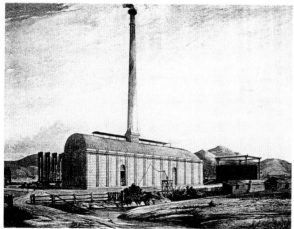

Fig. 7. **George O'Brien**, *View of the Dunedin Gas Light & Coke Company Works*, 1865. Watercolor on paper. Otago Early Settlers' Association Museum, Dunedin.

smokestacks compete for attention with church spires, and pride of place is given to Otago's constructed monuments, including bridges and breweries, paper- and sawmills, and the Dunedin Gas Light & Coke Company Works. The precision with which these structures are detailed suggests skills honed during O'Brien's various stints as an architectural draftsman and surveyor in Dunedin.

O'Brien's clarity and accuracy, which today are highly prized attributes, were not always well received by critics of his day. While one praised his depiction of "geological characteristics … faithfully given," another complained that a view of Dunedin harbor was "bounded by impossible miniature Alps … subjected to a process of dwarfing similar to that bestowed by the Japanese on trees."[40] In November 1876 O'Brien's twenty-eight landscapes in the inaugural exhibition of the Otago Art Society (an organization he helped found the preceding February) were condemned by one reviewer for "the painful detail [which] results in trees such as were never seen," while another congratulated the artist for his "wonderful … fidelity to the characteristics of rugged Otago mountain scenery."[41] One man's fidelity is another's failure.

Such division of opinion among critics is hardly novel; but the average viewer would likely have concurred with those who found O'Brien's drawing "exceedingly clever in execution" and agreed that his works "will probably attract attention, on account of the carefulness in which the details are worked out."[42] Whether the detail was careful or painful, the illusion was sufficiently "clever" to convince most viewers and critics of the veracity of his scenes, and well into this century O'Brien was considered the sine qua non of the topographic tradition. What escaped most modern viewers of his precisely drawn *View of the Dunedin Gas Light & Coke Company Works* (Fig. 7) is that the artist's full title for the work continued, "projected by Stephen Hutchison C.E. Engineer and Lessee." As Roger Blackley recently pointed out, "O'Brien has skillfully combined authentic, closely observed details from everyday experience with architec-

tural fantasy…. Never actually built, the Coke Works remained a dream of Stephen Hutchison's, mediated by George O'Brien."[43]

The visionary image of an unrealized project, drawn so convincingly, hovers between the fantastic and the photographic. More remarkable yet is O'Brien's large pastiche of *Designs by R. A. Lawson*,▼ painted in the late 1860s. This neo-Gothic fantasy honors the most distinguished New Zealand architect of the mid-nineteenth century, combining several of his major designs (some never realized) centered on his masterpiece, the First Presbyterian Church, Dunedin. The structures are set convincingly in a green and hilly landscape of the type characteristic of the city and its environs. Yet the multiplicity of viewpoints of the buildings (managed through O'Brien's great finesse with perspectival drawing) and their variously real or imagined existence combine to make this clearly not a realistic view but an invention of the artist.[44] To the tradition of topography, O'Brien added a note of the fantastic, achieved through precise illusion.

O'Brien's designs for Lawson and, more particularly, his industrialized and inhabited landscapes document (or, in the case of the coke works, invent) the changes rapidly being wrought in the New Zealand landscape. They anticipate by several generations the views of construction and industry that inspired painters such as Doris Lusk▼ and Charles Tole▼ in the mid-twentieth century.

The influx of settlers continued in earnest through the mid-1800s, prompted in good part by conditions in Britain and the availability of land.[45] In 1861 immigration was given a dramatic new impetus by the discovery of gold in Otago and the Coromandel peninsula; the resulting rush drew miners from the goldfields of California and Australia, which had boomed in the preceding decade, and fortune hunters from around the globe. New Zealand's European (i.e., white, or pakeha) population nearly trebled in the 1860s, and doubled again in the following decade.[46] These dramatic increases

led to the expansion of older centers, the establishment of many new ones, and the clearance of vast tracts for settlement and cultivation.

Such feverish activity understandably had a great impact on the natural scene. Many colonists would have agreed with the visitor who thought, "it would be a blessing beyond all calculation if a branch of our British oak could be transplanted to New Zealand,"[47] and set to work, seeking "to cover with the verdure of fields and lawns many millions of acres … over which the fern and the myrtle at present hold undisputed sway."[48] They proceeded with a confidence born of the twin beliefs in God and Empire; the artist George F. Angas, visiting from Australia in 1844, was impressed by "the energy and enterprise of British colonists, and the benign influence of Christianity [which] combined, will eventually render the peaceful abodes of civilized and prosperous communities."[49] The transformation forecast by Angas was both rapid and, in many places, complete. As early as the 1850s, prospective emigrants were reassured that "many of the most populous and valuable districts are placed among scenery which … present[s] few of the characteristics of New Zealand landscape, and with nothing to remind the spectator that he is looking upon a foreign country."[50]

While some settlers doubtless welcomed (and needed) such reassurances, other arrivals came specifically to "look upon a foreign country," not to avoid its characteristic landscape. Despite the traveler's necessary commitment of funds and time, a fledgling tourism trade developed in New Zealand in the later decades of the nineteenth century, the ancestor to today's booming industry. As early as 1857 visitors were enticed to New Zealand's "fresh young land" by claims that it "offer[ed] a thousand scenes and sensations new to all blase travellers who have exhausted old-word [*sic*] 'sight-seeing.'" The novelty of the local scene, the restorative clime of "the Britain of the South," and the prospects for profits, and the improved transportation lured "any man having six months' holiday and £300." (The guide's author was something of a

flack for the European and Australian Steam Company.) "Manchester and Birmingham Bagmen may now visit the markets of Australia and Zealandia thrice a year for cash and orders ... invalids may elude the northern winter, have a tonic ocean cruise, and be back for strawberries in June." And, the guide advised, "artists may take an antipodal trip and return with portfolios crammed with the picturesque."[51]

Propagandists reported confidently that "New Zealand with its wealth of natural beauty ... will one day become the home of a great school of landscape painters."[52] Whether the Steam Company carried many painter-tourists – or invalids and bagmen – from Britain to New Zealand is unknown, but by various means and from various quarters, growing numbers of visiting artists joined other tourists (as well as resident New Zealanders) in seeking out the landscape's splendors. As colonial propagandists were fond of saying (and today's travel agents repeat), "New Zealand exhibits a world in miniature."[53] Over the years visitors have echoed the refrain; Mark Twain, for instance, praised the New Zealand landscape as "a combination of the fiords of Norway and the scenery of Alaska."[54] Its varied attractions – including the towering peaks and awesome glaciers of the Southern Alps; the deep fjords that cut the South Island's west coasts, most famously at Milford Sound; and the Thermal Wonderland of the central North Island, with its geysers, boiling pools, and (until their destruction in the eruption of Mount Tarawera on June 10, 1886) the fabled Pink and White Terraces at Rotomohana – all figured importantly in the scenic itinerary developed in the late nineteenth century.

In January 1876 Eugene von Guérard arrived from his Melbourne home for a short visit, his first and only to New Zealand. Yet, despite its brevity, his South Island sojourn yielded the two most widely exhibited New Zealand views of the nineteenth century, a pair of canvases that exemplifies a particular vision of landscape.[55] Each bears a lengthy and informative title – *Milford Sound with*

Pembroke Peak and Bowen Falls on the West Coast of the Middle Island, New Zealand▼ and *Lake Wakatipu with Mount Earnslaw, Middle Island, New Zealand*▼ – identifying the geographical specifics of the scene. Von Guérard's paintings are documents, defined by their particular titles and realized through the amassing of pictorial details. When shown in London, *Milford Sound* was praised for "the artist's conscientious respect for physical facts." With its mate, it illustrated the critic's characterization of New Zealand landscape art as "treated in the spirit of a physicist, whose chronicle of phenomena and facts is both precise and abundant."[56] In short, unlike other landscapes of the day, von Guérard's tourist subjects were treated not as aesthetic "arrangements" or momentary "impressions" but as monumental summations of place, empirically observed.

The artist's Germanic heritage and training are evident in the dramatic views of the wild scenery in Australia and New Zealand in which he specialized. Although the lure of gold had initially drawn him to Victoria in 1852, von Guérard's imagination was more stirred by the discovery of unfamiliar landscape, flora, and fauna than by the hard work and his poor luck in the goldfields, and he soon abandoned prospecting for painting.[57]

In Australia (and, in 1876, in New Zealand), von Guérard found exotic landscape subjects in abundance. His turn to them was inspired in part by his admiration for Alexander von Humboldt, the German naturalist whose early-nineteenth-century explorations in South America and subsequent writings about the region won an enthusiastic international reception.[58] In the United States, Humboldt's evocative descriptions drew the nation's interest southward, and his longing for an artist worthy of such exotic subjects motivated the travels of numerous painters, most notably Frederic E. Church. Church's South American views (Fig. 8), densely filled with natural incident and variety, provide an American parallel to von Guérard's detailed studies of South Australian and Victorian scenery, or Milford Sound and Lake Wakatipu. In

their wide-ranging travels and landscape discoveries, both men were fulfilling Humboldt's hope "that landscape painting will flourish with a new and hitherto unknown brilliancy when artists of merit shall more frequently pass the narrow limits of the Mediterranean, and when they shall be enabled, far in the interior of continents … to seize, with the genuine freshness of a pure and youthful spirit, on the true image of the varied forms of nature."[59]

In their grandiloquent style as well as their exotic subjects, von Guérard's New Zealand views also reflected his German training. At the Düsseldorf Academy, where he studied landscape painting under Johann Wilhelm Schirmer and Karl Friedrich Lessing, about 1840–45, he learned the habits of precise draftsmanship and close observation that distinguished his later paintings. "We fell in love with every blade of grass, every graceful twig," recalled one German landscape master of the period.[60] Such attention to natural detail was common to many of the painters who studied at Düsseldorf, among them a number of American artists, including Albert Bierstadt, who arrived there in 1853.[61] During his period at the academy, Bierstadt also studied with Lessing, and his and von Guérard's common tutelage is evident in their penchant for artfully composed views of dramatic landscape subjects, replete with carefully drawn details (Fig. 9). Like von Guérard, Bierstadt in Germany developed the practice of taking long walking tours in the countryside to study natural forms, particularly those of geological interest; also like his southern counterpart, Bierstadt allied himself with scientific or military expeditions that pushed into the interiors of their respective continents, seeking natural marvels beyond the scope of the familiar.[62] It was a Düsseldorf impulse that propelled alumni of the academy to corners of the world far from Germany, including Bierstadt's Rockies and Sierra Mountains and von Guérard's Milford Sound, Lake Wakatipu, and the mountain range aptly known as The Remarkables.

Von Guérard's theatrical vision of the New Zealand landscape in the 1870s was not the first non-British aesthetic to be applied to the subject.[63] It was, however, surely the most important to that date. His Germanic presentations of South Island scenery heralded the importation of other foreign styles which were increasingly evident toward the end of the century.

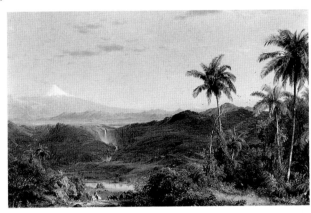

Fig. 8. **Frederic Edwin Church**, *Cotopaxi*, 1855. Oil on canvas. The Museum of Fine Arts, Houston. Hogg Brothers Collection, museum purchase by exchange.

Around 1890 three distinctive painters arrived independently from various European centers, and their collective example effected a modest revolution as New Zealanders discovered modern art. Petrus van der Velden (1837–1913) landed in 1890 from his native Holland, where he was associated with the Hague School. Shortly after his arrival in New Zealand, he spent six months sketching in the rugged Otira Gorge of the Southern Alps, a terrain very different from the cultivated farms of his Dutch upbringing, and the new inspiration prompted a distinctive response. According to van der Velden's biographer, "in Otira, his romantic sensibilities found a Wagnerian fulfillment."[64] Van der Velden's expressive, brooding views of the mountainous country and its dramatic cataracts became a favored subject with both collectors and students and followers (Fig. 10). More important, however, than the influence of his style (which was slight) was van der Velden's exemplification of the artistic

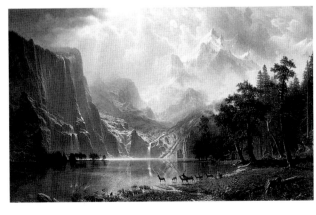

Fig. 9. **Albert Bierstadt**, *The Sierra Nevada in California*, 1868. Oil on canvas. National Museum of American Art, Smithsonian Institution. Bequest of Helen Huntington Hull.

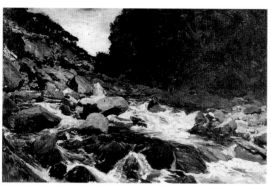

Fig. 10. **Petrus van der Velden**, *Mountain Stream, Otira Gorge*, 1891. Oil on canvas. Dunedin Public Art Gallery.

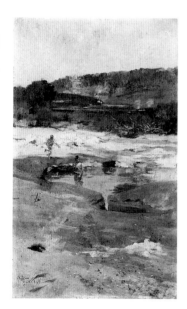

Fig. 11. **Girolamo Nerli**, *At Rotorua*, ca. 1897. Oil on panel. Collection National Art Gallery, New Zealand.

life, being among the first to pursue his interests so professionally and visibly in New Zealand. "He was," according to his obituary, "the best type of Bohemian,"[65] and his personal example provided important inspiration to a number of artists.

The itinerant Girolamo Nerli (1860–1926) studied in the early 1880s at Florence's Accademia di Belle Arti, in his native Tuscany. His acclaimed skills as a colorist were, however, not the result of academic training but of his admiration for the French impressionists, whose inventions were familiar in Italy from the 1870s onward, and the inspiration of the Macchiaioli, whose deft brushwork and colorful, plein-air effects vitalized Italian painting beginning in the 1860s. In both Australia (where the painter was based, 1885–1893 and 1898–ca. 1904) and New Zealand (1893–1898), critics of Nerli's day were struck by the novel merger of "the poetry of the Arno and the *chic* and *abandon* of Paris in his nature."[66] But they were predictably divided on its significance. Some applauded him for the introduction of "Southern neo-Continentalism" with its "daring independence ... [and] disregard of generally accepted trammels" and delighted at his "substitution of the mere sketch for finished work."[67] Others wishfully anticipated the waning of the vogue for "three splashes of paint to the right and three to the left, constituting the picture."[68] Although Nerli concentrated on portraiture and figure compositions, his small-scale landscapes (Fig. 11), often punctuated by figures sketchily brushed, show his color and technique at their liveliest; but such works, which recently have been of great interest to critics, are as scarce as they are effective, and no plausible claim can be made for Nerli as the founder of a continuing landscape school. What did endure was the interest in pleinairism inspired by his example; his sketchy technique also prompted the vogue for a somewhat

tepid Impressionism that in New Zealand (as in the United States) long survived its original practitioners.

About the same time, Impressionism was also introduced, via Scotland, by James Nairn (1859–1904), who arrived in New Zealand in January 1890, seeking an ameliorative climate for his poor health. As a student at the Académie Julian in Paris in the 1880s, he was inspired by the impressionists, as well as by James Whistler's aestheticism.[69] But, like J. Alden Weir and many other Americans in the French capital, he succumbed most fully to the influence of the popular Jules Bastien-Lepage and his conservative variant on impressionist color and technique. Nairn's allegiance to plein-air sketching was furthered by his association with the Glasgow Boys, the school of Scottish impressionists who tempered the extremes of French style with a reliance on realistic forms, broadly brushed in dark tones. Nairn brought this manner to Wellington, where it received a mixed response (Fig. 12). Pupils at the Wellington Technical School favored Nairn's instruction and eagerly followed his advice: "Always go direct to Nature for your work, and you cannot go wrong"; but conservative critics dismissed the newcomer's work as "bilious" and "chromatic lunacy."[70] The artist himself was unmoved by the assaults – "I shall always make a point of trying to outrage the taste of the ordinary public," he proudly claimed[71] – and with enthusiasts founded the Wellington Art Club. Its members often joined Nairn for sketching at Pumpkin Cottage in the rural Hutt Valley near Wellington, there to "go direct to Nature."

As with Nerli and van der Velden, Nairn's style was developed in Europe and transplanted without great change to a new environ; like them, it was ultimately his persona, more than his paintings, that stimulated students and intimates, but the influence could not survive his early passing. As E. H. McCormick concluded, "it is less as interpreters of New Zealand than as teachers that both van der Velden and Nairn are important to the history of New Zealand art. With their arrival ended

the phase of amateurs expressing themselves chiefly in water-colour and pencil sketch. From the nineties onwards New Zealand art becomes more varied, more sophisticated, more in touch with movements abroad…. What they did was to hasten that development and to direct the untrained enthusiasm of young students into channels more profitable than it might otherwise have taken."[72]

The possibilities of their techniques were realized early in this century by successors and students. Although he was largely self-taught as a painter, the peripatetic Edward Fristrom moved easily into the New Zealand art community following his arrival from Brisbane in 1903. Like many arrivals around the turn of the century, Fristrom brought an aesthetic shaped by current European vogues, in his case that of his native Sweden; but more than the imports of the 1890s, his was further shaped by his new environs. He shared with Nerli and Nairn a predilection for the outdoor sketch, producing many small vignettes of landscape and foliage throughout the country, brushed with a loose and rapid stroke;▼ generally he eschewed the more dramatic aspects of New Zealand scenery, but even when he painted the Southern Alps, it was with an intimacy and immediacy that separated his work from the drama conveyed by earlier visitors, like von Guérard.[73] Later in life, working in northern California, he complained that great distances separated his San Anselmo home from the "painting ground … away from houses and ordinary common farms and endless fields of cultivation" – painting grounds that were closer at hand in Europe or in "little small New Zealand."[74] It was in such ordinary settings, neither wildly dramatic nor cultivated and inhabited, that Fristrom found the inspiration for his finest works. As Elizabeth Wilson aptly summarized, "Fristrom's approach to landscape is decidedly anti-picturesque, his viewpoint is never that which allows, by its elevation, the panoramic vista, but is invariably low, filling his pictures with not the distant but the immediate environment."[75] It was a subject and a solution that was admired in his lifetime by critics who sought in

paintings a reflection of "the minor characteristics of [New Zealand] nature, landscape and seascape,"[76] and continues to be so today. His most recent biographer summarized Fristrom's achievement as "defin[ing] the landscape not in terms of the sublime or the grandiose but in terms of the small, the seemingly insignificant elements, that, by his close scrutiny and 'enclosure,' were imbued with a significance wholly their own."[77]

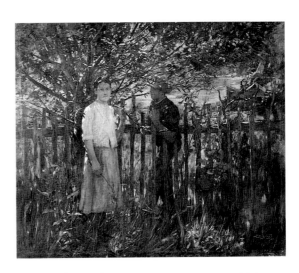

Fig. 12. **James McLachlan Nairn**, *A Summer Idyll*, 1903. Oil on canvas. Collection National Art Gallery, New Zealand.

29

In the predilection for the gentler, even prosaic face of nature, Fristrom paralleled the interests of many landscapists at the turn of the century. In the Connecticut countryside, for example, Fristrom's contemporaries, such as John Twachtman, Theodore Robinson (Fig. 13) and J. Alden Weir, delighted in working out-of-doors, often painting small streams, overgrown corners of the pasture, or granite ledges bedecked with laurels, rather than the torrent of Niagara or the lofty summits of the Rockies. The most immediate inspiration for such motifs was offered by the impressionists; but the focus on the local and the familiar was grounded in long tradition, dating to the early nineteenth century when John Constable, dissenting from Gainsborough's assertion that no landscape outside Italy is worth painting, claimed (as Kenneth Clark put it) that "his art could be found under every hedge."[78]

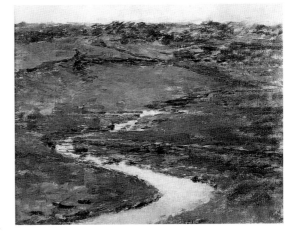

Fig. 13. **Theodore Robinson**, *On John H. Twachtman's Property*, ca. 1894. Oil on canvas. Collection of Mr. and Mrs. John Graves.

The hedges of New Zealand – or, more properly, the native trees – provided

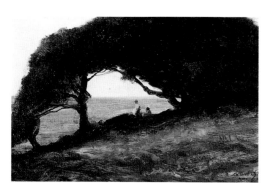

Fig. 14. **Charles Walter Stetson**, *A Glimpse of the Sea*, 1903. Oil on canvas. Collection of Jerry Jackson.

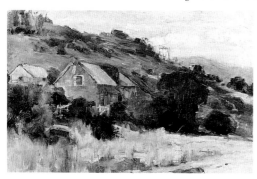

Fig. 15. **Edward Fristrom**, *Homestead, Lake Wakatipu, Queenstown No. 1*, ca. 1905. Oil on cardboard. Collection National Art Gallery, New Zealand.

Fig. 16. **Arthur Wesley Dow**, *Modern Art*, 1895. Lithograph. Helen Foresman Spencer Museum of Art, The University of Kansas, Lawrence.

Fristrom with some of his finest moments as a painter. During his decade in the country, he moved gradually away from depictions of imported species, like the ubiquitous poplar, which lent the pictures a sense of anyplace, everyplace – or placelessness – toward indigenous growth which clearly bespoke "New Zealand." The tea tree, the pohutukawa, and finally the karaka provided arboreal symbols of place, just as the blasted American oak had for Thomas Cole, or the umbrella pines of Italy did for visitors like George Inness or Walter Stetson (Fig. 14).

The distinctive forms of native trees also prompted more decorative compositions as Fristrom silhouetted the masses of foliage against sea and sky or rhymed the slender verticals of their trunks. The rhythmic designs and art nouveau patterns that sometimes resulted led at least one critic to remark on "the audacity of … Fristrom's artistic jokes," especially evident in his "Aubrey Beardsley trees."[79] On rare occasion, Fristrom would transform sketches from the field into even more stylized compositions, likely completed in the studio. Two views of a *Homestead, Lake Wakatipu, Queenstown* illustrate the progression from initial impression (Fig. 15) to decorative design,▼ accomplished through the elimination of details and the flattening and dark outlining of forms. The continuous undulant line and the simplification of pattern recall decorative tendencies that would have been familiar to him from his Scandinavian upbringing and that were internationally popular by the turn of the century. They also show affinities with the modern designs of the American painter and printmaker Arthur Wesley Dow (Fig. 16), who was one of the most influential teachers of the day; while it is doubtful that Dow's graphics were known in New Zealand at that early date, his enormously popular treatise, *Composition*, was available and possibly known to Fristrom.[80] The striking affinity between the artists' works, both in style and subject (generally local and modest), suggests Fristrom's distant but current involvement with an international mainstream.

By far the most memorable of Fristrom's inventions is the remarkable *Pohutukawa*.▼ A favorite native species, the pohutukawa is familiarly known as the Maori Christmas tree, for it blooms dramatically in the New Zealand summer when "woody tumours burst in scarlet spray," inspiring painters and poets alike.[81] Like Fristrom's *Homestead*, *Pohutukawa* is probably the result of studio transformations of plein-air sketches. Here any lingering suggestions of impressionist stroke or transparency are banished; the tree and its setting are at once evocative of region and season, yet denatured and transformed in a marvel of artifice. The move away from representation to the service of modern style provides a harbinger of developments in the next generation. ■

CHAPTER 2

Uncovering New Zealand

Looking backward from mid-century, Peter Tomory, a gallery director and influential champion of New Zealand artists, concluded that "those years between the First World War and the depression were indeed a wasteland."[1] Nostalgia for a distant northern "home" affected the view of generations, even of native New Zealanders who lamented, "we are Englishmen, born in exile."[2] This romantic yearning for elsewhere colored artists' vision and stultified innovation. The belief that "art" (as opposed to technique) could be taught – and nowhere better than in the hallowed institutions and settings of the northern hemisphere – led to a rising tide of expatriation, as many local talents were lured to England and the Continent. Those who returned – Tomory's "blind and unfeeling" veterans of Royal Academy exhibitions or other foreign triumphs – were often unsettled by the reentry to New Zealand. "Their eyes, conditioned to the grey north light of Europe and a land of a different lay cultivated into sophisticated forms by centuries of peasants and painters, were shocked and puzzled by the brilliant Pacific light and an untamed land. No immemorial elms but the silent jungle of the bush."[3] Such physical characteristics of the New Zealand environs were often remarked on by early colonists. Yet their role in the critical discourse about art did not assume prominence until much later.

Light and land – nowadays constants in an ongoing debate about the distinctive nature of New Zealand painting – were noted as chief characteristics of the local scene in 1929, when John Cam Duncan wrote of "its spaciousness, its clairvoyant atmosphere … and its swift changing lights."[4] A few years later, such observations were codified in one of the most frequently quoted passages of New Zealand art criticism, when the poet A. R. D. Fairburn proclaimed: "There is no golden mist in the air, no Merlin in our woods, no soft warm colour to breed a school of painters from the stock of Turner, Crome, Cotman and Wilson Steer. Hard, clear light reveals the bones, the sheer form, of hills, trees, stone and scrub. We must draw rather than paint,

even if we are using a brush, or we shall not be perfectly truthful."[5]

Fairburn's prescription was inspired by the landscape paintings of Christopher Perkins. He arrived from London to teach at Wellington Technical College in 1929 and left for England less than five years later; yet during that short time, he developed a modern view of the New Zealand landscape that inspired local artists long after his departure. He had studied at London's Slade School of Art and was part of the circle of young modernists who sought to enliven British painting. By the time he arrived in New Zealand, Perkins recalled, "I had [Slade professor] Henry Tonks and Stanley Spencer and Picasso's Blue period behind me."[6]

He also had behind him Cézanne and the landscape of the south of France, where he had lived briefly in the early 1920s, and the recollection of the French master and his environs profoundly shaped Perkins's vision of New Zealand.[7] Initially disappointed by the moribund state of local culture – he had expected to find a "vigorous native art" – Perkins set about with the zeal of a missionary to spark a "new vision … [and] turn the stark facts of life in this country, such as the tin dairy shed, into a unit of living design." Soon after his arrival in Wellington, he lent credence to the theory of local illumination when he told a local reporter that "the future of New Zealand as a country for painters is guaranteed by its marvellous light," thereby ingratiating himself with some locals; but the modern paintings that came from his easel disconcerted the generally complacent and conservative taste, provoking "The Culture War" (as Perkins and his friends called it) waged through published criticism and letters to the local newspaper editor.[8]

Perkins's view of *Taranaki*▼ honors the indigenous architecture (here, the simple tin-roofed structures of a dairy factory) that early won his attention, treating it and the landscape setting with a rigorous structure derived from Cézanne. Perkins struggled with the painter's problem of balancing consider-

▼

31

ations of design and subject, wondering "How much may design be allowed to distort material, and how much material is really needed for rich yet economical effect; how to find the timing, the tone and color pitch, the spacing and proportion for that perfect unison."[9] In *Taranaki* and elsewhere, he opted ultimately for form and style. Unlike, for instance, the precisely measured structures of George O'Brien, Perkins's buildings serve the demands of painting design over architectural documentation and play an important formal role in the composition.

Fig 17. **Marsden Hartley,** *Purple Mountains, Vence,* 1924–26. Oil on canvas. Phoenix Art Museum. Gift of Mr. and Mrs. Orme Lewis.

The unconventional prominence of the buildings in the foreground also suggests a symbolic role, adding to the local color and asserting the image's regional or national connotations through emphasis on New Zealand's ubiquitous tin-roofed buildings. Other details – water towers and foliage, and, some would say, the hard light and emphatic shadows – likewise support the allusion to place. No motif does this more so than the elongated cloud girdling the snowy peak, a common meteorological occurrence at Taranaki, but also a reference to the Maori name for the islands, *Aotearoa,* or "Land of the Long White Cloud." Place is symbolized by one of its most familiar and beloved features, and by oblique reference to its native people. Both in subject and as an image, Perkins's *Taranaki* has survived its initial detractors to become a modern icon of the nation.

The painting, however, conveys an aesthetic terrain as clearly as a nationalistic one. In addition to Heaphy's precedent with the same subject – *Mt. Egmont Viewed from the Southward* [see p. 156], an image probably unknown to Perkins – Taranaki's strong profile, clear illumination, and firm drawing recall other famous summits, from Hokusai's Fujiyama to Cézanne's Mont Sainte-Victoire. The fascination

with Cézanne and with the Provençal landscape was widespread in the 1920s and led many artists, Americans as well as Perkins, to the south of France. It was there that Marsden Hartley, for example, sought to escape from the expressionist angst of his Berlin-period work (1921–24) and return to "the French purity of feeling."[10] He acclimated to the clear light and patiently studied the topography, trying "to see over the surface of a place and find the key,"[11] finally discovering it through the alembic of Cézanne's rigorous vision, which eliminated expressive mannerism and extraneous detail. Hartley's pristine Provençal patterns (Fig. 17), compositions of nearly architectural solidity, suggest his new belief that "nature is ... primarily an intellectual idea," better realized through "intellectual clarity" than "imaginative wisdom or emotional richness." In Cézanne's country he, like Perkins, came to prize formal values: "I would rather be sure that I have placed two colors in true relationship to each other than to have exposed a wealth of emotionalism gone wrong in the name of richness of personal expression."[12]

Such formalism was neither limited to the pilgrims to Aix nor solely dependent on the experience of Provençal light – or its vaunted southern equivalent in New Zealand. During the 1920s and 1930s, numerous painters were challenged by the arid light and vast scale of the American West. Like the pioneers on the Oregon Trail, whose "visual habits had developed in the size and distance clues of a humid landscape" and for whom the West's "clear air and absence of trees made perspective exceedingly difficult,"[13] painters, too, struggled to come to terms with the environs. That region of the country, where, as one critic aptly noted, "the biggest and simplest forms of man and the biggest and simplest forms of nature merge,"[14] elicited solutions of various types; yet common to all was the challenge of light and land. In New Mexico landscapists of the Taos School, most notably Ernest Blumenschein, moved toward pictorial solutions that gave primacy to hard-edged patterns and simplified forms. The deserts of Arizona

32

and southern California prompted even more dramatically stylized results from Maynard Dixon, of whom one commentator has written, "Only in bareness and brilliance did [he] arrive at his own country."[15] Dixon used the crisp shapes of mountain, mesa, and dune, patterned with long, lateral shadows, to develop his distinctive landscape designs from the 1920s onward (Fig. 18).

Other terrains prompted comparably purist visions, as many painters reduced landscape elements to simple, hard forms during the formalist decade of the 1920s. Inspired by his travels to the far north, with its "hard horizons at the edge of the world where … skies are clearer and deeper,"[16] Rockwell Kent invented a style of hard-edged clarity that served him well in landscape paintings and, most famously, in his dramatic graphic style. Canada's Lawren Harris, a founder of the modernist Group of Seven, similarly distilled stylized designs from the north-country landscape (Fig. 19). His compositions of the 1920s and early 1930s exemplify the first stage in an aesthetic evolution – Harris called it "painting abstracted from nature" – that led him ultimately to Abstract Expressionism. As he explained: "Most of the great artists of the past had looked beyond the appearance and 'abstracted' – that is, they extricated from the surface plenitude of nature its essential forms in order to give their works a basic aesthetic underpinning, and thus a greater coherence and unified force of expression."[17]

Taranaki is very much part of that broad turn toward such clarity, indebted to Cézanne and an international style more than to local atmospherics or circumstance. At their finest, Perkins's New Zealand scenes set a new standard for "coherence and unified force of expression" or, in his own words, "a unit of living design." In both his teaching and his work, he insisted on what he called "firm drawing," and the resulting forms helped banish the romantic mists or impressionist fog of an earlier generation.[18]

Perkins's celebration of regional or national landscape subjects is also part of an international movement between the wars, marked by a gravitation to familiar scenes, to "native grounds," as the local became iconic.[19] For landscapists, it was a period of global homecoming, which (despite evident differences in technique) embraced subjects as diverse as Georgia O'Keeffe's New Mexican hills and Grant Wood's tidy fields of Iowa, Stanley Spencer's Cockham countryside and Ben Nicholson's Cornish coastlines, Ernst Kirchner's Alpine subjects and Oskar Kokoschka's urban panoramas. New Zealand critics echoed sentiments elsewhere in believing that "painting flourishes best when firmly painted on its own ground."[20] This nascent regionalism was advanced by Perkins's work, which converts eventually praised for "making us conscious of ourselves as a nation."[21] His example proved liberating and inspirational to many younger artists who, like him, often treated their motifs with clarity of vision, firm drawing, and structural emphasis, uncovering the landscape's forms. The influence was not confined to images of Perkins's Wellington or to Rotorua where he later resided; indeed, the pursuit of indigenous subjects was conducted throughout the nation.

The South Island's Canterbury region and Christchurch, its main center, proved especially fertile ground for Perkins's precepts. After a visit in 1904, the French social scientist André Siegfried published an exceptional account of life and manners in New Zealand. This latter-day Tocqueville of the south noted that "each country has its artistic and literary centre, or rather, in each country there is one town which prides itself on being the capital of letters and of art, the refuge of science and civilisation. Boston tries to be the Athens of the United States; and Toronto, the Boston

Fig 18. **Maynard Dixon**, *Desert Southwest* (detail). Oil. Location unknown.

▼

33

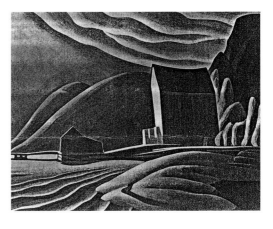

Fig 19. **Lawren Harris**, *Fish House, Coldwell, Lake Superior*. Oil. Location unknown; from catalogue for *Exhibition of Contemporary Canadian Painting*, shown in New Zealand, 1938.

of Canada." Siegfried concluded that, "Christchurch aspires to be the Toronto of New Zealand."[22]

The city was one of the earliest settlements in New Zealand – to this day, it is the most "English" center in the nation – and it had long prided itself on its cultivated society. As early as the 1860s, when the arts were rarely included in school curricula anywhere, the provincial government employed itinerant masters to teach drawing to the children of Christchurch; and in 1881 the Canterbury College Board of Governors founded an art school in the city. Instruction in landscape was introduced at the school four years later.[23]

By 1927, when Rita Angus enrolled at the school, it and the city of Christchurch were in their heyday as an artistic and cultural center. Their liveliness led one visiting Australian critic to "doubt if there is another city of its size in the Empire where the conditions are so favourable for future expansion, not only of painting and sculpture but literature and music."[24] Decades later, after she had achieved status as one of New Zealand's leading modernists, Angus recalled the excitement of those school years and provided a telling indicator of her formative influences: "the composition of paintings [projected in art history classes] impressed me…. [I was] absorbed in the work of Vermeer portraits and Cézanne."[25]

The precise realism of the Flemish tradition left its imprint on her portrait style, as is evident in the paintings of self and friends she began in the 1930s, images that share affinities with the portraits of Grant Wood, who was also deeply affected by the Flemish primitives.[26] An equivalent sensitivity to precision and pattern appeared in her landscapes as well, properties that were inspired by Cézanne's forms and structure. Throughout her life she retained her interest and respect for the French master: "Cézanne's temperament was fundamentally classical," she noted in 1960. "He was for structure at any cost, rooted in the nature of things."[27]

Locally, these qualities were reinforced by the example of Christopher Perkins, whom Angus also admired. Following his lead, she sought out motifs that had significance, both of locale and to the artist. In 1936 in the railway station at Cass, on the line through the rugged Alps from Christchurch to the west coast, she found the perfect subject. Like Perkins's *Taranaki* of a few years earlier, Angus's *Cass*▼ records a specific view of building and landscape yet transforms it through her intense vision and style – "structure … rooted in the nature of things." As Ronald Brownson has aptly described, Angus's structures, like the railway station at Cass, "implied through symbols historical metaphors and social values: farming, travelling, learning, producing, eating, living as a family." The station, while the compositional focus of the painting, is not its only content. "*Cass* operates on shifts in spatial-temporal meaning – the main figure remains contemporary while its immediate environment recalls an historical context [of the Arthur's Pass region]." Noting Angus's uniformity of intense color and active pattern, Brownson concluded that "a symbolical pictorial geometry is at the heart of the painter's landscape construction."[28]

Angus shared with American painters – Grant Wood, for instance – the symbolic intent in landscape, part of the period's sensibility; despite the distance and difference between Canterbury and Cedar Rapids, Iowa, the telling juxtaposition of present-day subjects and activities with the land's traditions (alpine or agrarian) bespeaks a similar celebration of place and history. Her formal plays – insistent patterning, emphatic contours and drawing, contrived scalar relationships – also parallel those Wood employed in his Iowa views of the same era.

Such devices grew more pronounced in Angus's subsequent treatments of the South Island terrain. In *Central Otago*,▼ she captures quintessential New Zealand scenery earlier made famous in the views of von Guérard, O'Brien, and a host of other painters. Yet, unlike theirs, "her vision carries her beyond the externals to the basic forms of the earth," as one critic wrote.[29] In her work style transforms the familiar fields and peaks into a fantastic terrain, yielding not the tourist's view but

a personal conception, achieved over time and realized through concentration and distillation. Frederick Page once explained that, "Like the Chinese," whose art was another of Angus's great enthusiasms, "she paints not so much the thing in front of her, though she starts from there, as the essence of the thing."[30]

During the middle decades of the century, painters often realized the essence of the land through the simplification and baring of its essential forms. Doris Lusk, Angus's friend and colleague in Christchurch, evoked the bare hills and distant vistas around the city in her *Canterbury Plains from the Cashmere Hills.*▼ Her image is indebted, in its simplification of topography and elevated vantage point, to the example of Colin McCahon, whose *Takaka: Night and Day*▼ antedated the Lusk view by several years.[31] The tendency continued well into the 1970s, when Charles Tole stylized his subject even more dramatically in *Landscape with Red Stanchion.*▼ Like many modern views, Tole's bears evidence of human presence in the land, here represented by the simple red bar intersecting the prospect, artifice introduced into nature; the distinctive sense of place is provided by the characteristic bald hills of New Zealand, one of which terminates in a *koru* motif, an organic design based on the fern frond that is used in Maori decoration.

Baring of the land, whether by human acts or in the artist's imagination, suggests the effort to reduce subject to its structural essentials; for the painter, it could arise from the effort to typify place through its geological forms. With ancestry in the precisely drawn watercolors of Kinder, O'Brien, and generations of topographers, the bald hill emerged even more frequently in the 1940s as a prominent feature of New Zealand landscape art and as an emblem of place. For Colin McCahon, the very ubiquity of the hills was the basis of their appeal; he called them "monotonous, yes, but with a cumulative grandeur, like Bach."[32] So typical was the motif that it emerged in a recent typological study as one of the four basic classes of New Zealand landscape art: Horizontality; Headlands; Bay Forms; and Bald Hills.[33]

This classification is of interest on several counts. It eschews discussion of landscape art in traditional terms as sentimental or nationalist symbols (e.g., the proverbial "silent bush" or "hard, clear light," exemplifying New Zealand). Furthermore, by downplaying differences of individual mannerism or style (brushwork, color, etc.) and concentrating instead on the forms depicted, it avoids conventional gatherings of artists by regional school or artistic technique. Consideration of forms dominates symbol, subject, and style. The shapes that determine the categories reflect the formalist tenets that shaped international aesthetic discourse in recent decades, including debates in New Zealand; but the emphasis on geological forms seems especially a New Zealand trait. Like the poet R. A. K. Mason, many of his compatriots felt "for ever bondaged fast to earth."[34]

The volcanic peaks and glaciated gorges, the surf-worn cliffs, braided streams, and talus slopes – and the bald hills – provided a varied face to the land, and one that was in many cases unique and specific to New Zealand. During the 1920s and 1930s, as poets and then painters found inspiration in the local, such land features became a familiar part of their repertoire of images.

In 1939, on the eve of the nation's centennial, Charles Brasch wondered poetically about "The Land and the People":

They who found and we who find
Shore, mountain, dogged bush,
What have any of us learned
Of the place except its obvious look?[35]

To Brasch, the land offered possibilities beyond the superficials of form and contour, "shore, mountain, dogged bush." The spirit of the land pervaded his art, as he personified the "groins and armpits of the hills" and sought a merger of self and place. In some of the most famous lines in all New Zealand verse, he declared that

Man must lie with the gaunt hills like a lover,
Earning their intimacy in the calm sigh
Of a century of quiet and assiduity,
Discovering what solitude has meant

Before our headlong time broke on these waters.[36]

▼
35

The poetic conjunction of land and time evokes a host of complex associations; these were further prompted from an unexpected source in the years between the world wars. In 1922 Professor Charles Cotton of Victoria University, Wellington, published *Geomorphology of New Zealand*, a systematic introduction to the distinctive landforms of the islands. While a treatise, even an introductory one, on such a specialized subject might elsewhere have slipped into oblivion, in New Zealand Cotton's *Geomorphology* became an enduring favorite, expanded and reissued over the years, and today it is widely regarded as a classic of its genre. In the preface to the 1942 edition, the author mused over the book's "considerable popularity notwithstanding that a rashly promised sequel which was to present a regional treatment of New Zealand landforms has failed to appear."[37] For a people in quest of a *national* identity during the 1920s and 1930s, the more particularized, regional sequel would perhaps have been less compelling than the broader introduction presented in the initial volume.

Fig. 20. **Alfred Sharpe**, *A Jam in the Lava Cleft, Hay's Creek, Papakura*, 1878. Watercolor on paper. Auckland City Art Gallery Collection. Presented by John Leech, 1936.

"Geomorphology makes its appeal," wrote Cotton, "not only to geologists and geographers but also to all who love Nature and have eyes for the natural landscape." To the scientist, the forms of the land revealed geologic process in the production, transportation, and deposition of earth materials; but beyond this, they provide "a record – which is in many cases the only record available – of a late period in the history of the earth."[38] It was this sense of geological time that was newly important to lay readers of the period – not the arcana of Cambrian layers or homoclinal shifts but a more general sense of antiquity embedded in the land.

Early settlers in New Zealand found it "a country fresh from nature's rudest mint, untouched by hand of man."[39] But this freshness was also troubling, for, though the landscape might be transformed to a semblance of England, there was still "one thing wanting … the charm of age, the vestiges of the past, the spot endeared by old associations and traditions."[40] The legacy of colonial accounts is evident in the concern of later New Zealanders that theirs was "A land without a past; a race/Set in the rut of commonplace."[41]

Occasionally, artists found serendipitous surrogates for the vestiges of the past, such as the giant drums of kauri log dropped like broken columns into the pristine bush, a subject photographed by Kinder and painted by Alfred Sharpe (Fig. 20). In their images, the wilderness seems to draw meaning from its opposite, the constructed ruins of the venerable kauri that define the nature of their surroundings. Like the rude intrusion of the human-made object into the natural arena in Wallace Stevens's "Anecdote of the Jar," the amputated columns of kauri

> *made the slovenly wilderness*
> *Surround that hill.*
>
> *The wilderness rose up to it,*
> *And sprawled around, no longer wild.*

The poet's jar, lying "gray and bare" on a southern hill, "took dominion everywhere."

> *It did not give of bird or bush,*
> *Like nothing else in Tennessee.*[42]

Similarly discordant combinations of the created and the natural recur in modern images of New Zealand, such as John Johns's *Pylons*,▼ in which hard, rectilinear forms glisten dramatically against folded hills and lowery sky, or Richard Killeen's *Hillsborough*,▼ where blank whiteness and rigid forms seemingly cancel the view over hallowed ground.

In America as well, wilderness elicited strong response, but one less tinged with anxiety than is often found in New Zealand's colonial accounts. In the 1830s Thomas Cole, like many others, was inspired by the vast, virgin land to the west of the Alleghenies, with its "sublimity of a shoreless ocean un-islanded by the recorded deeds of man." He acknowledged that "its scenery may differ from the old

world's, yet inferiority must not therefore be inferred; for though American scenery is destitute of many of those circumstances that give value to the European, still it has features, and glorious ones, unknown to Europe."[43]

Since the seventeenth century, artists had evolved a complex iconography of people and their associations with place evinced through architectural ruins, evidence of their hands and deeds. In their unsettling absence, pioneers analogized by naming features in the land for their constructed semblances: hence, the number of rocks known as Castle, Table, Chimney, etc., in the American West, or New Zealand's Bastion Rock, "Frenchman's Cap," and similarly christened landmarks. In New Zealand, as in the United States, such geomorphic forms offered reassuring proof of a local past, "natural ruins [being] a substitute for a cultural history."[44] As one critic recently put it, "The land endures in timeless violence, a reminder of our own genetic ancestral antiquity."[45]

In the years between the world wars, an anxious generation of young New Zealanders, their uncertainty fueled by a sense of rootlessness in place, grew preoccupied with their land, as if through poetic or painterly will they could sink their roots and secure their position. In describing and illustrating the prominent features of their physical environs – the "native grounds" and "natural ruins" – Cotton's *Geomorphology* provided them with a grounding in antiquity, a geological history far longer than any cultural one, European or Maori.

When Colin McCahon and fellow painter Anne Hamblett were married in September 1942, they received as a wedding present a copy of Cotton's *Geomorphology*. The donor, recalling McCahon's earlier panoramic view of *Harbour Cone from Peggy's Hill* on the Otago Peninsula, in which the rhythms of bare hills provided the pictorial drama, made a thoughtful choice. Many years later, McCahon still treasured the volume, acknowledging that "Cotton's explicit and ordered drawing was, and still is, a very big influence in my work."[46]

The impact of Cotton's illustrations (Fig. 21) is suggested in *Takaka: Night and Day*.▼ The picture was painted soon after McCahon's move from Nelson to Christchurch and represents a reminiscence of the Takaka Valley, near Nelson, rather than a topographical study from life.[47] In this crucial respect, it differs from the more documentary views, also from an unusual elevated vantage, by Doris Lusk and Charles Tole or, in this country, by specialists in regional landscape such as Ross Dickinson (Fig. 22). For McCahon, Cotton's was not a book of revelation but of clarification; it confirmed a direction toward structure in the land in which he was already propelled. The tendency toward generalized forms in his compositions was the result of his diverse enthusiasms, for both European and New Zealand art, contemporary and historical.[48] Cotton's illustrations brought to the adventitious mix a diagrammatic clarity, a geologist's sense of landscape forms and their underlying structure – the slope of a hill, the wideness of a plain, the "mountain-ness" of mountains – which the painter could then summarize and simplify in memorable compositions. McCahon himself suggested the importance of Cotton's vision when he admitted that his painting "does not have a great deal to do with the Takaka Valley which is full of trees…. The actual valley as I saw it was like a geological diagram, only overlaid with trees and farms. In my painting" – unlike Dickinson's, which is rich in rural details – "all this has been swept aside in order to uncover the structure of the land."[49] Despite the differences in their imagery and local geology, McCahon would likely have agreed with Grant Wood's observation that "the naked

Fig. 21. Illustrations from **C. A. Cotton**, *Geomorphology: An Introduction to the Study of Landforms*, first published 1922.

▼
37

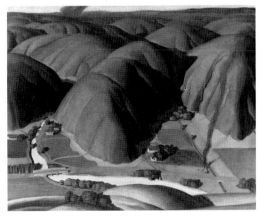

Fig. 22. **Ross Dickinson**, *Valley Farms*, 1934. Oil on canvas. National Museum of American Art, Smithsonian Institution. Transfer from U.S. Department of Labor.

earth in its massive contours asserts itself through anything that is laid upon it."[50]

Beyond its geomorphological qualities, McCahon's Takaka view is remarkable for the symbolism the artist invested in the work. His biographer, Gordon Brown, described McCahon's process and its effect: "When the landscape is closely inspected, then the features shown in the painting are those we associate with such a scene. But the painting's generalized simplicity of style has shorn it of its superficial scenic novelty or its possible sentimental interpretation. What is revealed is a more distant, harsher, symbolic reality."[51] The positing of symbolic value in geology or the landscape's forms is reminiscent of earlier images in American art. Although utterly dissimilar in style and technique, McCahon's *Takaka: Night and Day* evokes recollections of Frederic Church's South American volcanic subjects (most famously his view of *Cotopaxi* in eruption), the products of an age when geology was, in Barbara Novak's words, "the locus of some of the most controversial arguments about God, man, and religion."[52] *Cotopaxi* was praised by Church's contemporaries for conveying "the manner and method of Nature"; moreover, "both in general effect and in authentic minutiae," Church's painting was "true to the facts of nature and the requirements of art."[53] McCahon's later views (and distillations) of New Zealand's geomorphology, while less detailed in the specifics of the scene, are likewise invested with more than scenic significance; they are similarly the products of (Cotton's) science and aesthetic vision, and in the largest sense true to both the facts of nature and the requirements of art. Although not informed by Darwinian debate, as were Church's paintings, McCahon's *Takaka: Night and Day* is, like the view of the American artist-scientist, preoccupied with "creation and renewal," with land and spirit.[54]

The symbolic reality that Brown described might be one of place, as to some degree it is in all McCahon's New Zealand subjects; but it could also transcend place to address more universal concerns. In *Takaka: Night and Day*, the symbolic role is signified in the handling of light, which here plays a role beyond the simple definition of mass and contour in the terrain. The painting's title suggests time's passage, a pictorial concept reinforced by the transition from darkness to light across the span of the panorama. As darkness is lifted, the primordial landscape is revealed, seemingly at the moment of becoming; the connotations of light and land suggest Creation itself. The biblical inference is supported by more overtly religious images that McCahon was creating during the same period, and issues of faith, and of doubt, remained crucial throughout his career. Their translation to the idiom of landscape, uncovering its structure in quest for some fundamental truth in the land, was novel and unexpected. As early as 1950, Charles Brasch, a perceptive judge of art and letters and a friend of the painter, recognized McCahon's significance and was the first to assert: "There is no precedent in New Zealand for the work of Colin McCahon."[55]

Some early travelers through the New Zealand landscape had noted its paradisiac appeal; but, as Paul Shepard pointed out, "the most abundant reference in the immigrant literature to the native landscape was disparaging."[56] The climate and the bush simply would not conform to colonial notions of Eden. Some settlers regarded the landscape as "the most dreary and desolate ... [that] eye ever beheld" and even judged it "accursed ... [without] signs of the beneficence of the Deity."[57] Religious sentiment might occasionally be evoked by particular vistas; even that most secular of tourists, Augustus Earle, was moved by one "wild and magnificent [scene] as if just fresh from the hands of nature ... [which] failed not to lead the mind up to the contemplation of the Creator."[58] Overall, however, the religious reference was impoverished among early writings about the landscape. There was no antipodean Emerson to proclaim ringingly that "Nature [is] ever the ally of Religion: lends all her pomp and riches to the religious sentiment."[59] Nor was there a colonial school of philosophy based on nature and spirit, such as American transcenden-

talism. Perhaps as a result, religious symbolism did not flourish in New Zealand pictorial traditions of the nineteenth century, and there is no southern parallel to luminist light with its intimations of divine immanence in the world. Hence, McCahon's discovery of spiritual significance in natural forms marked an unexpected departure. Like the postwar innovations of his American counterparts, it was one that his contemporaries often misunderstood initially, even reviled, but is today honored.[60]

Religious associations continued to infuse McCahon's landscapes into the early 1950s. Gordon Brown has called the masterful *Six Days in Nelson and Canterbury*▼ a record of the artist's creation of his own Promised Land, in title and sexpartite composition recalling the six days of the Genesis Creation story.[61] The painting's passage through time and space was inspired by his time on the road, but it is not a literal travelogue. His creative process parallels that of American authors of the day, as noted by Tony Green: "Painting, like Kerouac's writing, becomes a presentation from memory of lost times."[62] The result is not a series of postcards from the provinces but a record of an imaginative, spiritual journey whose segments summarize the reductive and symbolic landscape forms invented by McCahon. Gridded, simplified, flattened, the six images resolve the pictorial challenges that preoccupied McCahon in landscape painting: depth, and change or time.[63] In sloughing off the trappings of clichéd scenic conventions, uncovering the land and baring its structure, McCahon sought something more than a picture of a particular region, of a single vista (or even six). His aim was nothing less than a new vision of New Zealand: "I saw something logical, orderly and beautiful belonging to the land and not yet to its people. Not yet understood or communicated, not even really yet invented. My work has largely been to communicate this vision and to invent the way to see it."[64]

Throughout his career, a landscape sensibility and inspiration persisted in McCahon's work; he admitted that "even when the landscape is not directly stated as such it has been implied both in form and light," as is evident in the abstract Gate series, begun in 1961, or the glowing composition *The Days and Nights in the Wilderness.*▼ Periodically, the forms of the land returned to his imagery; but, unlike the Nelson and Canterbury subjects of the late 1940s and early 1950s, in the later compositions, "the place is not stated, none of these paintings is of any actual landscape." McCahon continued: "Certainly the landscape is New Zealand but in an amalgam of both North and South. Nor is this the tourist's landscape we so often see painted. I am dealing with the essential monotony of this land, … a 'landscape with too few lovers.' "[65]

The intent mystified many at the outset, but one prescient correspondent congratulated the artist on his direction, which he detected as early as 1948. As Ron O'Reilly wrote to McCahon, "you are *generalising* the N.Z. landscape as it never before has been generalised – this is not Pangatotara or Tahunanui or the Dunedin hills but New Zealand and its feeling of familiarity and generality is legitimate only because you are not concerned (any longer) to give a portrait of a place, but on the contrary to *use* some things known to furnish your new world."[66] ■

▼

39

CHAPTER 3

Recovering New Zealand

Late in 1852 the *Whaleman's Shipping List and Merchant's Transcript* published a series of letters from an unknown American whaling captain regarding the prospects of the business that flourished in his home port of New Bedford. The letters provide insight to the shipmaster's private concerns for the future of his profession and, even more unusual, of his prey. He noted that in the South Atlantic, where right whaling began, "the harpoon and the lance soon made awful havoc," leaving many "bodies of whales ... where they had been gamboling unmolested for hundreds of years.... After the Southern Ocean whales were well cut up, the ships penetrated the Indian and South Pacific Oceans, St. Paul's, Crozettes, Desolation, New Holland, New Zealand and Chile. I believe that it is not more than twenty years since whaling began in either of these localities – but where now are the whales, at first found in great numbers? ... The better half have been killed and cut up in horse pieces years ago." The balance were scattered further southward; the elusive few that remained "know a whaleboat by sight or by sound" and were "as wild as the hunted deer."[1]

On land as at sea, alarm shortly followed arrival, as the European settlers of New Zealand tore into the land, eager to transform and domesticate it. Sometimes the pall of smoke from burning off the bush was so heavy it prevented surveyors from sighting through their theodolites, leading at least one survey party member to plead for restraint: "a bird or animal species once destroyed can never be restored on earth. So give the few rare birds a chance of existence."[2] However, in a land where the fate of the moa might have offered instruction, few New Zealanders heeded the appeal to conserve.[3] There, as elsewhere, need and greed proved mightier motives.

The land that Cook discovered and McCahon uncovered was a fragile one. Today, we are reminded of that often, but the sense of people's responsibility to the land, to their natural environs, has roots nearly as old as their occupation of it. An unknown whaler, a bird-loving surveyor, though rare in their day, represent the beginnings of an environmental awareness, the first, tentative voices in what today has become a chorus of conservation.

Uncommon was the New Zealander who would admit, as Herbert Guthrie-Smith did in 1926, that "I would devastate a shire to save a species."[4] Though his radical rhetoric was unusual for its day, his presentiment of environmental calamity was akin to Alfred Sharpe's in the 1880s. In his "Hints" published for aspiring watercolorists, Sharpe had directed them to the unspoiled landscape for inspiration, even as he recognized the perils to that realm. "Strive to reproduce Nature here as she is," he advised, "ere her originality disappears before the combined effects of advancing civilisation and imported vermin and vegetation."[5] Sharpe's concerns in turn paralleled those of the American painter Thomas Cole, who regarded his age's "meager utilitarianism" with alarm and feared the "iron tramp" of "improvement." Cole cautioned his countrymen to "cultivate the oasis that yet remains to us, and thus preserve the germs of a future and purer system."[6]

In 1872, when the United States Congress established the first national park at Yellowstone, Cole's inchoate hope was at least partially realized; fifteen years later New Zealand followed suit when national parklands were set aside at Tongariro, centered on the summits of three mountains given to the government by a Maori chief. Despite this novel government concern for wilderness preservation, the clearance of unprotected land and the sprawl of settlement continued unabated elsewhere in New Zealand and in the United States.

Early tourists in America often complained of the evidence of progress in the virgin wilds. One writer in 1830 noted "the horror with which a foreigner beholds such number of magnificent trees standing around him, with their throats cut, the very Banquos of the murdered forest."[7] The drear prospect of the ravaged land was often described in such unflattering terms. Isaac Weld was typical in remarking that tree stumps were "most disagreeable objects, wherewith the eye is continually

assailed."[8] William Strickland, who painted the girdled trees and dying forests of upper New York State in 1794, decried their destruction by the settlers (whom he called "barbarous savages") as being "without taste, judgment or foresight. Nothing is preserved and everything wasted."[9] Despite such protests, the clearance of the land continued and by mid-century provided a host of painters with poignant subjects, none more so than Sanford Robinson Gifford's *Twilight on Hunter Mountain,* 1866 (Terra Collection, Chicago), an elegy for the vanishing wilderness.

In New Zealand as well, settlement irrevocably altered the face of the land. In Northland, the towering kauri and other hardwoods were avariciously felled with axe and saw, and the forests rang with the sounds of industry and progress; in the words of one logger, "it is music to the Bushmans hears [*sic*] to hear a large Tree crashing, & Smashing in falling."[10] In the tangle of the bush, the torch proved efficient in clearing the land, and vast tracts of primeval growth were burned off. Guthrie-Smith described the drama of the fiery maelstroms that transformed the Tutira landscape: "In the very height of a gale the rushing charge of fire will in an instant check, the flames previously pinned down will erect their forked tongues like a crop, or lift as if drawn upward from the earth in the very consummation of their burning embrace.... As a lover wraps his mistress in his arms, so the flames wrap the stately cabbage-trees, stripping them naked of their matted mantles of brown, devouring their tall stems with kisses of fire, crackling like musketry amongst the spluttering flax, hissing and spitting in the tutu-groves, pouring in black smoke from thickets of scrub."[11]

The spectacle, which was a familiar one in nineteenth-century New Zealand, Guthrie-Smith found "engrossing ... enthralling," and it continued to be so in modern times, as suggested by Rita Angus's painting of *Scrub-burning, North Hawke's Bay,*▼ 1965. But in the flames' wake, a less scenic vista was presented, littered with blackened ruins and, even-

tually, sun-bleached, contorted limbs, the skeleton of the dead bush. Like visitors to North America in an earlier day, tourists in New Zealand were often moved to comment on the effect. Mark Twain described the Taranaki region as "one vast 'clearing' – covered, stretch after stretch, with prone & charred great trees and vast roots."[12] A generation later, Zane Grey thought the burned-off areas looked like "the lumbered districts of Washington and Oregon," and he lamented that "the joy of life that they [birds] vented so freely, had been quenched by the fire."[13] To his hosts, George Bernard Shaw complained about "the way the bush has been cut and burnt, and dead trees left standing ... [which] spoil[s] the landscape terribly."[14]

The ravaged land had not escaped New Zealanders' attention. Indeed, like the subject of Blanche Baughan's long poem, "A Bush Section," the New Zealander lived "with the Burnt Bush within and without thee." His "houseless and home-less country" was everywhere

> stuck, and prickled, and spiked with the stand-
> ing black and grey splinters,
> Strewn, all over its hollows and hills, with the
> long, prone, grey-black logs.

Like Stevens's alien jar in the wilderness that "did not give of bird or bush," Baughan's

> prone logs never arise,
> The erect ones never grow green,
> Leaves never rustle, the birds went away with
> the Bush.[15]

Despite its deathly silence and stillness, the extensive burned bush was to many New Zealanders emblematic of home; it became particularly so during the years around the centennial celebration in 1940 as the nationalist spirit swept through New Zealand arts and letters. Eric Lee-Johnson, returning from London in 1938, recalled that "I saw the familiar forest ghosts lining my route up through the King Country, it seemed they had turned out to greet me."[16] The memory stayed with him and the image reappeared in a series of paintings of gaunt, twisted forms from nature that occupied him over the next

several decades. These expressive forms are the descendants of Christopher Perkins's *Frozen Flames*,▾ one of his best-known paeans to the local.

The historian Michael Dunn provided a careful exegesis of the dead tree image as it was expressed in New Zealand art of the period. The ubiquity of the subject, as well as the precedents of Perkins and the poets, proved inspirational, and "the symbolic potential of the dead tree in New Zealand could hardly escape painters who were looking for some qualities in their work to give it a national character."[17] The subject and its symbolism of place echo the situation in American landscape painting of several generations earlier. Among landscapists in this country, a similar motif – the dead tree stump – became a prevalent image in the mid-nineteenth century, as Barbara Novak was the first to note, providing a symbol which "introduce[s] the double-edged sense of accelerated time that defines new values, replacing myth with history, the individual with the community. The stump, then, signifies the community participation that constructs the social fabric."[18] Nicolai Cikovsky, Jr., later extended her insights, recognizing the tree stump in American paintings as "a widely understood iconographic device. Although the cut stump appears in European and English art, its frequency and numbers in American art are unique, and it is a special element of American artistic language."[19] It detracts nothing from the evocative potential of either northern or southern stumps to recognize their parallel significance in other lands and other images; rather, it reinforces the potential of the motif as a special element of artistic language universally.

Perhaps paradoxically, the regional motif of "frozen flame and slain tree" in New Zealand also bespoke an international awareness on the part of the artists. Dunn likened the New Zealand subjects to imagery ranging from Max Ernst's mysterious forests, Yves Tanguy's surreal spaces, and Salvador Dalí's suggestive forms, to themes of trees or nature by Edward Weston, Paul Nash, and Henry Moore.[20] Such parallels, presenting a question of affinity rather than influence, suggest both the widespread interest in natural symbolism motivating many artists in many lands during the early decades of this century and the currency of the "New Zealand" motif.

So favored became the subject in New Zealand art at mid-century that, as Dunn concluded, "soon the dead tree was synonymous with a dead end."[21] In recent years, the tradition has been quoted with varying effect by younger artists, such as Peter Peryer's *Frozen Flame*,▾ which pays homage to Perkins's famous subject but transplants it to the concrete confines of the city. John Johns documented the bleak, charred interior of a Forest Service tract, a hallucinatory vision of "frozen flames" in a grid.▾ Richard Killeen parodies the past in *New Zealand Landscape Painting Tradition?*,▾ with its dead tree limb (a fruitless offshoot?) affixed to the frame.[22]

Beyond a symbol of place, the dead tree could evoke other associations; most immediately it provided an implicit commentary on an economy based on exploitation of the land, practices that had persisted in New Zealand since the earliest colonization. In recent decades those concerns have come to the fore in the work of numerous artists, as well as to the public at large. The preoccupation with such issues indicates an extension of self beyond the confines of the medium, of the studio, and a reengagement with the world. It was a move advised by the photographer John Pascoe, when he called on his colleagues to "leave the darkroom and the retouching pen and to mix with the outside world." If the artist wishes to capture "a feeling for the land …, he will need to be in touch with contemporary events."[23]

Socially motivated painters and photographers have found in landscape an apt vehicle for the expression of personal values applied to a larger realm. There were earlier hints of this extension, such as Kinder's record of changes in the landscape, both in metropolitan New Zealand and in the bush and goldfields, or Alfred Sharpe's cautionary notes in his "Hints

▾

42

for Landscape Students in Water-Colour." But in the contemporary era, the array of issues challenging man and the land seemed to grow more complex.

In 1961 Colin McCahon wrote of his "idea for a large-scale statement on nuclear warfare, this to take the form of … a screen rather than a wall painting as it could stand in the entrances to town halls, universities, etc."[24] Worries about a nuclear apocalypse were periodically expressed around the world during the Cold War period, for one notable instance in James Rosenquist's *F-111*, 1963; but for New Zealanders, not far removed from the testing grounds in the South Pacific, the issue had a specific regional urgency. While McCahon's monumental statement against nuclear war was never realized, he did complete a smaller three-panel screen (*I Talk of Goya*, 1976, Auckland City Art Gallery) that incorporated vertical forms that swell as they rise above a "horizon," ambiguous images connoting both trees and mushroom clouds. The generalized landscape references of the folding triptych are painted against a gold ground, which is at once evocative (of religious precedent) and reflective (of the vaunted light of the South Pacific, or perhaps of a nuclear blast). For McCahon, light and land, faith and purity were complexly interwoven: he inscribed and titled one of his abstract landscapes of the period, "as there is a constant flow of Light we are born into the PURE LAND."▼ The concern for purity in the landscape and anxiety about nuclear disaster prefigure recent developments in the movement for a nuclear-free New Zealand.

That movement was galvanized by protests over French nuclear testing at Mururoa in the South Pacific, which led to the sabotage of the *Rainbow Warrior*, the Greenpeace antinuclear vessel, in Auckland harbor in 1985. The sinking of the peace ship fired the passions of many New Zealanders, including Ralph Hotere, who was moved to produce a series of paintings and prints on the Black Rainbow theme. The images, in his typically somber palette, combine symbols drawn from pakeha traditions and from Hotere's own Maori culture, in

which he is one of the *kaumatua* (elders) of contemporary art. (The biculturalism that has distinguished his career, drawing inspiration from tribal traditions and McCahon's influential example, today marks pursuits in many realms by New Zealand artists, both Maori and pakeha.) Evidence of Hotere's political motivation and convictions had appeared previously in his works, as in paintings bearing the inscription "Polaris," an allusion to American missile-bearing submarines.

Such references as "Black Rainbow" and "Polaris" suggest the deep social and political commitment that have motivated Hotere's finest work; born of native circumstance, these attitudes were nurtured in the heated politics of Europe, where Hotere studied in the early 1960s (London, Vence, and Rome), and have been since sustained by events in New Zealand. His passions are not directed solely toward nuclear issues but engage human rights (apartheid), politics (a Watergate series in 1973), and international relations. In New Zealand, he has also been inspired by his native traditions, especially those relating to the land and its many associations sacred to the Maori. According to a Maori proverb, "The Land is a mother that never dies."[25] In traditional belief, the people are uniquely bonded to the land, a union of being and place to which one New Zealand art critic attributes the paucity of landscape detail among Maori painters. As explained by Peter Cape, "with the land and its people the fundamental concern [of Maori artists], anything that comes between the two is probably irrelevant."[26]

Anything that does come between the Maori and the land is disruptive and destructive, and certain to draw wrath. This was discovered in the early 1980s by the corporate backers of an aluminum smelting plant planned for Aramoana, not far from Hotere's studio. The project, which would have irrevocably altered the salt marshland near the pristine beaches of Aramoana, predictably drew the wrath of its would-be neighbor, as Hotere began a sustained and passionate series of protest paintings. Although not landscapes in any conventional sense, the various Aramoana

TOWARDS ARAMOANA

TEN WINDOWS

RALPH HOTERE
RECENT PAINTINGS & WORKS ON PAPER

RKS ART

Fig. 23. Announcement for
Ralph Hotere exhibition,
showing vandalized sign at
aluminum smelter site,
Aramoana.

paintings draw their significance from the imperiled land and suggest the vitality of "landscape" (or nature's) inspiration, even in abstract images. *Black Window – Towards Aramoana*▼ echoes the dark tones and simple forms of Hotere's minimalist works of the 1970s but here is given new piquancy by the conservationist imperative. The white cross, which bears connotations of suffering, cancels the "view" through the window frame; the visual tie to the land is also blocked by the tarry pitch suggestive of the smelter's emissions of cathode waste. Only in one quadrant is the black interrupted, with letters and numerals (stenciled in reverse, that is, "unnatural") and dark, fiery reds, suggestive of the smelter's fires in the night. In subject and format, the image parallels Donald Sultan's paintings of recent years, blackened, gridded evocations of industrial disasters and environmental calamity, but with an angrier mood. The slashing strokes at the bottom margin suggest Hotere's agitation, which grows more pronounced in *Aramoana – Nineteen Eighty Four,*▼ an Orwellian vision of ecological apocalypse.

In a series of Aramoana paintings on metal▼ Hotere made an exceptional summation of attitude and place. White pigment is splattered at top and bottom, repeating the angry patterns of black paint on the vandalized sign for the smelter site (Fig. 23). The name is stenciled over the corrugated iron salvaged from New Zealand's most common building material; the unusual support reinforces the local concern of the painting by providing an effective evocation of the special place. So too does the streak that runs down one of the corrugations, a bright course through the corrosion that symbolizes Aramoana, which means "the pathway to the sea."

Both the passion and the process evoke memories of Robert Indiana's constructions and paintings of the 1960s and later. As with Hotere's, Indiana's work betrays an engagement with the world, his social concerns often transformed into the imagery of protest; he incorporated the Ban the Bomb symbol into graphic paintings of the early 1960s, and in his con-

struction *French Atomic Bomb,* 1960, even shares an inspiration with the New Zealander's antinuclear themes (Fig. 24). Indiana's constructions were made from oak beams, rusted metal, and other detritus salvaged from razed warehouses; in the artist's words, his art effected the "happy transmutation of … the Unloved into the Loved."[27] These retrievals from New York's Lower East Side denote place (Coenties Slip) as surely as do the rusted iron scavenged from weathered buildings around Port Chalmers. On many of his sculptures and paintings, Indiana used stenciling, with a special affection for names referring to his American environment and redolent of history. Indiana felt a bond to literary men – just as Hotere was inspired by poets (Hone Tuwhare, Bill Manhire) – and from Melville in particular drew inspiration for his place names. He also loved Longfellow's litany of native tribes (in *Hiawatha*) and incorporated them into his art: Choctaws, Ojibways, Shoshones, Omahas, names as musical and evocative as Aramoana. Neither the Hoosier of Coenties Slip nor the Maori master of Port Chalmers is a landscapist by any traditional definition; yet, as surely as any delineator of the land, each is definitively shaped by his environs, sharing an intense bond to place, reflected and preserved in his art.

The ethos of conservation, so powerfully evinced in Hotere's art, motivated other artists as well. As alterations to the land increased in recent decades, such aspects of the modern environment increasingly figure in the artists' repertoire.

Robert Ellis is an urbanite and has been most of his life; in this he is typical of the majority of New Zealanders today. (Despite the colorful brochures of travel agents, New Zealand is more than a nation of shepherd and skier and sailor.) Shortly after coming to Auckland from London in 1957, Ellis's attention was captured by the growing metropolis; it became the subject of an extended series of Motorway paintings.▼ The paintings were not portrayals of a particular place; instead, by combining general urban characteristics, Ellis sought "to create a universal city symbol."[28] One of those

characteristics was provided in the post-war boom in highway construction, which altered the face of southern cities, just as it did in the northern hemisphere. To this day Ellis remembers the excitement of following these new concrete channels at high speeds through the city, commuting between his teaching position at the Elam Art School and his home in the suburbs, an experience that shaped his choice of subject.[29] Like a newcomer anywhere, he was often reliant on street maps – "all that information reduced to comprehensible symbols!"[30] – and they in turn helped inspire his unconventional overhead vantage on urban patterns. His service as an aerial reconnaissance photographer with the Royal Air Force in England in the late 1940s also proved inspirational in determining his point of view.

The Wright brothers' flight at Kitty Hawk in 1903 – or Richard Pearse's in New Zealand possibly the preceding year – brought new perspectives on the world. Even before the twentieth century, daring balloonists and imaginative artists had projected themselves above the ground to survey its forms and patterns; but only after World War I – the first conflict to produce heroes of the air – did the bird's-eye view became widely familiar. From Lindbergh to Earhart and beyond, the romance of flight captured imaginations internationally.

In New Zealand (as in Alaska), settlements separated by dense bush came to rely on air service, especially in the years before national highways wove the country together; to this day small single-engine planes on grassy paddock strips are a common sight in rural New Zealand. Overhead photographs of New Zealand towns, especially *White's Pictorial Reference of New Zealand*, an aerial atlas of all the country's settlements, have been perennial favorites because of their evocation of human presence and concomitant "triumph" over the land.[31] The view from above could prompt a complicated cluster of associations. As explained by John Pascoe: "Aerial photographs evoke history … history evokes topography … topography evokes people."[32]

The unpopulated landscape was also of interest, and from the air photographers have surveyed both its historical and natural features. Peter Peryer's *Pouerua*▼ resulted from his interest in both Maori associations with the volcanic peak and Kinder's nineteenth-century paintings of it; John Johns's forest views▼ record changes in the landscape, both those of geological antiquity and those more recently effected by the New Zealand Forest Service.

Aside from its intimations of time and people, the airborne eye also discovered a new aesthetic orientation, a modern perspective on the landscape that stimulated artistic vision. Howard Cook's view over the Connecticut River valley is symptomatic of an American generation that took to the air for inspiration (Fig. 25). In New Zealand too, flight and the aerial photograph proved influential. Colin McCahon, for instance, relied on such views for a series of paintings of the North Canterbury plains in the early 1950s, the gridded paddocks providing an abstract, "cubist" pattern on the land. A decade later, Ellis's city subjects similarly explore patterns, but ones discovered in a modern, metropolitan setting rather than in the traditional countryside.

In *Metropolitan Landscape*,▼ one of the finest of the series, the dense skein of light lines (motorways) is traced against the dark ground in heavy strokes of viscous pigment, sometimes squeezed directly from the tube onto the canvas. The evident love of materials reflects his early training at London's Royal College of Art, where he studied with, among others, Francis Bacon; the free technique – as well as the choice of natural subject – also suggests parallels to Paul Nash, Graham Sutherland, and the British romantics of the 1940s. In their effect, the linear designs may even imply affinities with the gesturalism of American painters at mid-century, suggesting the artist's receptivity to inspiration from

Fig. 24. **Robert Indiana**, Journal drawing for *French Atomic Bomb*, February 13, 1960.

▼
45

Fig. 25. **Howard Cook**, *Airplane*, 1931. Wood engraving. National Museum of American Art, Smithsonian Institution. Gift of Barbara Latham.

overseas.[33] Yet Ellis also depended on local sources, as in his adaptation of Maori wave forms for the stylized river symbols that appear in some of the Motorways paintings.

Although the urban patterns are studied from a general overhead perspective, there are multiple viewpoints within the composition; the eye looks down on the motorways, yet the clouds in the "foreground" are seen in profile, and the gaze toward the mountains and horizon returns the viewer to the vertical. (This use of varied viewpoints was also used, for example, by Rita Angus in *Central Otago*,▼ a pastiche of South Island scenery with wildly discrepant scale; her transformations, however, are more likely the product of experiences in the studio rather than aloft.) Ellis's retention of horizons in his Motorway paintings allowed him and the viewer to see in more than one defined direction, encouraging formal plays within the compositions.[34]

In the early Motorways, Ellis often showed the contrast of urban patterns to unlined land beyond the city. By the series' conclusion, the clash of bush and 'burb was eliminated as the stamp of construction filled the landscape, and Ellis's compositions. The encroachment of modernization, symbolized by the motorways' scars, was felt even further afield, as at the Maori community in the Bay of Islands which was home to the family of the artist's wife. In the Te Rawhiti series▼ (which takes its name from the ancestral settlement), Ellis juxtaposed the facade of the meetinghouse, which was patterned after the traditional architecture of the Maori's Ratana church, with the motorways looming ominously above it. Ellis had once claimed that his paintings of motorways "have no special comment to make on man and his environment.... I am not concerned with crusading with a special message."[35] Yet, in *Te Rawhiti XII* and others of the series, he creates a pictorial protest against the price of progress, and particularly against the regional council's decision to demolish the meetinghouse that stood in the path of the roadway.

Despite the artist's disclaimer, many have read a social point of view into Ellis's paintings, beginning with the Motorways. For example, the mayor of Auckland (not otherwise known for his aesthetic views) saw in them a warning "of the chaos coming from traffic congestion.... Motorways are an artificial division, cutting city people off from the countryside beyond. Look how those congested cities have no trees, no scenery – how much of a concrete jungle they are."[36] In the paintings of Te Rawhiti, the artist's personal engagement with his subject is more apparent – though the only pakeha in the community, Ellis was actively involved in rebuilding and preserving the meetinghouse and communal *marae* (open space) – and it surfaced again in his paintings of Rakaumangamanga, a peak sacred to the Maori in the Cape Brett area of the Bay of Islands.

The large unstretched canvases of that series▼ chart the mountain's form, scarring and sectioning the land and overlaying it with markings of the surveyor. (Rakaumangamanga is the site of a surveyor's trigonometric station.) Ellis explained that the mountain's prominence in the landscape and in the spiritual life of the local people inspired his extended treatments of the theme. "The works offer no commentary on conservation issues," he noted, "but do make reference to location, and attitudes about looking at land."[37] The effect of mountain profiled and sectioned and the fascination with markings suggest affinities with the landscape-inspired paintings of around 1971 by the American Pat Steir. While her *Looking for the Mountain* (Fig. 26), for example, is not indebted to the tribal view of land that underlies Ellis's selection of subject, it does share an interest in "looking" and marking. "My subject matter is always the same," she explained, "and it's always really about illusion, and the illusion of meaning." Like Ellis, Steir sought to possess – in a personal, not a realtor's sense – her mountain motif through its diagrammatic rendering: "I feel that certain kinds of images are mine," she has said, including "the silhouette of a certain kind of rolling mountain."[38] Her work incorporated signs of artifice (semicircle; gridding and layering) similar in function to his patterns of measurement;

the marks connote an interest in what one critic has called her "ideas and concepts about how we think, how we perceive and how we construct systems of information which allow us to communicate with others, both visually and verbally."[39] In short, both painters share an interest in systems for looking at subject.

Despite Ellis's disavowal, critics often interpreted the Rakaumangamanga motif in the light of colonial land practices and treatment of the Maori. Rob Taylor, for instance, was moved to reflections on "the historical, mythical, mystical associations of people with place [which] were pushed aside as the landscape was scrubbed off, restructured, pegged, numbered, mapped. This landscape of conflict, of sacred site as subdivision, became Ellis' subject."[40]

Artist's vision, or sacred subdivision? Attitudes about looking at land can include the perspectives of historian and conservationist, as well as the artist and the Maori. (The last is fundamental in understanding an Ellis painting like *Ka Tuturu te Whenua*,▼ whose title translates, "Preserve the Land.") Ellis's series – Motorways, Te Rawhiti, Rakaumangamanga – provide a Rorschach landscape, a palimpsest on which viewers can inscribe their individual and varied interpretations of the subject, and therein lies their power.

By his words and example, John Pascoe (1908–1972) helped revitalize the art of photography in New Zealand from the 1940s onward. "An interest in people related to their physical environment is more healthy than the ability to fake million dollar clouds in skies that were gray when the photograph was taken," he exclaimed, in a jibe at the soft-focus pictorialists.[41] Following Pascoe's summons, a new generation of New Zealand photographers banished the misty effects of pictorialism in favor of a clear focus on the land and its people, inventing a new document by which to conserve – and comment on – place.

As a photographer with the New Zealand Forest Service from 1952 to 1984, John Johns developed an extensive record of the natural arena and its changes. From within its depths and from high above

it, this forester-with-a-camera revealed patterns in the landscape – mirrored lakes, the repeated slender verticals in a second-generation growth, the uniformly textured "field" of a pine forest seen from overhead. Johns's superlative technique is evident in the subtle tones in his aerial views, and in subjects viewed more closely from ground level, such as the rhymed ridges of *Tussock Grassland*,▼ each sharply defined by light.

His mission was by nature a documentary one. It was also a conservationist's crusade. In *Clear Felled Settings, Kaiangaroa Forest*▼ the absence of horizon concentrates the view on the pattern of forest and felling, a patchwork defined by the slanting light. The photograph records new attitudes toward the environment and new practices in the management of timbering and forest growth, changes from the rude habits of clearing in earlier generations. The uniformity of these forests of introduced species – like the *Pinus radiata*, imported from California in the late nineteenth century and now covering many square miles of New Zealand – is at variance with the tangle and variety of the natural bush, and therefore strikes some as an alien intrusion.[42] Yet Johns celebrates the managed forests of fast-growing trees, both for the formal inspiration they provide and, equally important, for the precious relief they offer to New Zealand's imperiled stands of indigenous growth.

Native plants, like the kiokio or toetoe, have lately played important roles in Peter Peryer's art.[43] As his compatriots have often done in this century, Peryer seeks to root himself in place through his work; his photographic quest has been for a sense of home in his New Zealand. "I think art sanctifies the place we live in," he once explained. "I seem to want to make ordinary New Zealand things valuable and significant."[44]

After an initial excursion into expressive portrait images, Peryer turned to "ordinary New Zealand things" in the constructed environment. About 1980 he shifted to more formal concerns in a group of images whose cool detachment

▼

47

Fig. 26. **Pat Steir**, *Looking for the Mountain*, 1971. Oil, pencil, crayon, and ink on canvas. National Museum of American Art, Smithsonian Institution. Gift of Richard Hollander in honor of Jean S. Lighton.

provided catharsis from his brooding portraiture; the geometries of these photographs, some of which are abstract, also affected his vision, so that today he can trace a formal language over more than a decade's work – for example, a penchant for triangulation and intrusive forms "cutting into" the pictorial field.[45]

Noting that his medium is rooted in both art and science (optics, chemistry), Peryer defines his art as "a tool for investigation" in which he intends to apply the tenets of science. "I am interested in the qualities of observation, not imagination." (Peryer's current reading and conversational interests – including Richard Feynman, Stephen Hawkins, cosmology, botany, quantum physics – underscore his statement.) In recent years he has returned to familiar New Zealand subjects but now closely examines natural motifs from the landscape,▼ as if to call attention to the forms and forces of nature that complement human geometries. Like many photographers elsewhere, Peryer was early impressed by the work of Edward Weston, and his close focus on nature's details – flora, rocks, and geological forms – suggests an aesthetic kinship with the American artist; but his emphasis on indigenous species has more than a formal significance, or one of generic Nature. He is encouraged that his latest photographs of land and plants are "in tune with something on a deeper level, more depth, getting roots down into something. A bit more cosmic." In the native landscape, Peryer continues his search for the definition of both self and place.

Peryer's work usually involves discrete moments or motifs. Anne Noble, by contrast, has continued the tradition of an extended photographic documentary in various series over the past decade. With an ambitious two-year campaign devoted to the Wanganui River (1980–82),▼ she moved beyond essays on natural forms or singular, symbolic objects (an apple, a swan, lilies) to the larger landscape theater. The river flows 180 miles, from the mountains of the central North Island, through dense bush, past scattered Maori communities, to the

Tasman Sea at the port city of Wanganui. For the Maori, it was a spiritual presence in the landscape; as one of the major navigable water courses into the interior, the Wanganui was also significant for colonists' trade and settlement, and it later enjoyed a vogue as a tourist attraction. In the history of New Zealand photography it also played an important role as the subject for several landmark series, most famously the views of the river and its people made by Alfred H. Burton in 1885. Hence, when Noble, a Wanganui native, returned to photograph the river after years of schooling in the cities (Wellington, then Auckland), it was a homecoming at once personal, cultural, and professional.

She has said of the Wanganui series: "I want to offer my pictures as an experience of this landscape, to make people love it deeply."[46] This is clearly more than topographic landscape or documentary reportage on Maori life. "Usually a photograph gives information. I am interested in taking photos where the process of looking at them demands that you experience them as well."[47] By experiencing the photograph she meant more than inspection of her compositional skills and technical finesse, seen in the photographs' framing (often panoramic), their dramatic black-white contrasts, the adventurous use of grain, the cumulative effect of fifty prints that constitute the series. Beyond that, she sought to engage the viewer with the river's stories, and with its emotions, "its wildness, its serenity, its physical force. How it looks when it is swollen, turbulent, misty, calm – all its moods."[48] It must have pleased her when critics likened her subjects to "the terrain of a pilgrim's progress, the backdrop for a passion play."[49]

Such literary interpretations of the series to some degree parallel the artist's own interests. While she is not intent on illustrating a prior literary or poetic conceit – her method is too intuitive for that – she shares some of the precepts of the poet James K. Baxter. Her panorama of *The Bridge to Nowhere, Mangaparua Valley*,▼ while documenting a folly abandoned after a futile effort to conquer the bush,

also is redolent of the kind of spirit that moved Baxter as well. Noble's image echoes (but is not illustrative of) the poet's sentiment:

> How many roads we take that lead to Nowhere
> The alley overgrown, no meaning now but loss.[50]

Baxter spent his final years beside the Wanganui in an idealist commune at the remote settlement called Jerusalem, to which he had hiked thirty-five miles barefoot through the bush, a pilgrimage that captured the imaginations of many young New Zealanders in the 1960s. His brooding temperament found a spiritual home in the remote and mysterious Wanganui valley, where he steeped himself in the ethos of place and its indigenous people. Noble explains some of her Wanganui photographs, such as *Otukopiri, Koriniti,*▼ 1981, in his terms, as evocations of Maori spirits (*taniwha*) representing, as Baxter wrote, "a principle in nature and in the human soul." The interest in Maori mythology, what Baxter called "dreams and omens and hidden spiritual relationships to the dead and the living and our non-human environment," is echoed in other works by poet and photographer, suggesting an important source of inspiration for both.[51]

Through technique as well as subject, Noble is able to convey spiritual meaning. She equates the range of tones in her work to the emotional range, "one's own voice and feelings translated into tones of grey." The frequent contrast of inky blacks to luminous whites, notable in many of the Wanganui series, suggests similar import; Noble explained that the black "shapes" the images, while the whites convey "spiritual values."[52] The contrasting values recall Colin McCahon's limited chromatics, especially in his word pictures, suggesting another crucial kinship to Noble's work. Like Baxter, McCahon had a profound interest in the Maori culture and used it to create a personal mythology and symbolism infused with a sense of melancholic brooding and isolation. In her return to her Wanganui home and river and in her loving, extremely personal response to place, Noble draws on and extends an

important strain in modern New Zealand art and letters.

After the Wanganui project, Noble spent four years in London (resulting, most notably, in a series on the contemplative order of nuns at the cloistered Tyburn Convent), before once again returning to the banks of the Wanganui in 1989. There she has recently completed another series based on the contemplation of nature. The new work was inspired by birds, first photographed at a Dorset swannery and continued in New Zealand. Unlike the dark views of the river, Noble's "spiritual" whites dominate in the swan series SONG … without Words,▼ continuing the tonalities of the convent suite. Of the earlier works Noble once said, "My photographs are of the ritual of prayer and the atmosphere of silence,"[53] concerns that inform her constructed swan tableaux as well. From the panoramic format of the Wanganui views, Noble makes a dramatic focal shift to close-ups, so tightly viewed and cropped that the subject is initially illegible. Yet the sensibility of the panoramist echoes in the tripartite arrangement of photographs in pale friezes; the insistent horizontal format similarly recalls the earlier landscape series, now echoed in evocative "feather-scapes." Noble explained the series' intent as "observation, discovery, fact and poetry of a visual kind."[54] As did the vital subjects of river and bush, freighted with cultural association, so did the symbolic mute swan elicit from her a strong subjective response to natural form and force. ■

▼

49

CHAPTER 4

Rediscovering New Zealand

Peter Peryer, like many adults, looks back on his childhood as the source for attitudes and habits of later life; that time provided the basis for his working method, "photographing from my own experience."[1] His crucial formative years were spent in a small town in rural Hokianga, north of Auckland, an upbringing that he now regards as a case of massive cultural dislocation. "I was brought up in an Italian religion in an English education system in a Maori area, with a helping of American soda-pop drive-in culture thrown in. This feels like *Frontierland* to me. And if I am concerned with the family and belonging and identity then I think it is a national issue. It's a big issue for us. Who are we?"[2]

If the answer to that is elusive, so too is the answer to Where are we? Although explorers and cartographers have long since fixed New Zealand's location by longitude and latitude, its position in the world – and the mind – continues to evolve from generation to generation. Peryer approached the directional signpost at Bluff, at the southern end of the South Island where New Zealand's "mainland" ends, as if it might provide some clue to Where? He found in lieu a queue, "carloads of cameras com[ing] to this monument, day after day, year after year,"[3] all seemingly in a similar pilgrimage. But knowing the direction to London or Hobart, the equator or the South Pole, only fixes Peryer – and place – by indirection, where he is not. His wry photograph▼ substitutes name for place, language for landscape, implying the futility of seeking Where? in vanes.

Peryer's Frontierland analogy, like the Bluff sign's indicators of direction to faraway Sydney and London and the South Pole, resurrects what Francis Pound has called, dismissively, "that old topos of distance" that reigned over the New Zealand imagination at mid-century.[4] R. A. K. Mason had used the sense of frontier in his poetic lament for "these beleaguered victims…

> *here in this far-pitche d perilous hostile place*
> *this solitary hard-assaulted spot*
> *fixed at the friendless outer edge of space.*[5]

And, in one of the most famous images of modern New Zealand poetry, Charles Brasch defined the islands' place: "distance looks our way."[6]

But Peryer significantly differentiates his concept from the poets' frontier, by suffix – Frontier*land* – giving it a Disneyesque spin. The Hokianga he recalls from the immediate postwar years is to Mason's "outer edge" as the ersatz environs of an American theme park are to the historical realities that inspired them. So too are the fragmentary names on a Bluff signpost substitutes for place. *Bluff* and Frontierland present us with replacements for reality. The traditional concepts of distance and the local have been succeeded, as Francis Pound has written, by a "more complex sense of region … a regionalism aware of the complicity of its 'local' with its 'foreign' – of its inseparability from what it has defined as its 'other,' in order to constitute its own place. Where you are, it shows – and, unlike the old regionalism, *it knows* – is also defined by where you are not."[7]

In commemorating the three-hundredth anniversary of Abel Tasman's historic landfall (1942), Allen Curnow had written

> *Always to islanders danger*
> *Is what comes over the sea.*[8]

Today, however, inspiration is a more likely arrival, and a painter such as Richard Killeen can remark on the earlier, nationalist view of place with titles such as *Island Mentality* or *From Here to the World* (1971) or *Across the Pacific* (1978). Apparently comfortable in his situation, Killeen celebrated place (and paternity) in *Born Alive in New Zealand (for Samuel)*,▼ dedicated to his first child. For Samuel and his father, "home" is not some distant imperial capital or country village; in the postcolonial here and now, home *is* New Zealand, where one is "born alive" and lives and creates that way.

At first Killeen's distinctive "cutouts" might appear to have little to do with traditions of landscape, or even, but for the titles, with place. Yet they evolved naturally from his early paintings in conventional format and media, works of the late 1960s whose

hard edges and landscape referents anticipated the artist's mature cut-out technique which he first used in 1978. As the prized student of Colin McCahon at the Elam Art School, Killeen was inculcated early with the grand tradition of New Zealand landscape painting and the subjective transformations within the idiom his teacher effected.

Yet even in his youthful works, Killeen eschewed McCahon's brooding and oracular manner for a lighter touch, as seen in the wry *Man Reading a Newspaper.*▼ Unlike McCahon's anxious "I" who struggles with the world, Killeen's man is detached from his environs, his hard forms seeming to be almost cut out from the background. The discontinuities – between man and setting, between foreground print and background landscape – reflect various enthusiasms of the period, from the expressive dislocations in McCahon's landscapes to James Rosenquist's influential layerings of images in early pop paintings, and may prefigure the division between the units of his cutouts.

Although surrounded by Nature, Killeen's man with a newspaper stands apart from it, turning his back on emblematic New Zealand scenery (including the long, white cloud). This contemporary reader relies on print for information on experience – that is, the weather (nature) in which he exists – a translation of sensation. He is cut off by the news: from the old – his (natural) history and traditions (of landscape, art, and perception); from his present (weather, and viewer); and from his future ("Ahead," "Forecast," "Further," all on "our" side of the divide). The hard forms of the figure enforce his separation from his environs, the effect of being cut out.

The white cruciform in his landscape *Hillsborough*▼ likewise seems to pop out from its natural surroundings. The painting's circular format, unusual for a landscape, is self-contained, refusing the lateral extension into natural space often implied in (generally horizontal) landscape images; Killeen's view seems not so much framed as sliced by a compass out of a larger context. (The tondo format

also provides, in its familiar religious associations, potential for wry comment on the sanctified traditions of New Zealand landscape art.) But for Killeen, the transit from the landscapes of the late 1960s to the cutouts of the next decade was neither direct nor immediate.

In the early 1970s he played further with the painter's legacy, as in the parodic *New Zealand Landscape Painting Tradition?*, 1971;▼ in form, as well as in title and subject, the approach was inventive, as he defined the familiar arboreal subject by positive-negative reversals, another possible prefiguration of the cutout. Other works of the 1970s explored hard-edged, abstract geometries (triangles, grids, "combs"), often in repeated patterns of undifferentiated color against a blank white ground. In 1976 he began to combine the geometric with silhouetted forms from nature, such as insects; that year, he also first painted on aluminum panels, giving the image its distinctive hard surface effect. Both experiences proved crucial two years later, when he first cut his designs out of aluminum and spray-painted them with acrylic lacquer, creating composite cutouts incorporating natural and geometric imagery.

At first the shapes were painted in uniform dark tones, the image of each unit solely reliant on silhouette for definition. Many of these cutouts involved organic forms, such as the early and aptly named *Primordial*▼ with its simple shapes of leaf and mushroom, insect and fish. As with Peryer's and other photographers' close focusing on details from nature, Killeen excerpts subject from setting, literally and tangibly, thereby endowing it with a new and forceful primacy. In their arrangement, pinned on the blank wall, the shapes suggest a naturalist's specimens, oddly reminiscent of Sydney Parkinson's souvenirs of discovery from two centuries earlier (see Fig. 1). In 1966, wondering to himself about his art school efforts at abstraction, Killeen had written in his journal: "the background is unnecessary. I am not painting the background but only the symbol?"[9] With the cutouts, the background was finally dispensed with, but not the symbol.

▼

51

Killeen disavows any interest in cryptic symbolism; yet he acknowledges the resonance of his images. They "are not symbols that have hidden meanings, but they do have associations outside the paintings." The artist's intent is "to use a consensus of human experience to communicate something about the situation we all find ourselves in." As with human experience, the results seem random, an effect that Killeen encourages through both image and format. The method of the infinitely changeable cutouts he describes as "more democratic and less hierarchical in its organisation than conventional framed painting … because each image is a movable object that is out of the compositional control of the artist."[10]

By their excerption and simplification in most characteristic silhouette, the *Primordial* shapes refer insistently and materially to the natural world from which they were liberated, provoking associations with the environs. In his Island Mentality▼ series, this allusion was further localized by the inference of the title, each unit (organic or geometric) reading as a separate "island" of different color isolated against the non-background of the wall. (As he explained his intent, "Colour is applied to each image to emphasise the idiosyncratic nature of that image."[11]) A familiar school exercise for young New Zealanders is to draw a map of the country. As recalled by one former schoolboy, the poet Denis Glover: "I always traced mine … but the result only showed a great emptiness within."[12] Killeen's shapes here might also be viewed as showing an emptiness within, a lack of incident, an "island mentality."

By the mid-1980s, however, emptiness had been replaced by richly complex images within each shape, initially painted with the brush, later transferred by photocopier or generated by computer. The selection of motifs and shapes follows the concept recorded in his notebook: "in the eyes of the universe everything is the same – equal."[13] In gathering images for these cutouts, Killeen borrowed from diverse and

unrelated contexts a vast repertoire of graphic signs, following the postmodernist strategy of appropriation.

The postmodern attitude was born in the 1970s of European theory (literary, feminist, political), especially French post-structuralism; in recent years, it has been adapted internationally to various circumstances and with varying effect. In New Zealand it was embraced with particular enthusiasm by some influential artists and critics during the 1980s.[14] The new orthodoxy subverted an earlier generation's quest for a hegemonic New Zealand Art. To the postmodernist, the traditional hierarchical canon is antithetical, including that of a nationalist school.

It might seem paradoxical that the viewer can read any regional presence into Killeen's cutouts, given his commitment to the decidedly place-less means of postmodernism. Yet, in the same democratic spirit that occasioned their construction, Killeen anticipated varied interpretations of his work, and seemingly encouraged it. "As in all human experience the viewer is not just a spectator but an active participant," he explains.[15]

With the introduction of varied color and the multiplication of units in his cutouts, the possible arrangements and rearrangements became more expansive and complicated. Yet the presence, often prevalence, of organic shapes continued an intimation of the natural world. In *Born Alive in New Zealand (for Samuel)*, these range from purely abstract shapes, organic and geometric, to imaginative fish and animal forms. For the son of an artist born in the South Pacific, these seem aptly symptomatic of region and profession. The associations – evoked through signs of land and landscape, history, geography, and art – are, however, decidedly personal, rather than the result of topographic or scenic conventions or of nationalistic imperative.

The marine life, for example, may allude to New Zealand's oceanic situation and, by implication, the "distance [that] looks our way" over the waters. The bug-eyed flying form of blue and yellow evokes Japanese or Chinese kites, suggesting a

▼
52

new sense of region proximate to the Asian continent. The stack of bulls beneath a benedictory hand suggests the hallowed, ancient origins of the painter's craft at Altamira and in other prehistoric caves. The burning tree stump ("frozen flames") is a more local reference to practices in land clearance and nationalistic painting. The lobed gray forms recall Maori decorations, as well as the abstractions that the pioneering modernist Gordon Walters derived from them, works that have been increasingly admired in the past decade. The sectioned volcanos suggest the illustrations in Cotton's *Geomorphology* and, by extension, the example of Killeen's teacher, Colin McCahon, who was so influenced by the book. That hero of New Zealand modernism is more directly quoted in the hills, a favorite McCahon motif, here allusive to his early Otago peninsula panoramas in particular and to the land of New Zealand in general.

More important, however, than any catalogue of symbols, intended or intuited, is Killeen's ability to summarize his personal experience in a visual code. Comfortably "at home" in his position, in New Zealand and in the world, he rediscovers his place and reinvents it in a painted legacy for his son.

Ruth Watson's place is on a Canterbury farm – or, it would have been, had the times and circumstances been different. The daughter of a farm family which for generations had cultivated the fertile land of the Canterbury plains, Watson was the first to leave the agrarian community "for the city and the arts."[16] Looking back on her rural childhood amid hay barns and shearing sheds, shelter belts and paddocks, she recalls not a pastorale but only the consideration of the land "in terms of its prospective productivity – how many sheep in a paddock." On the distant horizon to the west rose the Southern Alps, but if she regarded them at all (and she does not remember doing so), it was only because of "the scenic convention of the view," a vestigial romantic attachment to the concept of landscape.

In the city of Christchurch, at Canterbury University's Ilam School of Fine Arts, Watson quickly discovered other conventions of vision. During her time there (1980–84), students were encouraged to "adopt" a model whose work and technique they would study closely. Watson chose Jasper Johns, admiring his sense for materials, especially encaustic, and fascinated by "his layering of medium and meaning." She was initially drawn by the example of his targets and only later encountered Johns's maps, a source that was to prove crucial for her own work by the end of the decade. Although she had been encouraged in her early years at Ilam, she was disappointed at the reception for her efforts to layer meaning and medium in collages of paper fragments ("aerial views, contours maps, etcetera"). Watson also chafed at the macho traditions of the school and later recalled that her time there "was all a bit of a disaster really."[17]

After leaving Ilam, she continued her work in encaustic and collage; in 1986, at her first solo exhibition (James Paul Gallery, Christchurch), both techniques were combined in *Ancient History Book*, whose word fragments and cryptic symbols collaged onto an encaustic surface allude both to recorded history and the contemporary. (Words such as "ancient," "myths," and "lost world" evoke a distant time and place, and so too encaustic, whose invention is attributed to the Greeks; the medium also invokes Johns's modern achievements, as did her stroke and use of signs.) The wedding of technique with content and past with present forecasts the directions of her recent work.

Considerations of time and distance and conventions of seeing continued in *Tour of New Zealand*.▼ What might at first appear as a witty send-up of "scenic convention," a pop banalization of clichéd New Zealand scenery and tourism, reveals itself after contemplation as a thoughtful reprise on place and tradition. The design is patterned on board games (Fig. 27) which were popular in New Zealand in the decades after World War II. Watson's choice of subject suggests a continuing interest in history, although

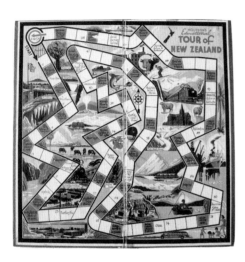

Fig. 27. Holdson's Educational Tour of New Zealand.

here using a retrieval from recent popular culture rather than a motif anchored in geological or cultural antiquity.[18] The game recreates the time-honored experience of traveling through the landscape that had inspired New Zealanders from Kinder to McCahon but reduces that national pilgrimage to a code (*Whangarei/Return to Nelson, Wellington/Advance*). What appears to be a literal copy of the original "Holdson's Educational Tour of New Zealand" has in fact been altered in small but telling ways in "Watson's" version. The insertion of the artist's name in the logo personalizes "her" map and, by extension, "her" place. Watson has further altered the "landscape" in strategic details. While the timeless treasures of New Zealand tourist scenery remain largely unchanged, she has increased the size of the factory behind Stokes's bull, alluding to an increasingly urban, industrialized landscape, and eliminated several cattle in Taranaki's pastures, a poignant reference to the failure of family farms, including the Watsons' own in Canterbury. The skyline of Wellington has been updated with a new skyscraper in a vaguely International Style, while over Auckland the Union Jack, symbol of northern, imperial rule, has been lowered and replaced by the New Zealand national flag with its Southern Cross. These are subtle touches but ones that convey Watson's attention to issues of contemporaneity and national identity, to a rediscovery of New Zealand.

The slick finish of the scenic vignettes, which seem transposed from a glossy travel brochure, contrasts dramatically with the encrusted surface of the course through the landscape, as if the tour had been ruined by the passage of time and the tramp of countless tourists. Compounding the richness of the encoded tour is the embedding of language beneath its surface. As with her *Ancient History Book*, the painting simultaneously discloses and conceals words and phrases

collaged beneath the "tour." Those that can be read add a note of disquieting enigma or dissonance: "reassuring" – "discovery … never harmless" – "a bad move" (tourism?); "illusory or real" (New Zealand? or art?); "woman" – "a hard-on!" – "sexua" – "death." Yet any effort to construct or imply a narrative is ultimately futile, for Watson would seem to agree with Killeen's notion that "combinations of ideas that have no relevance to each other [are] better."[19] The fragmentation and illegibility frustrate the effort to give meaning to the game's surrogate for the New Zealand experience. In a dictum beloved by postmodernists in New Zealand as elsewhere, Roland Barthes proclaimed: "The birth of the reader is the death of the author." In Watson's work it is finally impossible to "read" the painting – and the author survives.

The new genius loci informs Watson's *Another View of the World*▼ as well. She discovered this "found object" ready-made and, in a Duchampian gesture, appropriated it from the visual environment. She altered it slightly, eliminating the elaborate marginal decoration of the original, and then photocopied it in a small edition. The global projection is taken from what to northerners – or to imperialists – is an unconventional perspective. In this view, America is pushed nearly offstage, obscured and unlabeled, while England's "home" and Europe, the proverbial motherlode of culture, are invisible. At the center is New Zealand, a cutout afloat in the watery distances. The only verbal guides are to Wellington, Pacific, and Asia. *Another Map of the World* reorganizes the familiar and posits a new definition of a New Zealander's place and region.

Watson's *Mappa Mundi*,▼ her most ambitious work to date, is even richer in technique and associations.[20] Like her previous works, the object continues her concerns for maps and mapping and for history. She explained her interest: "The development of mapmaking goes hand in hand with colonisation. Drawing a map is a way of controlling the world image or controlling your part of it."[21] For Watson – as for her early role model, Queen Elizabeth I – the map provides a means to understanding

and control. It might seem paradoxical that new maps of the world should be invented now, long after its "discovery" by Captain Cook or Telestar. But Watson's is no ordinary graph or ordinary vision. Like the maps of medieval or Elizabethan times, the *Mappa Mundi* provides more metaphor than information.

The twelve tapered forms recall the gores of early maps by which the world was imperially sectioned. Their shape and construction, however, simultaneously prompt other associations. The canoe-like forms have a special context in New Zealand; according to legend, the land was initially settled by Maori who arrived in seven canoes composing the Great Fleet. For an island race, the double-ended vessels remain important to this day, both practically and ceremonially; their echo in the gores of Watson's map provides reference to locale and tradition, and to the resurgent Maori culture of New Zealand. The gores might also be likened to shields, invoking another cluster of associations involving the tribal. The postmodernist disdain for "privileged" media has led to complicated reassessments of what used to be called "primitive" art and tribal cultures. This has been a special motivation for many women whose view of the world has likewise traditionally been from the margins. Contemporary feminists have merged considerations of tribal forms and craft traditions in powerful new images, such as Alison Saar's assemblages echoing African fetishes or, in New Zealand, Claudia Pond Eyley's shield paintings and Philippa Blair's cloaks. The *Mappa Mundi* similarly echoes this alliance in the map's "shields," which evoke objects intended for combat and shelter, for display and concealment. The anatomical analogies of the vesical form further enrich its reading, leading to one critic's conclusion that Watson's is "a vaginal map ... used to attack old, traditional, and masculine representations (maps)."[22] Like the form and handling of Robert Ellis's *Rakaumangamanga* – or the famous flowers of Georgia O'Keeffe – Watson's map is a richly associative subject and treatment, capable of eliciting multivalent responses simultaneously.

On its surface as in its silhouette, the *Mappa Mundi* is complex. Line and mass define a fantastic new world uncharted by Cook or Tasman. The equatorial line – here, as in other Watson map constructions, copying the surveyor's black-and-white range pole – momentarily provides familiar grounding in this unfamiliar terrain. The association with surveyors evokes habits of mensuration in the landscape that have persisted through the ages, linking Ptolemy to the young Washington, Thoreau, and Heaphy, and they in turn to Ellis and aerial photographers, Nancy Graves's lunar map paintings and Watson's *Mappa Mundi*.

The graphic rod also suggests parallels with a similar form in the work of William T. Wiley, one of what Dore Ashton called his "almost-readable symbols,"[23] which has become a signature image in his paintings and constructions. In his works, as in Watson's, the striped pole or line stands apart from the fictive space of the artwork as a "real" object, which in Wiley's constructions is often made tangible. Yet, as Wiley wrote (and as Watson knows), the surveyor's range pole (and similar devices for measurement) suggest only "some insane idea about accuracy being something concrete and visible. Rulers [and] yardsticks ... [are] reminders of abstract points of destination ... and fantasies about the illusion of a fixed order."[24]

Fig. 28. **William T. Wiley**, *Hide as a State of Mind*, 1971. Ink and watercolor on paper. Des Moines Art Center.

Wiley's *Hide as a State of Mind* (Fig. 28) presents a different sort of world map but one as rich in metaphoric potential as Watson's. Offshore from Wiley's obscure land is a small raft, akin in scale and significance to the ship in the extreme right gore of *Mappa Mundi*, a symbol of man and his rational exploration of terra incognita.[25] Deep in his landscape is mystery, concealment – "hide" – which reason ("a state of mind") and the

▼

55

surveyor's pole reveal, only to elicit wonder ("God only knows what we were Expecting"). Within Watson's Cyclopean continent at the center of the map lurks similar obscurity or (to use one of Wiley's favorite words) enigma, from which the explorer's ship flees. Language embedded within the image reinforces the obscurity, being like Wiley's symbols and phrases "almost-readable" yet ultimately incoherent. Both artists seem to distrust words, Wiley putting them through endless homonymous plays, Watson embedding and fragmenting them in the image; in the end, both wind up confounding the meaning of language, of mapping, of art as a projection of the world.

The resinous surface of Watson's work is scarred and eroded, an effect that recalls her love of Jasper Johns's manipulated encaustic surfaces.[26] The surface scoriation also suggests the passage of time, as if this eroded object had been retrieved from some distant epoch. Speaking of the coded system of the map, Watson invokes the metaphor of landscape and history: "The invisible world of the code is a vast landscape, with flooding rivers of persuasion, cracks into which we can push unwanted perceptions, and criss-crossed by electric fences erected by group motivations of power."[27] In the fissured and peeling surface one critic found evidence of stress in the painting, which by analogy suggested the stresses in history, especially that of women.[28] For Watson, history is as suspect as words or maps; she sees it as another strategy of control. As Lita Barrie has noted, Watson's Elizabethan map "suggested that history could have been written differently – that history is an effect of selection procedures that are embedded in the codes we continue to use as spectacles through which we see the world."[29]

To know a place (New Zealand, the Pacific, or the world), Watson must stand the tradition of Tasman, Cook, and Mercator – and white, northern, male, imperial society – on its head, adjusting their worldview with the invention of her new codes. Hence, the novel projection of *Another Map of the World*. And hence, the insertion of the feminine into the world. The role of woman figures large in the *Mappa Mundi*: in the vesical forms of the map, in the fetal contours of the pale continent at its center, and in the suggestion of control mediated not by power but by the senses. (Sight, hearing, and touch are evoked by the one-eyed landmass, the ear-shaped form to its left, and the fingerprint to its right.) A projection of southern parallels, a metaphoric woman's map to past and future, Watson's view is a rediscovery of the world uniquely shaped by her time and place, a rediscovery as yet without parallels in our own. ■

NOTES

Introduction

1. Apirana Ngata, "Maori Land Settlement," in *The Maori People Today: A General Survey*, ed. I. L. G. Sutherland (Wellington: New Zealand Institute of International Affairs, 1940), 176–177.

2. Barbara Novak, "Influences and Affinities: The Interplay between America and Europe in Landscape Painting before 1860," in *The Shaping of Art and Architecture in Nineteenth-Century America*, by R. J. Clark et al. (New York: The Metropolitan Museum of Art, 1972), 27–28.

3. See William H. New, *Dreams of Speech and Violence: The Art of the Short Story in Canada and New Zealand* (Toronto: University of Toronto Press, 1987).

4. Ann Davis, *A Distant Harmony: Comparisons in the Painting of Canada and the United States of America* (Winnipeg Art Gallery, 1982), vii.

5. Jock Phillips, "New Worlds – Similar or Different?" in *New Worlds: The Comparative History of New Zealand and the United States*, ed. Jock Phillips (Wellington: Stout Research Centre, 1989), 5.

6. Mark Twain, reported in *Press* [Christchurch], November 13, 1895; quoted in Miriam Jones Shillingsburg, *At Home Abroad: Mark Twain in Australasia* (Jackson: University Press of Mississippi, 1988), 155.

Chapter 1

1. *Description of a View of The Bay of Islands and the Surrounding Country … Painted by Robert Burford* (New York: William Osborn, 1840), 3.

2. Broadside advertising exhibition of Caleb P. Purrington and Benjamin Russell's "Original Panorama of a Whaling Voyage Round the World [on] Three Miles of Canvass [*sic*]," at Amory Hall, Boston [1849]; Collection of Old Dartmouth Historical Society, New Bedford, Massachusetts. Precise dates of the Boston exhibition are uncertain; the broadside bears the handwritten inscription "april 2*d* 1849," but the work was also mentioned in the Boston *Evening Transcript* on January 3 of that year. Subsequently, it was exhibited in New York City, Louisville, St. Louis, Baltimore, and Cincinnati. The panorama, which the New Bedford artists completed "after two years of studious labor," is now in the collection of the New Bedford Whaling Museum, New Bedford, Massachusetts. Unfortunately, the final scenes – including the views in New Zealand – are missing, probably due to wear and tear on the "three miles of canvass," which were wound from drum to drum to produce a moving picture for the spectators. While the original painting was sizable, advertised claims of its length were greatly exaggerated.

3. William B. Willcox, ed., *The Papers of Benjamin Franklin* (New Haven: Yale University Press, 1974), 18:214–217. It is unclear whether the pamphlet, penned in 1771, was published that year or later; a French translation, possibly from Franklin's manuscript, appeared in 1772. Some accounts suggest that it was not published in English until mid-decade, at which point hostilities with the American colonies might have led to an indifferent reception for the proposal. In any event, Franklin's mission of mercy to the Maori never materialized.

4. Johann Eckermann, *Conversations with Goethe*, quoted in Ross Fraser, "Pictures of a Gone World," *Landfall* 23, no. 1 (March 1969): 71.

5. In addition to the canoe model, which returned on the ship *Nantucket* in 1850, sailors brought back diverse souvenirs, including war clubs from the Marquesas Islands, spears from Fiji and elsewhere, large Hawaiian neck ornaments and other objects of personal adornment, Melanesian masks from various islands, tapa cloth from many places, Japanese silks and fans, and other artifacts now in the museum at Nantucket. At least in the seafaring communities of coastal New England, such treasures from exotic Pacific cultures were familiar in the early nineteenth century.

6. William Winstanley's view of the cities of London and Westminster (measuring 2,400 square feet) was exhibited in New York City in 1795, and it was followed by his comparably sized view of Charleston, South Carolina, and Edward Savage's even larger London view, both in 1797. See Rita Susswein Gottesman, *The Arts and Crafts in New York, 1777–1799* (New York: The New-York Historical Society, 1954), 18, 23, 29, and 33.

7. Vanderlyn attributed the poor reception of his Versailles project to its having been preceded by three other panoramas at the Rotunda (including the work of Robert Burford), as well as to the unfavorable timing of its debut during the slow summer season and to an outbreak of yellow fever the following autumn. But the choice of subject apparently also contributed to his panorama's doom: "[H]ad I bestowed my time and attention in painting a view of N. York instead of Versailles, I should I am now convinced have reaped more profits – but [I was not] aware of the general ignorance here respecting Versailles, and its former brilliant court etc."; Albert Ten Eyck Gardner, *American Paintings: A Catalogue of the Collection of The Metropolitan Museum of Art* (New York, 1965), 1:124.

8. For information on the Sydney and Hobart panoramas, see Anthony Murray-Oliver, *Augustus Earle in New Zealand* (Christchurch: Whitcombe & Tombs, 1968), 23. Murray-Oliver dates the Hobart panorama exhibition to 1829; Jocelyn Hackforth-Jones claims that it was shown in London in 1831; Hackforth-Jones, *Augustus Earle, Travel Artist: Paintings and Drawings in the Rex Nan Kivell Collection* (Canberra: National Library of Australia, 1980), 149. It is, of course, conceivable that a popular panorama might have been exhibited more than once.

9. *Description of a View of The Bay of Islands, New Zealand, and The Surrounding Country … Painted by Robert Burford from Drawings Taken by Augustus Earle, Esq.* (New York: William Osborn, 1840). The Panorama was built by Frederick Catherwood in 1837 and opened under his direction in January of the following year. It was an enormously successful operation during its brief existence, before the wooden rotunda burned to the ground in July 1842. See Victor W. von Hagen, "Mr. Catherwood's Panorama," *Magazine of Art* 40, no. 4 (April 1947): 143–146.

10. William Dunlap, *A History of the Rise and Progress of the Arts of Design in the United States* (1834; New York: Dover, 1965), vol. 2, pt. 2, 322. Earle also produced drawings at Madras, India, from which a panorama was later made and exhibited by Messrs. Daniell & Parris; he also made views of the island of Mauritius, in the Indian Ocean, intended for a panorama by Burford or another hand; Richard J. Koke, *A Catalogue of the Collection, Including Historical, Narrative, and Marine Art* (New York: The New-York Historical Society, 1982), 2:2.

11. In 1799 Ralph Earl became the first American artist to travel to Niagara Falls; there he made sketches that were used in painting a panorama (14 by 24 feet) of the cataract, which was unveiled in Northampton, Massachusetts, and traveled to various American cities before being sent to London; Edward J. Nygren, *Views and Visions: American Landscape before 1830* (Washington, D.C.: The Corcoran Gallery of Art, 1986), 255.

In addition to Augustus, his sister, Phoebe (1790–?), also followed their father's calling, specializing in flower painting. Ralph's son, Ralph E. W. Earl (1788–1838), like his father and uncle, was primarily a portrait painter, best known for the numerous depictions of his close friend and patron, President Andrew Jackson.

12. Dunlap, *Arts of Design*, 322. Dunlap repeated a long, amusing anecdote from Morse about a nighttime walk on the moors with Earle, when

the pair feared for their lives from murderous sailors rumored to be marauding in the area. Ron Radford mentioned the association with Allston and Trumbull in "A Colonial Augustan Age," in *Creating Australia: 200 Years of Art, 1788–1988*, ed. Daniel Thomas (Adelaide: Art Gallery of South Australia, 1988), 75.

13. Radford, ibid., implies a visit with Allston, suggesting that Earle's *Trajan Inconsolable after the Battle of Ctesiphon*, ca. 1827 (Art Gallery of South Australia, Adelaide) – the first painting made in Australia of an elevated European subject – might have been inspired by Allston's composition for *Saul and the Witch of Endor* (Mead Art Museum, Amherst College, Amherst, Mass.), which was probably underway by the time of Earle's departure from the United States in February 1820.

14. Dunlap, *Arts of Design*, 325. Today the Earle drawings – including an architectural study, landscape, and sketches of soldiers and figures in period dress or Mediterranean costume – are in the collection of The New-York Historical Society, New York City. See Koke, *A Catalogue of the Collection*, 2:1–4.

15. Much of the debate regarding Earle's book focused on the author's harsh judgments of British missionaries, who had been established in the Bay of Islands region since 1814; critics in the United States joined their English counterparts in suspecting that "the missionaries had received some unfavourable information respecting [Earle]; and ... they had reason to regard him as unfriendly to their vocation"; Review of Earle's *Narrative*, *American Quarterly Review* 13 (March 1833): 171.

Carlyle's admission was made in an unpublished review of Earle's *Narrative*; the manuscript is in the National Library of Scotland, Edinburgh (MS: 1798); see K. J. Fielding, "Carlyle Considers New Zealand," *Landfall* 33, no. 1 (March 1979): 51–60. Coincidentally, Charles Dickens also briefly considered a publishing venture in the colony: "[I] Dreamed of *Timeses* all night. Disposed to go to New Zealand and start a magazine"; Letter to Charles Sheridan, January 1847, in *The Letters of Charles Dickens*, ed. Graham Story and K. J. Fielding (Oxford: Clarendon Press, 1981), 5:4.

16. John Galt, *The Life, Studies, and Works of Benjamin West, Esquire* (1820; Gainesville, Fla.: Scholars' Facsimiles and Reprints, 1960), 1:105.

17. Earle, *Narrative*; quoted in Murray-Oliver, *Earle in New Zealand*, 138. Earle, quoted in E. H. McCormick, *Letters and Art in New Zealand* (Wellington: Department of Internal Affairs, 1940), 15.

The analogy to the ancients was repeated by Charles Meryon, who in the 1840s was stationed with the French navy to guard the interests of compatriots settled at Akaroa; "[W]hen reading a few passages of Homer," he wrote, "I had once seen real parallels between the present-day Maoris and the ancient Greeks"; Letter to Antoine-Edouard Foley, April 29, 1848, Bibliothèque Nationale, Paris; quoted in Marian Minson, *Encounter with Eden: New Zealand, 1770–1870:*

Paintings and Drawings from the Rex Nan Kivell Collection, National Library of Australia (Wellington: Alexander Turnbull Library, 1990), 35.

Reminiscence of classical Europe could even be prompted by cartography. One early settler seemed heartened to realize that "the outline [of New Zealand] is very much like that of Italy reversed"; Rev. James Bueller, *Forty Years in New Zealand* (London: Hodder and Stoughton, 1878), 3.

18. Murray-Oliver, *Earle in New Zealand*, 137.

19. Prefatory remarks by the editor of *Narrative*; quoted in Francis Pound, *Frames on the Land: Early Landscape Painting in New Zealand* (Auckland: Collins, 1983), 40. (The supposed editor could well have been Earle himself.) *Description of a View of The Bay of Islands*, 3.

20. Quoted in Pound, *Frames on the Land*, 40.

21. The seal trade was greatest in the first decade of the nineteenth century. Deep-sea whaling in pursuit of the sperm whale, begun in the 1790s, peaked in the 1830s; shallow-water "bay whaling" for the black right whale replaced sealing in the 1820s and flourished into the 1840s. Flax exports reached their zenith in 1831; two years later, their value was surpassed by exports of native timber, which crested in 1840. Throughout this period, innovations in agriculture increased crop yields to provide for a growing populace, and by the 1830s led to sizable exports, particularly of wheat. Much of this international commerce was with Australia – "New Zealand is becoming a perfect granary for New South Wales," reported the *Sydney Gazette* in May 1836 – but significant trade lines also reached to Britain and North America. See W. H. Oliver, ed., *The Oxford History of New Zealand* (Oxford: Clarendon Press, 1981), chap. 2.

22. Michael Bryan, *Bryan's Dictionary of Painters and Engravers* (1849; London: G. Bell and Sons, 1927), 3:25.

23. In 1845 several of Heaphy's images were issued as lithographs to accompany Edward Jerningham Wakefield's *Adventure in New Zealand*, a publication of the New Zealand Company intended to encourage colonization.

Conversely, New Zealanders sometimes regarded the art of other nations as propaganda. In the late nineteenth century, when the landscapes of the Hudson River School were widely broadcast through reproductions in *Harper's Monthly Magazine* and other popular journals, one New Zealand reader acknowledged that the American artists were "immigration agents of a very superior kind"; W. M. Hodgkins, quoted in Peter Entwisle, *William Mathew Hodgkins and His Circle* (Dunedin Public Art Gallery, 1984), 161.

24. R. E. Kennedy, Review of *A Century of Art in Otago*, *Landfall* 2, no. 2 (June 1948): 154.

25. Wystan Curnow, in the exhibition and catalogue *Putting the Land on the Map* (New Plymouth: Govett-Brewster Art Gallery, 1989), provides a provocative contemporary reading of the significance of art and cartography in New Zealand since 1840.

26. Pound, *Frames on the Land*, 56. Many recent critics in New Zealand have focused on the perennially popular mode of landscape with new interest, laying "frames on the land" (Pound), "putting the land on the map" (Curnow), and otherwise burdening the natural environ or its depictions with postmodern interpretation.

27. Don W. Thomson, *Men and Meridians: The History of Surveying and Mapping in Canada* (Ottawa: Department of Energy, Mines and Resources, 1969), 3:frontispiece.

28. For Thoreau's career, see *A Thoreau Gazetteer* (Princeton, N.J.: Princeton University Press, 1970), by Robert F. Stowell (coincidentally, a New Zealander); for Whistler, who in 1820 drew the first contour map of an American site (Salem Harbor, Mass.), see Arthur F. Frazier, "Whistler's Father – Topographer Extraordinary," in *Plotters and Patterns of American Land Surveying*, ed. Roy Minnick (Rancho Cordova, Calif.: Landmark Enterprises, 1985), 172–174.

If Thoreau's and Whistler's pursuits as surveyors are unfamiliar today, such is not the case with the one for whom the latter was named. George Washington's hagiographers early wove his youthful service as a colonial surveyor into legendary accounts of the Father of His Country, providing the basis for painted portrayals. (See, for instance, Emanuel Leutze's *Washington as the Young Surveyor* [Cooper-Hewitt Museum, New York], painted in 1852 or earlier.) Aspects of the Washington legend were familiar even to New Zealand audiences in the nineteenth century; for example, during a lecture tour in 1895, Mark Twain regaled Christchurch listeners with "a new version of the George Washington cherry tree story which tickled the audience immensely"; *Press*, November 21, 1895; quoted in Shillingsburg, *Mark Twain in Australasia*, 148.

American artists as diverse as George Inness, Charles Christian Nahl and William Sidney Mount depicted the anonymous American surveyor and his work, as did a host of less well-known painters and illustrators; similar subjects, especially in the American West, were recorded as well by documentary photographers such as Timothy O'Sullivan and William Henry Jackson.

For a summary of the surveyor's life depicted in nineteenth-century New Zealand art and literature, see Nola Easdale, *Kairuri, the Measurer of the Land: The Life of the Nineteenth-Century Surveyor Pictured in His Art and Writings* (Petone, N.Z.: Highgate/Price Milburn, 1988).

29. E. H. McCormick, *Letters and Art in New Zealand* (Wellington: Department of Internal Affairs, 1940), 33–34. It was McCormick who recognized in Heaphy's view of *Mt. Egmont Viewed from the Southward*, ca. 1840 (Alexander Turnbull Library, Wellington), "one of the few satisfying paintings of that inspiration – and snare – for New Zealand artists" and helped to elevate the picture to its present position as a national icon. McCormick's text is one of the most enduringly valuable in the government-sponsored series of *New Zealand Centennial Surveys*.

30. Gordon H. Brown and Hamish Keith, *An Introduction to New Zealand Painting, 1839–1967*

(Auckland: Collins, 1969); revised and enlarged as *An Introduction to New Zealand Painting, 1839–1980* (Auckland: Collins, 1982).

31. Gordon H. Brown, *The Ferrier-Watson Collection of Watercolours by John Kinder* (Hamilton: Waikato Art Gallery, 1970), 33.

32. Worthington Whittredge, "The Autobiography of Worthington Whittredge," ed. John I. H. Baur, in *Brooklyn Museum Journal* 1 (1942): 55.

33. John Ruskin, *Elements of Drawing;* quoted in Linda S. Ferber, "Luminist Drawings," in John Wilmerding, *American Light: The Luminist Movement, 1850–1875* (Washington, D.C.: National Gallery of Art, 1980), 248.

34. Roger B. Stein, *John Ruskin and Aesthetic Thought in America, 1840–1900* (Cambridge, Mass.: Harvard University Press, 1967), 41.

35. Weston Naef, "'New Eyes' – Luminism and Photography," in Wilmerding, *American Light,* 272. In addition to their mutual interests in the possibilities of landscape and photography, Kinder likely would have admired Ruskin's drawings of architecture, a field in which he too was active, both as a topographic landscapist and, in 1867, as the designer of Saint Andrew's Church, Epsom, built in the "Selwyn Style" characteristic of Anglican churches in the Auckland region erected under the direction of Bishop George Augustus Selwyn. See Michael Dunn, *John Kinder: Paintings and Photographs* (Auckland: SeTo Publishing, 1985), 95–98.

36. While the forms of the land appeared convincing, Kinder's colors were sometimes less so. Using as preparation his field drawings and loose watercolor sketches made *en plein air,* the artist produced the finished views in his studio. Painted away from the changeable effects of outdoor light and atmosphere, the final products sometimes betrayed a sameness of tone that was noted by at least one early reviewer. Remarking on Kinder's penchant for a yellowish cast in his landscapes, the critic complained about the "pervading tinge of yellow which gives a rather sickly appearance to the drawings and which we can hardly think would be justified by nature"; *New Zealand Herald,* March 3, 1871; quoted in Dunn, *Kinder: Paintings and Photographs,* 56.

37. Sometimes the informative inscriptions were elaborate and extensive, as if through written explication Kinder could enhance the veracity of the visual effect. For example, his watercolor *Rotomahana with a View of the Tarata,* January 16, 1858 (The Bath-House, Rotorua's Museum of Art and History), on recto and verso bears a legend of more than one hundred words explaining the source of water for the boiling lake, the creation of calcified terraces, and the etymology of *tarata;* see Dunn, *Kinder: Paintings and Photographs,* 137.

38. John Ruskin, *Modern Painters* (1846; Chicago and New York: Belford, Clarke & Co., 1870), 2:21–22. The argument for "truth of earth" provides the opening lines for Ruskin's text. Gordon Brown pointed out that Kinder's adherence to Ruskin's principles antedated the artist's arrival in New Zealand (1855); it was manifest as early as July 1854, in a group of pen and ink landscape drawings made on the Yorkshire coast

of England; Brown, *Ferrier-Watson Collection,* 18.

39. It has recently been suggested that he may have arrived in 1862, or even a year earlier, but documentation has not yet been found. For what biographical information does exist, see Roger Collins and Peter Entwisle, *Pavilioned in Splendour: George O'Brien's Vision of Colonial New Zealand* (Dunedin Public Art Gallery, 1986), passim.

40. *Auckland Weekly News,* October 31, 1885; *The Press,* February 28, 1870; both quoted in Collins and Entwisle, *Pavilioned in Splendour,* 37, 35.

41. *Otago Daily Times* [Dunedin], November 23, 1876; *Evening Star,* November 3, 1876; both are quoted in Collins and Entwisle, *Pavilioned in Splendour,* 35–36. Sharp differences in critical opinion, such as have recently characterized discourse regarding New Zealand's art, clearly have a long tradition.

42. *Evening Star,* September 9, 1886 (quoting the *Lyttleton Times);* review by G. J. S., *Saturday Advertiser,* December 27, 1879; both are quoted in Collins and Entwisle, *Pavilioned in Splendour,* 37, 36.

43. Roger Blackley, "George O'Brien: Pavilioned in Splendour," *Art New Zealand* 39 (Winter 1986): 56.

44. Such a composite was unprecedented in New Zealand. In America, the closest parallel is Thomas Cole's well-known *Architect's Dream,* 1840 (Toledo Museum of Art), combining various structures reflecting the world history of architectural styles. The composition of Cole's imaginative assembly is based on Claude Lorrain's compositions. Like O'Brien, Cole painted his canvas for a leading architect of his time and place, the Gothic revivalist Ithiel Town; however, unlike Lawson who bought O'Brien's view, Town rejected Cole's picture. Chances of O'Brien's being aware of the American painting seem remote, however. More likely, O'Brien was familiar with the famous drawing by the noted Victorian architect Charles Robert Cockerell (1788–1863), which combined all of Sir Christopher Wren's buildings in an imaginary grouping, an image that Cole might have known as well. That such architectural fantasies still have the power to capture the imagination was demonstrated in a recent American advertising campaign that relied on a composite photograph of familiar monuments – the Alamo, the Statue of Liberty, Saarinen's Saint Louis arch, etc. – arrayed in an eye-catching frieze.

45. In Britain, the Parliamentary enclosure acts of 1801, 1836, and 1845 – which forever altered the nature of land holding and the English landscape – invariably worked to the detriment of laborers and cottagers; to them, the prospect of cheap and abundant lands in the colonies was understandably attractive. For a review and tabulation of the enclosure acts, see William E. Tate, *A Domesday of English Enclosure Acts and Awards* (Reading: The Library, University of Reading, 1978). Free land was also an inducement in military recruitment; during hostilities with the Maoris in the early 1860s, British "efforts to raise volunteers in this [New Zealand] and the

neighbouring colonies for general service during the war, on condition of obtaining grants of land, have been most successful"; *The Illustrated London News,* January 2, 1864, 5.

46. The total population (other than Maori) of North and South Islands was 99,021 in 1861; 256,393 in 1871; and 489,933 by 1881. Throughout this period, the provinces of Auckland and Otago (the latter most affected by the gold rush) alternated as most populous; *Oxford History of New Zealand,* 117, table 1.

47. J. L. C. Richardson, *A Summer's Excursion in New Zealand, with Gleanings from Other Writers* (1854); quoted in Paul Shepard, *English Reaction to the New Zealand Landscape before 1850* (Wellington: Department of Geography, Victoria University, 1969), 30. Shepard's compilation and introductory essay provide one of the most valuable surveys of colonial attitudes to the landscape.

48. R. G. Jameson, *New Zealand, South Australia, and New South Wales: A Record of Recent Travels in these Colonies, with Especial Reference to Emigration and the Advantageous Employment of Labour and Capital* (1842); quoted in Shepard, *English Reaction,* 17.

49. George French Angas, *Savage Life and Scenes in Australia and New Zealand: Being an Artist's Impression of Countries and People at the Antipodes* (1847); quoted in Shepard, *English Reaction,* 28.

50. Edward Brown Fitton, *New Zealand: its present condition, prospects and resources; being a description of the country and general mode of life among New Zealand colonists, for the information of intending emigrants* (1856); quoted in Shepard, *English Reaction,* 17.

51. Charles Hursthouse, *New Zealand; or, Zealandia, the Britain of the South,* vol. 2 (London: Edward Stanford, 1857); quoted in Shepard, *English Reaction,* 16.

52. Robert E. Irvine and O. T. J. Alpers, *The Progress of New Zealand in the Century* (Toronto and Philadelphia: Linscott, 1902), 382. The faith that artistic progress would be inspired by native scenery was widespread and enduring. Despite the relative scarcity of art schools, the fledgling public collections that yet awaited "well-selected master-pieces," and a struggling art community decimated by expatriation, the artist E. A. S. Killick claimed as late as 1917 that "there is no need to go to Paris to learn how to paint the New Zealand landscape…. Nature will provide all that is necessary"; E. A. S. Killick, "Landscape Art in New Zealand," in *Art of the British Empire Overseas,* ed. Charles Holme (London: The Studio, 1917), 90.

53. G. B. Earp, *Handbook for Intending Emigrants to the Southern Settlements of New Zealand* (1849, 2d ed.); quoted in Shepard, *English Reaction,* 43.

54. Mark Twain in [Christchurch] *Press,* November 13, 1895; quoted in Shillingsburg, *Mark Twain in Australasia,* 145–146. Twain visited Australia and New Zealand in 1895 on a four-month lecture tour.

55. Von Guérard's New Zealand landscapes created a sensation when first exhibited at the Victorian Academy of Arts, Melbourne, in 1877. During the following decade they were shown at

the Exposition Universelle de Paris (1878), the Sydney International Exhibition (1879), the Melbourne International Exhibition (1880), and the Colonial and Indian Exhibition in London (1886). A London reviewer's reaction was typical of responses elicited by the works: "[T]he vision of Milford Sound might be termed a fantasia in oils, so strange is its aspect, so suggestive of the magic land of romance and witchcraft"; J. A. Blaikie, "Art in New Zealand," *The Magazine of Art* [London], (1887): 35.

56. Blaikie, "Art in New Zealand," 35, 37.

57. For instance, von Guérard wrote: "Along the route [to Ballarat] the vegetation was of much interest ... wattle, she-oak, honeysuckle, eucalyptus etc. all quite new to me ... the forests through which we went were magnificent." The exotic bird life, as well as "the discovery of a scorpion as a bedfellow, the intolerable flies etc. were all new experiences," worthy of recording in his journal; quoted in Candice Bruce, *Eugen von Guérard* (Canberra: Australian National Gallery, 1980), 28. A typescript of von Guérard's *Journal of an Australian Gold Digger, 1852–1854* (likely a later translation from the original German) is in the Dixson Library, Public Library of New South Wales, Sydney; the original manuscript is lost. The journal was published as *An Artist in the Goldfields: The Diary of Eugene von Guérard*, introduced and annotated by Marjorie Tipping (Melbourne, 1982).

58. Alison Carroll noted that "it is highly probable that von Guérard knew of von Humboldt's ideas in Germany. Certainly one of von Guérard's Australian companions, Georg Neumayer, arrived in 1857 carrying a testimonial from him and, on von Humboldt's death in 1859, the Melbourne German Association, of which von Guérard was a member, held a special commemoration ceremony." Alison Carroll, *Eugene von Guérard's South Australia* (Adelaide: Art Gallery of South Australia), 4. For Humboldt and Australian art, also see Tim Bonyhady, *Images in Opposition: Australian Landscape Painting, 1801–1890* (Melbourne: Oxford University Press, 1985), 64–66.

59. Alexander von Humboldt, *Cosmos: A Sketch of a Physical Description of the Universe* (London: Henry G. Bohn, 1849), 2:452. On Humboldt and American artists' interest in South America, see Katherine Emma Manthorne, *Tropical Renaissance: North American Artists Exploring Latin America, 1839–1879* (Washington, D.C.: Smithsonian Institution Press, 1989).

60. Ludwig Richter, quoted in Hubert Schrade, *German Romantic Painting* (New York: Harry N. Abrams, 1977), 47.

61. For Americans in Düsseldorf, see *The Düsseldorf Academy and the Americans* (Atlanta: High Museum of Art, 1972).

62. In 1859 Bierstadt first visited the American West, serving as artist on General F. W. Lander's expedition to survey emigration routes through the Rocky Mountains. Many of his contemporaries likewise traveled in such company (either in an official capacity or informally), such as Thomas Moran, whose introduction to the West came in 1871 when he accompanied Ferdinand Hayden's

survey expedition to the Yellowstone. In Victoria, von Guérard often traveled (in an unofficial capacity) with such expeditions, for instance, to the Baw Baw Plateau (via the Dandenong range) with the geologist-anthropologist Alfred Howitt in 1858, and with him again on a government survey expedition through Gippsland in 1860; in 1862 he accompanied Professor George Balthasar von Neumayer's scientific expedition to Mount Kosciusko (probably von Guérard's most significant penetration of the interior) and also traveled with his meteorological expedition to Western Australia.

63. Aside from European artists attached to various nations' expeditions to the South Pacific in the late eighteenth and early nineteenth centuries, others from the Continent had spent time in New Zealand before von Guérard. Among them were the eminent French draftsman and printmaker Charles Meryon (early 1840s); Gustavus Ferdinand von Tempsky, a Prussian-born soldier, prospector, and amateur artist, who arrived in the New Zealand goldfields in 1862 (after failing in California) and was killed six years later in a skirmish with Maori warriors; and Nicholas Chevalier, of Russian and Swiss parentage, who studied art in Switzerland, Germany, and Rome before heading to Australia, from which he thrice visited New Zealand in the 1860s, producing romantic views in oil and watercolor that inspired the subsequent travels of his friend, von Guérard. For the most part, however, British training and taste were evident in New Zealand landscapes produced before 1890.

64. T. L. Rodney Wilson, *Petrus van der Velden, 1837–1913: The Hague School in New Zealand* (Wellington: A. H. & A. W. Reed, 1976), 34.

65. Obituary in *Lyttleton Times* [Christchurch], November 13, 1913; quoted in Brown and Keith, *Introduction to New Zealand Painting*, 87.

66. James Green, "Da Libra," *The Australasian Art Review*, June 1, 1899; quoted in Jane Clark and Bridget Whitelaw, *Golden Summers: Heidelberg and Beyond* (Melbourne: National Gallery of Victoria, 1985), 23.

67. Green, quoted in Clark and Whitelaw, *Golden Summers*, 87.

68. Discussion of Nerli's work, in Christchurch *Press*; quoted in Pound, *Frames on the Land*, 27.

69. Nairn struck the captain of his New Zealand–bound ship as "stark, staring mad," an impression the artist reinforced by decorating his cabin in a scheme of gold, blue, and green, a Whistlerian decor that the captain complained he would have to repaint. See A. St. C. Murray-Oliver, *Brief Notes on James Nairn, Artist* (1939); cited in Colin McCahon, *James Nairn and Edward Fristrom* (Auckland City Art Gallery, 1964), 21–22.

70. Quoted in Brown and Keith, *Introduction to New Zealand Painting*, 83.

71. Quoted in Roger Blackley, *Two Centuries of New Zealand Landscape Art* (Auckland City Art Gallery, 1990), 59.

72. McCormick, *Letters and Art in New Zealand*, 121–122.

73. The difference is evident, for instance, in the comparison of Fristrom's *Mount Earnshaw [sic], Lake Wakatipu, New Zealand* with von Guérard's treatment of the same subject. See the sale catalogue of *Pictures, Drawings, Watercolours, Prints and Sculpture*, Christie's/South Kensington, London, October 29, 1987, lot 149.

74. Fristrom to Minnie F. White, June 10, 1925; quoted in Elizabeth S. Wilson, "Edward Fristrom," (thesis, University of Auckland, 1981), 195. Fristrom was perhaps attracted to the United States by the attention given to the Panama-Pacific International Exposition in San Francisco in 1915, and by the prospect of critical and financial success. "He said you can sell anything there," recalled one of his students, Minnie F. White, quoted in Wilson, "Fristrom," 211. In California he participated in art activities both in Carmel and in the San Francisco–Marin County area, exhibiting views of seaside dunes, weathered barns, and rural landscapes; the last were sometimes punctuated by the prominent placement of (imported) eucalyptus trees, which would have been familiar from his years in the Antipodes. Alas, fame and fortune eluded Fristrom. Although his obituary made the obligatory reference to a "noted artist," his repute was essentially local; "Noted Artist Dies at San Anselmo Home," *Daily Independent Journal* [San Rafael, Calif.], March 28, 1950, 1. Records of his American career are scanty, and works from that period remain unlocated.

75. Wilson, "Fristrom," 125.

76. Review of Canterbury Society of Artists exhibition, *Lyttleton Times* [Christchurch], March 18, 1917; quoted in Wilson, "Fristrom," 127n16.

77. Wilson, "Fristrom," 155.

78. Kenneth Clark, *Landscape into Art* (Boston: Beacon Press, 1969), 74–75.

79. *New Zealand Graphic*, May 18, 1907, 25.

80. A first edition of Dow's *Composition* (1899) is today in the library at Canterbury University in Christchurch, along with two later printings. Multiple editions are also in the Otago University library, Dunedin. Both instances suggest a serious contemporary interest in Dow's influential theory. In the United States his teaching and publication proved liberating for his students, a large and diverse group that included Charles Sheeler, Max Weber, and Georgia O'Keeffe among other notable modernists. For information on Dow, see Frederick C. Moffatt, *Arthur Wesley Dow, 1857–1922* (Washington, D.C.: National Collection of Fine Arts/Smithsonian Institution Press, 1977).

81. Allen Curnow, "Spectacular Blossom," in *The Penguin Book of New Zealand Verse*, ed. Allen Curnow (Auckland: Penguin, 1960), 209.

1. Peter A. Tomory, "The Visual Arts," in *Distance Looks Our Way: The Effects of Remoteness on New Zealand*, ed. Keith Sinclair (University of Auckland, 1961), 72. His indictment of the local scene between the wars has often been cited by others and now is part of the canon of New Zealand's modern art history.

2. A. R. D. Fairburn, "Some Aspects of N.Z. Art and Letters," *Art in New Zealand* 6, no. 4 (June 1934): 213.

3. Tomory, "The Visual Arts," 71. The description and the sentiment are reminiscent of earlier generations of American landscapists on their homecomings from European sojourns. Worthington Whittredge, for instance, after a decade abroad returned to the United States in 1859 to "the most crucial period of my life. It was impossible for me to shut out from my eyes the work of the great landscape painters which I had so recently seen." He was left "in despair" by the difference of the Catskill mountain scenery from that in Europe. "The forest was a mass of decaying logs and tangled brush wood, no peasants to pick up every vestige of fallen sticks to burn in their miserable huts, no well-ordered forests, nothing but the primitive woods with their solemn silence reigning everywhere"; Whittredge, "Autobiography," 42.

4. John Cam Duncan, "New Zealand Painters," *Art in New Zealand* 1, no. 3 (March 1929): 169. In 1933 James Shelley similarly noted that whereas in the northern hemisphere, a mountain thirty miles distant "finds itself behind veil upon veil of hazy atmosphere," its New Zealand counterpart "fairly bounds across the sky," from which observation southern painters should determine to practice clarity in their landscape renderings; quoted in Francis Pound, "Harsh Clarities: Meteorological and Geographical Determinism in New Zealand's Art Commentary Refuted," *Parallax* 1, no. 3 (Winter 1983): 264.

Modern discussions of the purportedly distinctive clarity of New Zealand's light had been anticipated in the late nineteenth century by the watercolorist Alfred Sharpe. In his "Hints for Landscape Students in Water-Colour," published in the Auckland press, he claimed that "the difference of the atmosphere … is so great that 20 miles is the average limit of vision in England, while 60 to 70 miles is that limit here"; "Hints," no. 9 (April 1890); quoted in Roger Blackley, "Writing Alfred Sharpe" (thesis, University of Auckland, 1978), 2:54.

5. Fairburn, "Some Aspects of N.Z. Art and Letters," 215.

6. Perkins, letter to Hamish Keith, December 27, 1966; quoted in Gordon Brown, *New Zealand Painting, 1920–1940: Adaptation and Nationalism* (Wellington: Queen Elizabeth II Arts Council of New Zealand, 1975), 21. Stanley Spencer was among Perkins's circle of young artist friends in London, as were Paul Nash, Colin Gill, and David Bomberg, the latter two being especially close.

7. Cézanne and Provence also shaped the critical (and meteorological) views of the poet-critic Fairburn, who later claimed that "our clear atmosphere (approximating that of the South of France rather than to the misty horizons of England) offers the best possible conditions for the landscape painter." Perkins reinforced these impressions in his admirer, and probably was their mediator; A. R. D. Fairburn, "Some Reflections on New Zealand Painting," *Landfall* 1, no. 1 (March 1947): 54.

8. Christopher Perkins, quoted in Jane Garrett, *An Artist's Daughter: With Christopher Perkins in New Zealand, 1929–1934* (Auckland: Shoal Bay Press, 1986), 31. His daughter's recollections of the Wellington cultural scene (chap. 10) provide a unique, firsthand account of the "war" and local conditions for the arts from within the Perkins family.

Perkins's recognition in critical circles was delayed by his absence from New Zealand (after 1933) and by the scarcity (until the late 1960s) of his works in public collections. In 1940 the influential Eric McCormick, an astute judge of early New Zealand painting, remained blind to Perkins's work, damning *Taranaki* for its "oppressive obviousness of a formula" and its "eclecticism." He concluded that "few would question the superiority of Heaphy's less sophisticated version of the same subject"; McCormick, *Letters and Art in New Zealand*, 191–192.

9. Perkins, quoted in P. W. Robertson, "The Art of Christopher Perkins," *Art in New Zealand* 4, no. 13 (September 1931): 9ff.

10. Marsden Hartley to Alfred Stieglitz, April 28, 1923; quoted in Gail R. Scott, *Marsden Hartley* (New York: Abbeville, 1988), 75.

11. Hartley to Stieglitz, February 2, 1926; quoted in Scott, *Hartley*, 76.

12. Hartley, "Art – and the Personal Life," *Creative Art* 2 (June 1928): xxxi–xxxiv.

13. Paul Shepard, "Dead Cities in the American West," *Landscape* 6, no. 2 (1956–57): 28.

14. Ruth Pielkovo, "Dixon, Painter of the West," *International Studio* 77, no. 322 (March 1924): 468.

15. Lawrence Clark Powell, "The Essential Vision," in *The Drawings of Maynard Dixon* (San Francisco: Achenbach Foundation for Graphic Arts/The Fine Arts Museums of San Francisco, 1985), 9. Dixon's wife, the photographer Dorothea Lange, recalled that the pine woods of the High Sierra were "too closed in" and not to his liking, and that he preferred a vantage point above timberline "where he could see the shape of the land and rock"; Lange, quoted in Powell, "The Essential Vision," 9.

16. Rockwell Kent, quoted in "Two Examples of Modern Painting," *The Bulletin of the Cleveland Museum of Art* 9, no. 10 (December 1922): 171.

17. Lawren Harris, "An Essay on Abstract Painting," *Journal of the Royal Architectural Institute of Canada* 26, no. 1 (January 1949): 3. New Zealand art audiences were introduced to contemporary Canadian painting in a large exhibition that toured Britain's southern dominions, including New Zealand, in 1938. The imaginations of New Zealand artists were excited – both by the works' formalism and nationalism – and it is remembered as "the most significant exhibition" of the period. See Anthony Mackle, *Aspects of New Zealand Art, 1890–1940* (Wellington: National Art Gallery, 1984), 13. The show represented the formal innovations and "very distinct Canadianism" that had emerged over the previous generation and included numerous paintings by Harris and his colleagues in the Group of Seven; Eric Brown, "Introduction," *Exhibition of Contemporary Canadian Painting* (Ottawa: National Gallery of Canada, 1936), 5–6.

Harris moved away from stylized landscapes toward the subsequent stages traced in his schema of abstract painting, in the late 1930s beginning non-objective compositions (inspired by his theosophical faith, rather than observation), and finally working as an abstract expressionist at mid-century.

18. Perkins, quoted in Brown and Keith, *Introduction to New Zealand Painting*, 123.

19. The concern for nativeness expressed through landscape had been anticipated a half-century earlier by the prominent American critic S. G. W. Benjamin. In 1879 he wrote of American landscapists that, "thoroughly, almost fanatically, national by nature, even when their art shows traces of foreign influence, and drawing their subjects from their native soil, they have created an art which can fairly claim to be ranked as a school"; Benjamin, "Fifty Years of American Art, 1828–1878," *Harper's New Monthly Magazine* 59 (June 1879): 251. Julie King has recently pointed out that Benjamin's series of articles was known and admired by one of New Zealand's leading watercolorists of the period, William M. Hodgkins: "I have for several years attentively watched the progress of art in America," he wrote. She argues that Hodgkins's works may have been inspired by Benjamin's praise for his American contemporaries (and the *Harper's* illustrations of their works), and that his aspirations for landscape painting in New Zealand would surely have been encouraged by the progress along similar lines in another young artistic and national community; Julie King, "W. M. Hodgkins and His American 'Cousins,'" *Bulletin of New Zealand Art History* 10 (1989): 5–9.

20. Frank Rutter, "Internationalism in Art," Christchurch *Press*, September 17, 1932; quoted in Janet Paul, "Biographical Essay," in *Rita Angus* (Wellington: National Art Gallery, 1982), 16.

21. Robertson, "The Art of Christopher Perkins," 22.

22. André Siegfried, *Democracy in New Zealand* (London: G. Bell and Sons, 1914), 254. The French magistrate Alexis de Tocqueville visited the United States in 1831 and four years later published his keen observations on American life, *Democracy in America*. His book was enormously influential in his own day and remained so for generations; seven decades after its appearance it provided the model (and the title) for his compatriot's examination of New Zealand society.

23. The only older art school in New Zealand was founded at Dunedin in 1870. Unlike all others, which were associated with technical colleges or independent, the Christchurch institution's affiliation (and its recognition by the Canterbury University Senate in 1926) made it the only accredited art school in the country, permitting

▼

61

it to award graduates of the four-year course of instruction the requisite qualification to teach in the technical schools. This monopoly persisted until 1952, when statutes governing accreditation were revised. Information on art instruction from Brown and Keith, *Introduction to New Zealand Painting*, 100; Rosemary Entwisle, *The Dunedin School of Art and the La Trobe Scheme* (Dunedin: Hocken Library, University of Otago, 1989), 11–12; John Oakley, *Paintings of Canterbury, 1840–1890* (Wellington: A. H. & A. W. Reed, 1969), n.p.

24. William Moore, quoted in Paul, "Biographical Essay," in *Angus*, 14.

25. Angus, quoted in Paul, "Biographical Essay," in *Angus*, 14.

26. One of her friends recalled Angus's fascination with contemporary American painting of the 1930s (reproductions of which appeared in the American popular press as well as in art books, both readily available in New Zealand). "*American Gothic* by Grant Wood struck a particularly responsive chord because of its stresses on the virtues of a pioneering culture"; Paul, citing Betty Curnow, in *Angus*, 48.

Wood discovered the Flemish masters during a sojourn in Munich in 1928, and was especially affected by Hans Memling's crystalline realism. He was impressed "by the lovely apparel and accessories of the Gothic period" and by the artist's treatment of local people in contemporary dress, aspects that would have appealed to Angus as well. See Wanda M. Corn, *Grant Wood: The Regionalist Vision* (New Haven: Yale University Press, 1983), 28–29.

27. Angus (1960), quoted in Anne Kirker, "The Later Years, 1959–1970," in *Angus*, 59.

28. Ronald Brownson, "Symbolism and the Generation of Meaning in Rita Angus's Painting," in *Angus*, 81–82.

29. Roland Hipkins, "Contemporary Art in New Zealand," *The Studio* 135 (April 1948): 111.

30. Frederick Page, "Rita Angus," *Landfall* 15, no. 3 (September 1961): 265. Angus's keen interest in oriental art was shared by Georgia O'Keeffe. Landscapes and floral subjects provided important inspiration for both painters, an interest that seems in part commonly derived from oriental aesthetics. As with Angus's, critics often wrote of O'Keeffe's reductive images and abstractions in terms of "distillation" and "essences."

31. McCahon painted the large canvas in Doris Lusk's Christchurch home while a guest there. "Because the room was so small, the canvas had to be draped around three sides of the room," he recalled. "Later it was finished in the dining room where there was more space"; Colin McCahon, "Paintings, Drawings, and Prints by Colin McCahon," *Auckland City Art Gallery Quarterly* 44 (1969): 4–5.

32. *Colin McCahon: A Survey Exhibition* (Auckland City Art Gallery, 1972), 11.

33. J. Bowring, "Painting New Zealand" (dissertation, Lincoln College, University of Canterbury, 1989), passim.

34. R. A. K. Mason, "Old Memories of Earth," in *The Penguin Book of New Zealand Verse*, 159.

35. Charles Brasch, "The Land and the People (II)," in *Collected Poems: Charles Brasch*, ed. Alan Roddick (Auckland: Oxford University Press, 1984), 2.

36. Charles Brasch, "The Silent Land" (1945), in *Collected Poems: Charles Brasch*, 218. Brasch's image of "gaunt hills" was often woven into art and literary criticism, but it found echo in other places as well. In *A State of Siege*, the novelist Janet Frame has her artist-protagonist wonder: "Why cannot I be left in peace to live the life I have chosen to live, in communion with mountains and rivers and shrubs and valleys … to make my view of them, to draw from them a new intensity of vision…. There are some who, knowing my new purpose in painting, will remind me that I, Malfred Signal, may be regarded as promiscuous, even an adulterous woman, to lie so with the landscape of my country, 'to lie with the gaunt hills like a lover'"; Janet Frame, *A State of Siege* (Christchurch: Pegasus, 1967), 223.

37. C. A. Cotton, *Geomorphology: An Introduction to the Study of Landforms*, 3rd ed. (Christchurch: Whitcombe & Tombs, 1942), n.p.

38. Cotton, "Preface," *Geomorphology*.

39. Charles Hursthouse, quoted in Shepard, *English Reaction*, 40.

40. Hursthouse, quoted in Shepard, *English Reaction*, 37.

41. William Pember Reeves, "A Colonist in His Garden," *The Penguin Book of New Zealand Verse*, 98.

42. Wallace Stevens, "Anecdote of the Jar," in F. O. Matthiessen, ed., *The Oxford Book of American Verse* (New York: Oxford University Press, 1964), 630–631.

43. Thomas Cole, "Essay on American Scenery" (1835), in *American Art, 1700–1960: Sources and Documents*, ed. John W. McCoubrey (Englewood Cliffs, N.J.: Prentice-Hall, 1965), 108, 101.

44. Shepard, *English Reaction*, 14.

45. Jim Ritchie, "Putting the Land on the Map," *New Zealand Listener*, January 26, 1985, 31.

46. McCahon, *Auckland City Art Gallery Quarterly*, 5.

47. McCahon's decision to move to Christchurch seemed influenced in part by his happy participation in the November 1947 exhibition of "The Group," a collection of progressive artists that included Rita Angus, Doris Lusk, and other Canterbury modernists. McCahon regularly participated in The Group's exhibitions until 1977.

48. Among McCahon's early interests were Cézanne's work, especially his handling of pictorial space; the starkly simple landscape imagery of quattrocento masters like Gentile de Fabriano and Fra Angelico; Hans Hofmann's theory, conveyed to New Zealand by Flora Scales who had studied at his Munich school in 1931; Picasso's paintings, of interest for their cubist space and for the quality of line in compositions of the 1920s; and the changing practices in New Zealand's art, especially the work of Toss Woollaston, whose discovery by McCahon while a schoolboy determined his choice of career, which was later shaped by the older painter's

friendship and guidance. As in his art, so too in his life McCahon was basically restless and inquisitive, and in his peripatetic youth he was exposed to more of the South Island's scenic variety than most of his compatriots. It was, in short, an aesthetic education as varied and as serendipitous as any of his American contemporaries, with results that could similarly surprise.

49. McCahon, *Auckland City Art Gallery Quarterly*, 5.

50. Grant Wood, quoted in Matthew Baigell, *The American Scene: American Painting of the 1930s* (New York: Praeger, 1974), 111.

51. Gordon H. Brown, *Colin McCahon: Artist* (Wellington: A. H. & A. W. Reed, 1984), 25.

52. Barbara Novak, *Nature and Culture: American Landscape Painting, 1825–1875* (New York: Oxford University Press, 1980), 49.

53. Henry Tuckerman, quoted in Novak, *Nature and Culture*, 50.

54. See Katherine Manthorne, *Creation and Renewal: Views of Cotopaxi by Frederic Edwin Church* (Washington, D.C.: National Museum of American Art, 1985), for a detailed discussion of Church's volcanic subjects.

55. Charles Brasch, "A Note on the Work of Colin McCahon," *Landfall* 4, no. 4 (December 1950): 337. Brasch's bold assertion was the opening sentence in the first important appreciation of the artist. About the same time, Brasch celebrated the artist in his epic poem, *The Estate*, written between 1948 and 1952:

I think of your generation as the youngest
That has found itself, has seen its way in the
 shadows
Of this disconsolate age, this country indifferent
To all but the common round, hostile to every
Personal light men would live by.
.

I count with you chiefly that painter, contracted to
 pity,
Who first laid bare in its offended harshness
The act of our life in this land, expressed the
 perpetual
Crucifixion of man by man that each must answer,
Rendered in naked light the land's nakedness
That no one before had seen or seeing dared to
Publish – an outrage to all whose comfort trembles
Hollow against such vision of light upon darkness.

Collected Poems: Charles Brasch, 63.

56. Shepard, *English Reaction*, 3.

57. Sarah Mathew, *Journal*, quoted in Shepard, *English Reaction*, 24. Most often, the industrious colonist looked not for deity in the landscape but for arable land and pasturage. Augustus Earle's practical eye was typical: "I ramble much about the country, in order to form some judgment of its capability of improvement"; Earle, quoted in Murray-Oliver, *Earle in New Zealand*, 154.

58. Earle, quoted in Murray-Oliver, *Earle in New Zealand*, 153.

59. Ralph Waldo Emerson, "Nature" (1836), in *Selections from Ralph Waldo Emerson*, ed. Stephen E. Whicher (Boston: Houghton Mifflin, 1957), 39.

60. By the 1970s critical recognition of the singularity of McCahon's vision and effort increased.

In concluding his review of the *Homage to the South Island* exhibition (Auckland City Art Gallery, 1978), Denys Trussell lamented: "Only a handful of our painters have responded deeply to the enigma of our landscape, and we can ill afford to exclude their work from collective themes such as this"; Denys Trussell, "Views of the South," *New Zealand Listener*, May 27, 1978, 18. His remarks were inspired by McCahon's paintings (*Takaka: Night and Day* and *Six Days in Nelson and Canterbury*) and by the omission of Rita Angus, Doris Lusk, and Toss Woollaston.

61. Brown, *Colin McCahon*, 26.

62. Tony Green, "McCahon and the Modern," in *Colin McCahon: Gates and Journeys* (Auckland City Art Gallery, 1988), 31.

63. Green, "McCahon and the Modern," 30. McCahon's layered fragments in a grid, a device that he introduced in *Six Days in Nelson and Canterbury*, parallels American compositions of the late 1940s (e.g., Adolph Gottlieb's pictographs) that were often reproduced in current periodicals, such as *Art News*, which McCahon read avidly. The format anticipates the gridded designs that became an international hallmark of contemporary art during the 1960s. The layering, which McCahon used repeatedly, was prefigured in the coastal profiles drawn by colonial surveyor-artists such as Charles Heaphy (see Fig. 5), images that McCahon might have seen in reproduction or at the Alexander Turnbull Library in Wellington during his visits there in the late 1940s. He certainly knew such works while he was employed as Keeper and Deputy Director of the Auckland City Art Gallery (1956–64), during which time the Heaphy view appeared on the cover of a gallery exhibition catalogue (*Early Watercolors of New Zealand*, September 1963).

64. McCahon, "Beginnings," *Landfall* 20, no. 4 (December 1966): 363–364.

65. McCahon, "A Landscape Theme with Variations" (statement for exhibition at Ikon Gallery, Auckland, May 1963); quoted in Anthony S. G. Green, "Colin McCahon's Paintings and Drawings at the Ikon Gallery," *Bulletin of New Zealand Art History* 2 (1974): 34–35.

In August 1958 McCahon returned from an influential visit of nearly four months in the United States. Shortly after his homecoming he created the ambitious *Northland Panels* (National Art Gallery, Wellington) on eight unstretched canvases. McCahon's phrase – "a landscape with too few lovers" – was written on one of them. The trope has been often repeated by New Zealanders in discussions of the native landscape, demonstrating once again the artist's powers as an evocative phrasemaker.

McCahon explained the genesis of the painting: "We went home to the bush of Titirangi. It was cold and dripping and shut in – and I had seen deserts and tumbleweed in fences and the Salt Lake Flats, and the Faulkner country with magnolias in bloom, cities – taller by far than kauri trees. My lovely kauris became too much for me. I fled north in memory and painted the *Northland Panels*"; quoted in Anthony Green, "McCahon's Visit to the United States," *Bulletin of New Zealand Art History* 3 (1975): 25.

The hyperbole – Caravaggio may have *fled* north, not McCahon – is characteristic of the artist's rhetoric. (On another occasion, the McCahons found the Isabella Stewart Gardner Museum in Boston "so awful" that they "just fled"; Brown, *Colin McCahon*, 88.) Such inflated language is memorable and did not pass unnoticed by his contemporaries. Eric McCormick, for instance, parodied the painter's pronouncements, claiming: "I fled to the South of France – or, more accurately, I biked there"; quoted in Wystan Curnow, Review of *The Inland Eye* by E. H. McCormick, *Landfall* 17, no. 2 (June 1963): 197.

66. R. N. O'Reilly to Colin McCahon, May 26, 1948; quoted in Brown, *Colin McCahon*, 27.

▼

Chapter 3

1. Everett S. Allen, *Children of the Light: The Rise and Fall of New Bedford Whaling and the Death of the Arctic Fleet* (Boston: Little, Brown and Co., 1973), 140–141. The unknown correspondent (probably either Captain Asa Tobey of the *Lagoda* or Captain Charles A. Bonney of the *Metacom*) had conservation interests in mind more for commercial than humanitarian reasons; nevertheless, his empathy with his quarry, the whale "as wild as the hunted deer," was unusual for its time.

2. Explorer Douglas (1904), quoted in Easdale, *Kairuri*, 160.

3. The moa, a large, flightless bird indigenous to New Zealand, was hunted to extinction by the Maori before the arrival of Europeans. If the early colonists were negligent of its fate, later poets and painters were not. About 1925 Trevor Lloyd (whose cartoons featuring the kiwi helped make it the national emblem) painted *The Death of a Moa* (Auckland City Art Gallery), a fanciful image of one (the last?) of the species mourned by a varied flock of native birds and Maori fairy figures. Allen Curnow was later moved to verse by the skeleton of the great moa in the Canterbury Museum, Christchurch:

> *Interesting failure to adapt on islands,*
> *Taller but not more fallen than I, who come*
> *Bone to his bone, peculiarly New Zealand's.*
>
>
>
> *Not I, some child, born in a marvellous year,*
> *Will learn the trick of standing upright here.*

Allen Curnow, "Attitudes for a New Zealand Poet (iii)," in *The Penguin Book of New Zealand Verse*, 205.

4. Herbert Guthrie-Smith, *Tutira: The Story of a New Zealand Sheep Station*, 3rd ed. (Edinburgh: William Blackwood & Son, 1953), ix. He realized, however, that "I am in advance of my time in relative values set on man and beast."

Guthrie-Smith's admission was made in the preface to the second edition (1926) of his book which, along with the original preface (1921), was included in subsequent printings, providing an ongoing authorial commentary on its success. Like Cotton's *Geomorphology*, which appeared the following year, Guthrie-Smith's "record of … change noted on one sheep station in one province … treated deliberately from a local point of view" won immediate acclaim among New Zealand readers and similarly seemed to answer some deep-seated need for attention to the familiar and the particular; "Original Preface," *Tutira*, vii.

5. Alfred Sharpe, "Hints for Landscape Students in Water-Colour," *Auckland Weekly News* (suppl.), November 11, 1882; quoted in Blackley, "Writing Alfred Sharpe," 2:47. Sharpe thought that by beginning "*de novo* at Nature's shrine," the artist might create something "worthy to be placed amongst works which will in the future be characterized as the 'In Memoriam' of what will then be our historical forests"; Sharpe, quoted in Brown and Keith, *Introduction to New Zealand Painting*, 22; Sharpe, "Hints for Landscape Students in Water-Colour, no. 11: General Notes," April 10, 1890, in Blackley, "Writing Alfred Sharpe," 2:68.

After relocating to Australia in 1887, Sharpe continued his environmental campaign. In addition to his concern for trees, he was agitated by "the extirpation of our native animals; although they are all unique of their kinds." His compassion went particularly to "our quaint little native bears." Noting that 3,784 koala skins had been sold the preceding week for a "miserable price," he protested that it was "a wicked waste of harmless and helpless animal life"; Sharpe, Letter to the editor re The Birds Protection Act, May 17, 1893; quoted in Blackley, "Writing Alfred Sharpe," 2:83–84.

City planners also drew his ire. When the local council announced plans to level the Hill Reserve in Newcastle, he again penned the editor, lamenting that the proposal was "doing away with all the romantic and picturesque features." Furthermore, the land reclamation project would alter the flow of breezes from the sea, and "bury the [music] rotunda in a damp and wind-swept gully"; Sharpe, Letter to the editor re Our Hill Reserve, June 29, 1892; quoted in Blackley, "Writing Alfred Sharpe," vol. 2 insert in Auckland City Art Gallery library copy, n.p.

Such an activism was, alas, rare among Sharpe's contemporaries.

6. Cole, "American Scenery," 100.

7. [Richard Biddle], *Captain Hall in America, by an American*; quoted in Bruce Robertson, "The Picturesque Traveler in America," in Nygren, *Views and Visions*, 206.

8. Isaac Weld, Jr., *Travels through the States of North America, and the Provinces of Upper and Lower Canada, during the Years 1795, 1796 and 1797* (1807); quoted by Robertson in Nygren, *Views and Visions*, 204–205. From his travels, Weld concluded that Americans "have an unconquerable aversion to trees."

A similar antipathy was found north of the border. "A Canadian settler hates a tree, regards it as his natural enemy, something to be destroyed, eradicated, annihilated by all and every means," wrote Anna James on visiting Ontario in the early nineteenth century; quoted in Brian S. Osborne, "The Iconography of Nationhood in Canadian Art," in *The Iconography of Landscape*, ed. Denis Cosgrove and Stephen Daniels (Cambridge: Cambridge University Press, 1988), 165.

9. William Strickland, *Journal of a Tour of the United States, 1794–1795*; quoted in Nygren, *Views and Visions*, 293. For Strickland's watercolor of *Ballston Springs* (The New-York Historical Society), see Nygren, *Views and Visions*, plate 153.

10. Fred Earp (1874), quoted in Gordon Brown, *Visions of New Zealand: Artists in a New Land* (Auckland: David Bateman, 1988), 123.

11. Guthrie-Smith, *Tutira*, 230.

12. Twain, quoted in Shillingsburg, *Mark Twain in Australasia*, 171.

13. Zane Grey, *Tales of the Fisherman's Eldorado: New Zealand*; quoted in Michael Dunn, "Frozen Flame & Slain Tree: The Dead Tree Theme in New Zealand Art of the Thirties and Forties," *Art New Zealand* 13 (1979): 40.

14. George Bernard Shaw, quoted in *Verdict on New Zealand*, ed. Desmond Stone (Wellington: A. H. & A. W. Reed, 1959), 136. Shaw and his wife visited New Zealand for four weeks in 1934.

15. Blanche E. Baughan, "A Bush Section," in *The Penguin Book of New Zealand Verse*, 104–111.

16. Eric Lee-Johnson, quoted in Dunn, "Frozen Flame & Slain Tree," 40.

17. Dunn, "Frozen Flame & Slain Tree," 43.

18. Barbara Novak, "The Double-Edged Axe," *Art in America* 64, no. 1 (January–February 1976): 50.

19. Nicolai Cikovsky, Jr., "'The Ravages of the Axe': The Meaning of the Tree Stump in Nineteenth-Century American Art," *Art Bulletin* 61, no. 4 (December 1979): 611.

20. In addition to Weston, Dunn might also have mentioned a veritable forest by artists in North America: Georgia O'Keeffe's writhing cedars and wizened maples; Alfred Stieglitz's bare boughs of chestnut; Charles Burchfield's blackened stands; the mournful tree with which Oscar Bluemner memorialized his late wife; eroded farmlands, filled with skeletal limb and bone by Alexandre Hogue, Jerry Bywaters, and other Dust Bowl painters; Paul Strand's studies of tortured limbs and roots; dead and weathered trees in Lake Superior country, a favorite motif of Lawren Harris and other Canadian nationalists; and more. Between the wars, a dead Birnham Wood to gallery came.

21. Dunn, "Frozen Flame & Slain Tree," 45.

22. Killeen's tree form in the "landscape" is undescribed, a negative image that is defined by the surrounding areas of white. This reversal results in an odd ghostly form, like a burned tree. The reversal of figure and ground may reflect another source in New Zealand tradition. Herbert Guthrie-Smith's *Tutira*, his record of life on a sheep station, includes an illustration of the "shape of fallen tree rediscovered by fire," recording the impression of the prone tree in the natural vegetation stimulated by its nutrients. This record of the past is undecipherable, except after a burn-off when its shape is rediscovered. Killeen, an inveterate collector of published images, would have known Guthrie-Smith's classic environmental history and perhaps recalled the illustration in his painting; see Guthrie-Smith, *Tutira*, 60.

For the dead-tree motif in contemporary art, see Francis Pound's insightful discussion of "The Stumps of Beauty & the Shriek of Progress," in *Art New Zealand* 44 (Spring 1987): 52–55, 104–105.

23. John Pascoe, "Photography in New Zealand," *Landfall* 1, no. 4 (December 1947): 302.

24. McCahon to John Casselberg; quoted in Tony Green, "McCahon and the Modern," in *Colin McCahon: Gates and Journeys*, 36. This letter has been often quoted in discussions of McCahon and especially his incorporation of writing into his imagery. The passage here cited ends with the famous declaration: "I will need words."

25. Cited in Elva Bett, "Inspiration from Parihaka," *New Zealand Listener*, November 7, 1981, 37.

26. Peter Cape, *New Zealand Painting since 1960: A Study in Themes and Developments* (Auckland: Collins, 1979), 90.

27. Robert Indiana, "Autochronology," in *Robert Indiana* (Philadelphia: Institute of Contemporary Art, University of Pennsylvania, 1968), 54.

28. Ellis, quoted in "Robert Ellis," *Vogue Australia*, November 1964, 42.

29. Conversation with the artist, Auckland, July 1990.

30. Ellis, quoted in *Vogue Australia*, 43.

31. *White's Pictorial Reference of New Zealand: Representative Airviews of New Zealand Cities and Boroughs* (Auckland: White's Aviation Ltd., 1960) remains a favorite book in many New Zealand homes and is avidly sought by bibliophiles. As early as 1950, Leo White had recognized his compatriots' taste and initiated publication of a series of "Air View Booklets."

Leslie Hinge was photographing Christchurch from overhead as early as 1918, in what were among the earliest – and perhaps the first – aerial views of New Zealand. One of his views, among the large collection of Hinge's photographs at the National Archives, Wellington, is captioned "Christchurch from Aeroplane, 2400 ft. Protected Leslie Hinge, 17/1/18" – an excursion that ended in a crash landing at the Addington racecourse!

32. John Pascoe, *New Zealand from the Air* (1968); quoted in Janet Bayly and Athol McCredie, *Witness to Change: Life in New Zealand* (Wellington: PhotoForum/Wellington Inc., 1985), 11.

33. Unlike some of his contemporaries in New Zealand, Ellis did not try to remain "unperverted" by foreign influence. "This growing sense of nationalism is quite absurd," he told an interviewer in 1974. "You can't just shut yourself off"; quoted in Colin Moore, "Wanted Art Freedom and Found It Here," *The Sunday Herald* [Auckland], February 3, 1974, 4.

Sensing Ellis's aesthetic kinship to artists in other places, the critic Peter Bromhead once lamented: "The frustration of these paintings for me is that I have the feeling Ellis is probably a very good abstract expressionist who hasn't quite been able to escape dehumanizing his subject as yet"; Bromhead, "It's Sheer Professionalism," *Auckland Star*, December 11, 1975.

34. Ellis explained that the Motorways paintings were often square and could therefore be hung in any direction, without a defined top or bottom; Peter Cape, "Robert Ellis: Viewing from a Distance What We're too Close to See," *National Business Review*, February 19, 1973, 7.

35. "Robert Ellis Answers Questions," *Barry Lett Galleries Newsletter* [Auckland], 6, no. 1 (October 13, 1965): n.p.

36. Mayor Robinson, quoted in "Art's Warning," *Auckland Star*, March 10, 1969. In his concluding remark, Mr. Robinson indicated perhaps the true reason for mayoral pique: "Look how much revenue is lost to the city by the land the roadways take."

37. Ellis, Statement for an exhibition; quoted in Gordon H. Brown, "Inside the Mount," *Auckland Star*, May 4, 1981, 25.

38. Ted Castle, "Conversation with Pat Steir (February 23, 1982)," in *Arbitrary Order: Paintings by Pat Steir* (Houston: Contemporary Arts Museum, 1983), 19, 22.

39. Marti Mayo, "Arbitrary Order: Paintings by Pat Steir," in *Arbitrary Order*, 6.

40. Rob Taylor, "Recent Exhibitions in Wellington," *Salient* [Victoria University, Wellington] (1985), 14; Clipping in National Art Gallery research files, Wellington.

41. John Pascoe, "Photography in New Zealand," *Landfall* 1, no. 4 (1947): 301–302. Pascoe's remark about fake clouds was likely directed toward the popular pictorialist George Chance (1885–1963), whose softly focused pastorales were often the result of manipulation in the darkroom. Chance freely admitted to "a certain amount of faking" in order to "assist [his] negative," darkening shadows, emphasizing contours, even inserting clouds in order to achieve the desired effect; see *George Chance: Photographs* (Dunedin Public Art Gallery, 1986), passim.

42. The landscape painter Don Binney, for example, is a defender of the native bush; he admits that "I only bother to enter a state forest when I want to relieve myself"; quoted in Blackley, *Two Centuries of New Zealand Landscape Art*, 98. The ceramic artist Barry Brickell, residing in the wild Coromandel country, complains that the Forest Service is "burning the young bush and planting pinus radiata because they want to make money!" Brickell, "The Hand Is more Important than the Brain," *Art New Zealand* 7 (August–October 1977): 38.

43. Peryer is a knowledgeable amateur in the field of New Zealand botany. He is also a gardener with a special interest in native plantings; he once ripped out the well-established landscaping at his Devonport home – roses, deciduous trees, and other exotics – and replanted the grounds in indigenous species. On another occasion, he created a fine native garden for two discerning collectors in Wellington, an achievement they regard as one of his finest works of art.

44. Peryer, quoted in Sheridan Keith, "A Desire to Understand," *New Zealand Listener*, February 7, 1981, 36.

45. These observations were made by the artist in conversations, March and July 1990. Except as otherwise noted, all quotes from the artist come from conversations and correspondence with the author, 1983–90.

46. Anne Noble, "Introduction," in *The Wanganui: Anne Noble*, special edition of *PhotoForum* [Auckland], 51–52 (September 1982): n.p.

47. Noble, quoted in Diana Bagnall, "Camera Captures River's Beauty," *New Zealand Herald* [Auckland], March 1, 1983, sect. 2, 1.

48. Noble, quoted in Bosworth, *The Wanganui*.

49. Sheridan Keith, "A Place of Potent Secrets," *New Zealand Listener*, October 9, 1982, 34.

50. James K. Baxter, "The Bay," in *The Penguin Book of New Zealand Verse*, 286.

51. Baxter, *Jerusalem Daybook*, 1971; quoted as preface to *The Wanganui*.

52. Noble, quoted in Bosworth, *The Wanganui*.

53. Noble, quoted in "Convent Life Featured in Noble Exhibition," *Wanganui Chronicle*, November 4, 1989.

54. *In the Forest of Dream* (Auckland: Moët & Chandon, New Zealand Art Foundation, 1990), 22.

▼

65

1. Conversations with the artist, July 1990.

2. Peryer, quoted in Keith, "A Desire to Understand," 36.

3. Artist's statements in *Photographs, Peter Peryer* (Auckland: Artspace, [1988]), n.p.

4. Alexa Johnston and Francis Pound, *NZ XI* (Auckland City Art Gallery, 1988), 8.

5. R. A. K. Mason, "Sonnet of Brotherhood," in *The Penguin Book of New Zealand Verse*, 162.

6. Charles Brasch, "The Islands (ii)," in *Collected Poems: Charles Brasch*, 17.

7. Johnston and Pound, *NZ XI*, 11.

8. Allen Curnow, "Landfall in Unknown Seas," in *The Penguin Book of New Zealand Verse*, 206. Peter Peryer was fond of quoting Curnow's lines in explaining his early portfolio *Mars Hotel* (1977), moodily expressive, poetic images of buildings and the dark land; Jim Barr and Mary Barr, *Peter Peryer Photographs* (Wanganui: Sarjeant Gallery, 1985), 25.

9. Killeen, Journal, quoted in Francis Pound, *Richard Killeen: Sampler, 1967–1990* (Auckland: Sue Crockford Gallery, 1990), 9.

10. Richard Killeen, Artist's statement, in *Seven Painters/The Eighties* (Wanganui: Sarjeant Gallery, 1982), 26.

11. Killeen, Artist's statement, in *Seven Painters/The Eighties*, 26.

12. Denis Glover, "Thoughts in the Suburban Tram," *Landfall* 20 (December 1951): 267.

13. Killeen, "Green Notebook," June 1969–March 1971, 44; quoted in Francis Pound, "Killeen's Suburbia," *Art New Zealand* 40 (Spring 1986): 48.

14. Luit Bieringa, as director of the National Art Gallery during the decade, was witness to the developments in New Zealand. He argues that in New Zealand, "non-Maori art has no specific tradition," and therefore "this lack of 'originals,' this art at 'second-hand,' has enabled us to move rapidly across the unmarked boundaries from modernism to post-modernism." Although important events preceded – including Killeen's discovery of the cutout – Bieringa dates the flowering of the postmodernist attitude in New Zealand to September 1984, with the simultaneous exhibitions in New York of *Te Maori* (The Metropolitan Museum of Art) and *Primitivism in 20th-Century Art* (Museum of Modern Art). Those shows both received considerable attention in New Zealand and "occasioned our own in-house debate about cultural context, influences, co-option and (mis-)appropriation. While the debate rages (largely unseen) in some quarters and is ignored conveniently in others, the re-writing of the relevant contexts and 'sites' of action relating to cultural property (physical or mental) is inevitable from this point onwards"; Luit Bieringa, *Content/Context: A Survey of Recent New Zealand Art* (Wellington: National Art Gallery, 1986), 12–13.

It is no surprise, then, that recent exhibitions in New Zealand of work by Cindy Sherman and Barbara Kruger, quintessential American postmodernists, have excited great attention among artists and critics, even more so than larger shows of Monet and Picasso presented at approximately the same time.

15. Killeen, Artist's statement, in *Seven Painters/The Eighties*, 26.

16. Watson's turn to the city was due, she explains, to the family's loss of the farm in an economic downturn. She explains this rupture with family traditions in a matter-of-fact tone, with no trace of regret or judgment passed on either "artificial" city or "natural" farm life; Conversations with the artist, July 1990. Except as otherwise noted, all quotes from the artist come from these conversations.

17. Watson, quoted in Alan Seymour, "Misrepresenting Her Art," *Evening Post*, February 24, 1988, 20. As she continued her reminiscences of art school, it is clear that they were not happy ones: "Their idea of someone who paints is you've got to chuck a lot of oil paint around – with as much oomph and straining and beer cans at hand as possible. That's a real artist – someone who paints with his penis. They've a pseudo-pretense of being interested in women, but that's if they slosh a lot of oil paint around too. If you imitate as much as possible the degree of slosh and arc of the spurting paint then you might make it into the club."

18. The subject might also be a reminiscence of personal history for the artist. The games were promoted (somewhat redundantly) as "educational & instructive" and found many buyers among parents eager for their children's improvement.

19. Killeen (1975), quoted in Pound, *Killeen: Sampler*, 11.

20. The wall-mounted dimensional object covers the constructed "skeleton" with a collage of Xerox, tissue, gauze and with paint; the surface is drawn on and coated with resins. The *Mappa Mundi* gives "mixed media" new meaning and, like its maker, is hard to categorize. "Drawing, painting, printmaking – artists are just artists," Watson protests; quoted in Seymour, "Misrepresenting Her Art."

21. Watson, quoted in Seymour, "Misrepresenting Her Art."

22. Stephen Zepke, "Repetitions: Toward a Re-construction of Phallic Univocality," *Antic* 7 (June 1990): 54.

23. Dore Ashton, quoted in *William T. Wiley* (Berkeley: University Art Museum, Univerity of California, 1971), 8.

24. William T. Wiley's journal ("Hides Log – How to Chart a Coarse"), in *William T. Wiley*, 37.

Jasper Johns's incorporation of actual rulers into his paintings, as well as similar devices for measurement of the abstract – "clock hands" of wooden strips, human arms describing a Vitruvian circle – were known to his admirer in Christchurch and possibly provided additional inspiration for Watson's measured "equator." In *Out the Window No. 2*, 1962, Johns moved the ruler across the wet pigment, its passage smear-ing and obscuring the field. Watson's striped line likewise anchors the viewer in the familiar "real" world (or its map) while obscuring the meaning of the image beneath it.

25. Watson's ship, once prominent in her design, has been partially obscured in her subsequent transformations of the work.

26. The large fingerprint, looming like a dark contour map in the third panel from the right, may refer to the tradition of gestural expression and autography received from the New York School painters. As with their distinctive strokes, or with Johns's hand and body prints, Watson has left her mark writ large upon the work.

27. Ruth Watson, Artist's statement, for *Drawing Analogies* (Wellington City Art Gallery, 1987), 48.

28. Miro Bilbrough, "Six Pack Ideas into Shifting Ground Show," *The Evening Post* [Wellington], February 9, 1989.

29. Lita Barrie, "Blurring the Distinctions of Modernism," *National Business Review*, February 5, 1988, 31.

PLATES

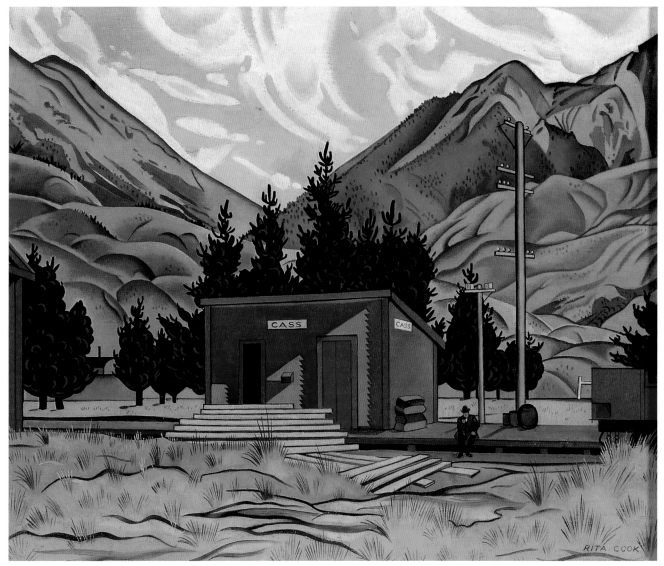

Rita Angus, *Cass,* 1936.
Oil on canvas, 376 x 474 mm.
(14¾ x 18¾ inches).
Robert McDougall Art Gallery,
Christchurch.

Rita Angus
Central Otago, 1940.
Oil on board, 350 x 548 mm.
(13¾ x 21½ inches).
Auckland City Art Gallery
Collection. Bequest of Mrs. Joyce
Milligan, in memory of the late Dr.
R. R. D. Milligan, 1987.

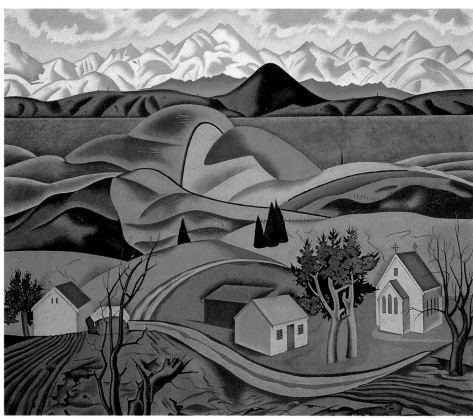

Rita Angus
Landscape with Arum Lily, 1953.
Oil on board, 520 x 424 mm.
(20½ x 17 inches).
Private collection, Wellington.

Edward Fristrom
Motutapu, ca. 1908.
Oil on canvasboard, 234 x 280 mm.
(9¼ x 11 inches).
Auckland City Art Gallery
Collection. Purchased 1969.

Edward Fristrom
A Cloudy Day, Palliser Bay.
Oil on canvasboard, 230 x 272 mm.
(9 x 10¾ inches).
The Wilson/Larsen family, in
memory of Minnie F. White.

Edward Fristrom
Pumpkin Cottage. Oil on
canvasboard, 272 x 250 mm.
(10¾ x 9¾ inches).
Sarjeant Gallery, Wanganui.

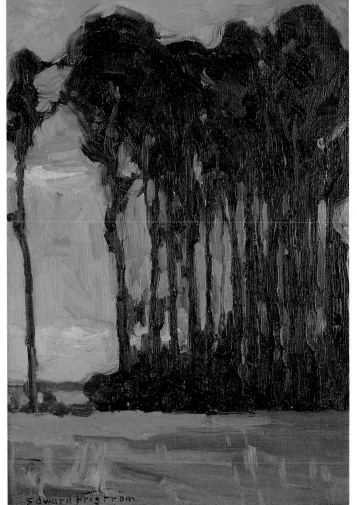

Edward Fristrom
A Decorative Effect, Masterton.
Oil on canvasboard, 266 x 183 mm.
(8¾ x 7¼ inches).
Private collection.

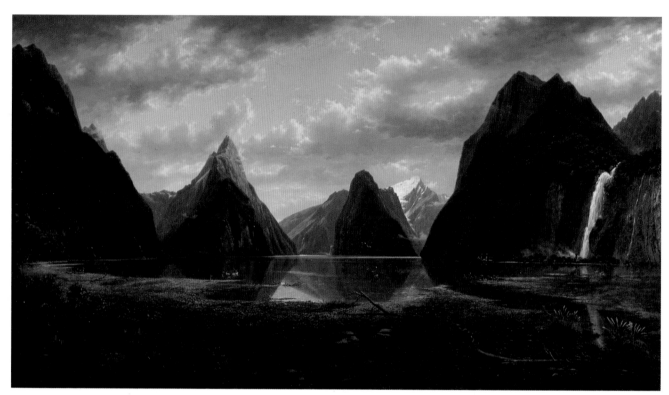

Eugene von Guérard
Milford Sound with Pembroke Peak and
Bowen Falls on the West Coast of Middle
Island, New Zealand, 1877–79.
Oil on canvas, 992 x 1760 mm.
(39 x 69¼ inches).
Art Gallery of New South Wales,
Sydney, Australia.

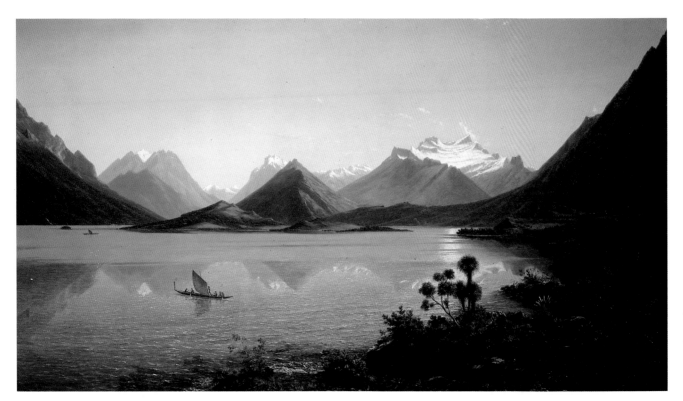

▼

79

Eugene von Guérard
Lake Wakatipu with Mount Earnslaw,
Middle Island, New Zealand, 1877–79.
Oil on canvas, 991 x 1765 mm.
(39 x 69½ inches).
Auckland City Art Gallery.
Mackelvie Trust Collection, 1971.

▼
80

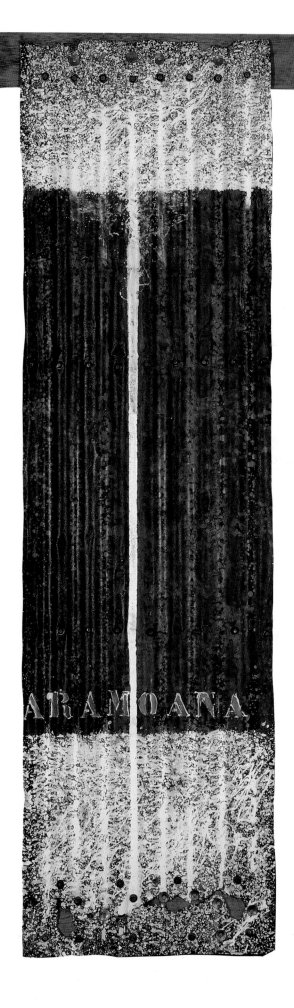

Ralph Hotere
Te Whiti Series (2):
Te Paepaepapatanga o te Rangi
(The place where the sky hangs
down to the horizon), 1972.
Oil on paper, 680 x 392 mm.
(26¾ x 15½ inches).
Private collection, Perth,
Western Australia.

Ralph Hotere
Aramoana – Pathway to the Sea, 1980.
Oil on corrugated iron,
2400 x 100 x 50 mm.
(94½ x 39⅜ x 2 inches).
The Bath-House,
Rotorua's Art and
History Museum.

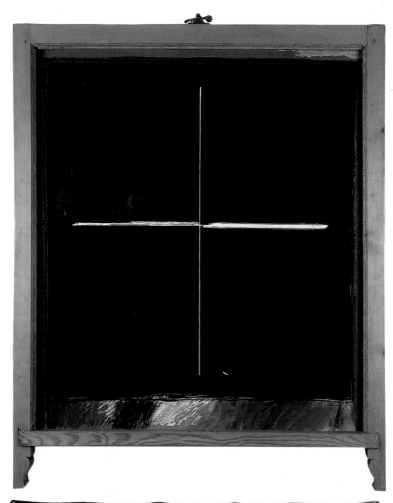

Ralph Hotere
Black Window – Towards Aramoana,
1981. Acrylic on board,
561 x 764 mm. (22 x 27¾ inches).
Chartwell Collection, Centre for
Contemporary Art, Hamilton.

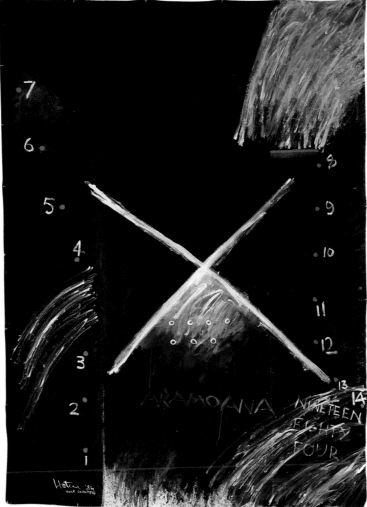

Ralph Hotere
Aramoana–Nineteen eighty four, 1984.
Acrylic on canvas,
2440 x 1830 mm. (96 x 72 inches).
Chartwell Collection, Centre for
Contemporary Art, Hamilton.

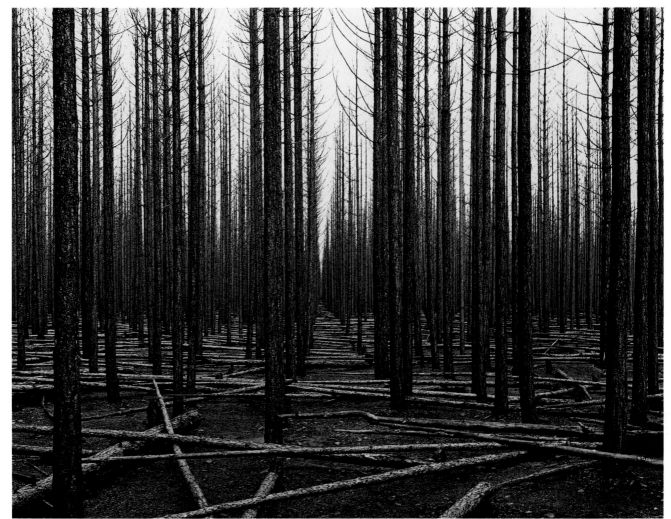

▼
82

John Johns
Burnt Pine Forest, Canterbury, 1955.
Silver print, 400 x 508 mm.
(15¾ x 20 inches).
Auckland City Art Gallery
Collection. Purchased 1976.

John Johns
*Clear Felled Settings,
Kaiangaroa Forest*, 1960.
Silver print, 406 x 508 mm.
(16 x 20 inches).
Collection of the artist. Courtesy
New Zealand Forest Service.

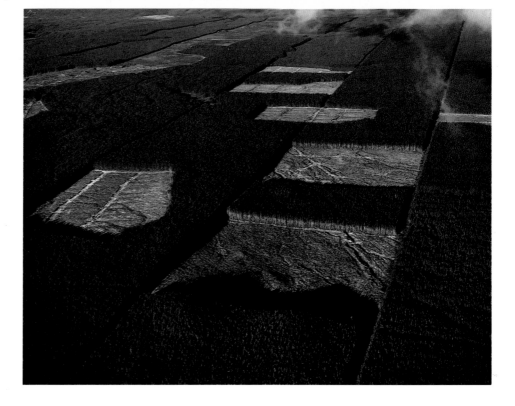

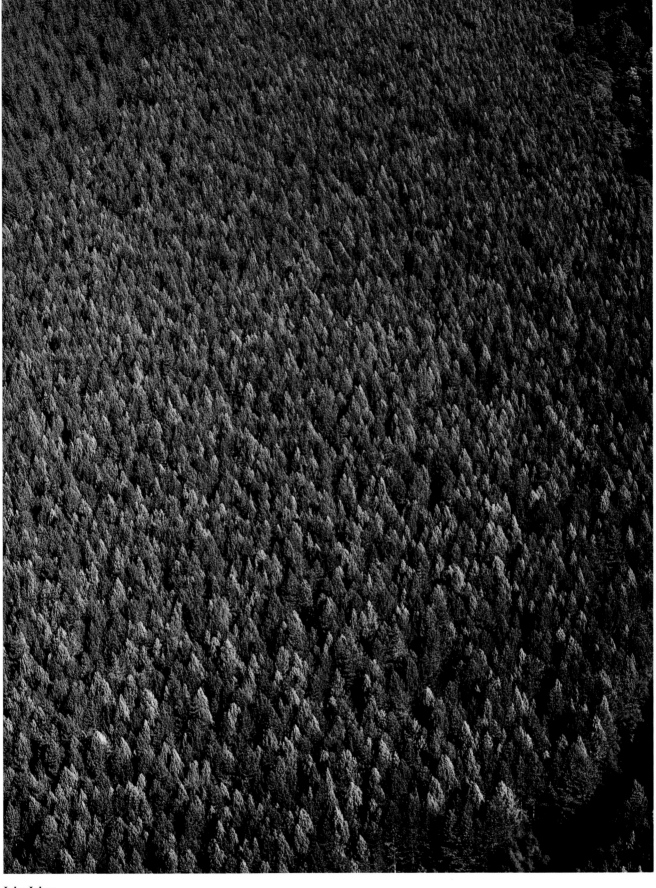

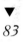

John Johns
Aerial View of Radiata Pine, Golden Downs Forest, 1959.
Silver print, 508 x 406 mm.
(20 x 16 inches) Exhibition print.
Collection of the artist. Courtesy
New Zealand Forest Service.

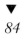

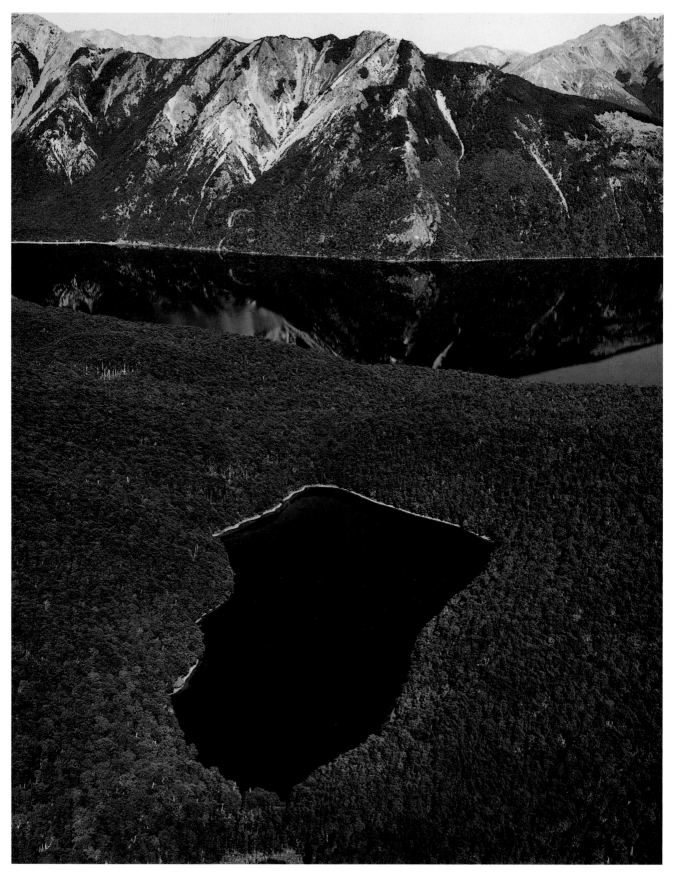

John Johns
Lake Marion and Lake Sumner Forest
Park, Canterbury, 1971.
Silver print, 508 x 406 mm.
(20 x 16 inches).
Collection of the artist.Courtesy
New Zealand Forest Service.

John Johns
Lake Sumner Forest, Canterbury, 1972.
Silver print, 508 x 406 mm.
(20 x 16 inches).
Collection of the artist. Courtesy
New Zealand Forest Service.

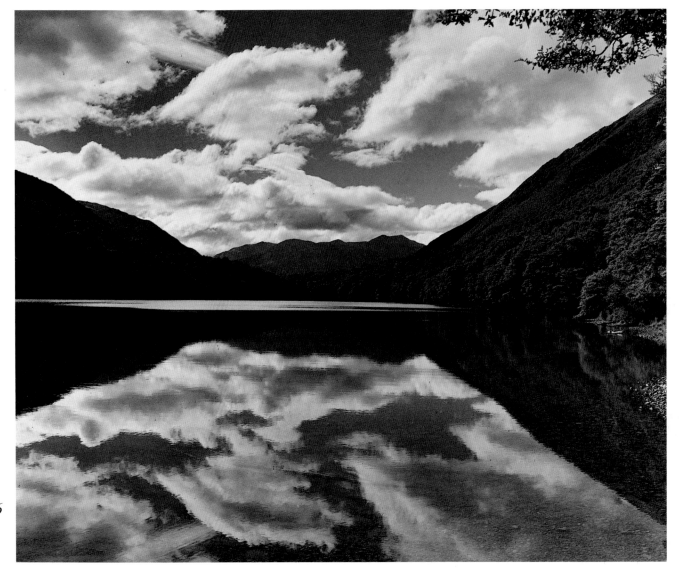

John Johns
*Lake Marion from the Southern Edge,
Canterbury,* 1972.
Silver print, 406 x 451 mm.
(16 x 17¾ inches).
Collection of the artist. Courtesy
New Zealand Forest Service.

John Johns
Pylons, 1975.
Silver print, 508 x 400 mm.
(20 x 15¾ inches).
Collection of the artist.
© John Johns.

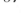

John Johns
*Tussock Grassland Viewed from
Lindis Pass, Canterbury,* 1980.
Silver print, 432 x 406 mm.
(17 x 16 inches).
Collection of the artist. Courtesy
New Zealand Forest Service.

JOHN JOHNS

Richard Killeen
Hillsborough, 1967. Synthetic
polymer resin on canvas,
455 mm. diam.
(17¾ inches; sight).
Hocken Library, University of
Otago, Dunedin, New Zealand.

▼

88 **Richard Killeen**
Man Reading a Newspaper, 1967.
Oil on canvas, 775 x 775 mm.
(30½ x 30½ inches).
Sarjeant Gallery, Wanganui.

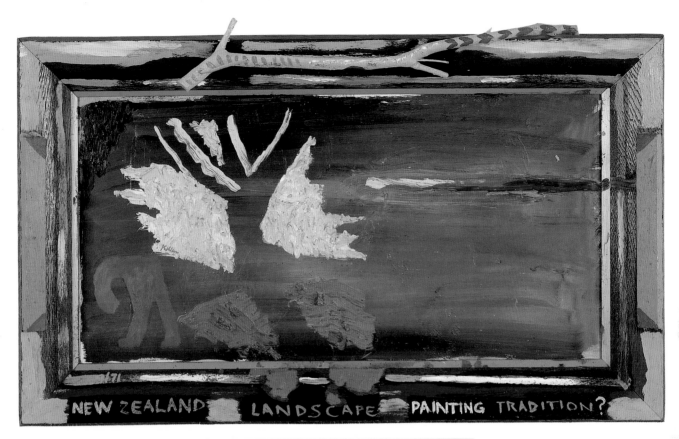

Richard Killeen
New Zealand Landscape Painting Tradition?, 1971.
Oil on hardboard, with wooden branch, 420 x 723 mm.
(16½ x 28½ inches).
Collection of Richard Killeen and Margareta Chance.

▼

Richard Killeen
Primordial, 1979.
Acrylic lacquer on aluminum (4 units), 1000 x 1000 mm., variable (39⅜ x 39⅜ inches).
Private collection.

Richard Killeen
Island Mentality No. 1, 1981.
Alkyd on aluminum (33 units),
3000 x 4000 mm., variable
(118 x 157½ inches).
Bank of New Zealand.

Richard Killeen
*Born Alive in New Zealand
(for Samuel)*, 1985.
Alkyd on aluminum (11 units),
2000 x 2000 mm., variable
(78¾ x 78¾ inches).
Collection of Richard Killeen and
Margareta Chance.

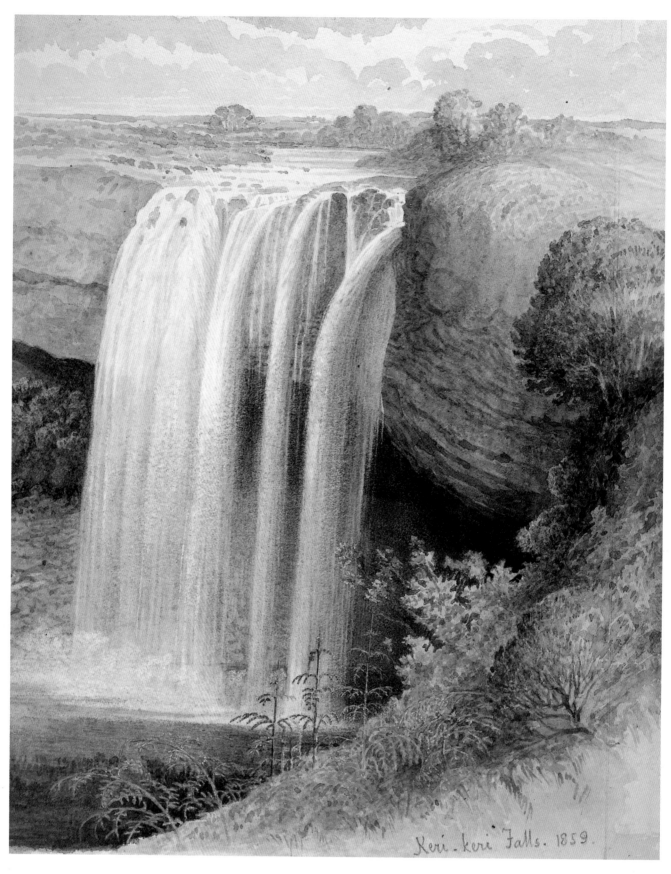

Keri-keri Falls. 1859.

John Kinder
Kerikeri Falls, 1859.
Watercolor on paper,
254 x 198 mm. (10 x 7¾ inches).
Auckland City Art Gallery
Collection. Presented by
Harold A. Kinder, 1937.

▼
92

John Kinder
Te Tarata, The White Terraces,
Lake Rotomahana, 1866.
Watercolor on paper, 248 x 354
mm. (9¾ x 14 inches).
Dr. Ferrier-Watson Collection.
Waikato Museum of Art
and History, Hamilton.

Crater of Pouerua. Pakaraka. Jan 11. 1874. Three separate craters

John Kinder
Crater of Pouerua, Pakaraka,
January 11, 1874:
Three Separate Craters.
Watercolor on paper,
185 x 366 mm. (7¼ x 14⅜ inches).
Auckland City Art Gallery
Collection. Presented by
Harold A. Kinder, 1937.

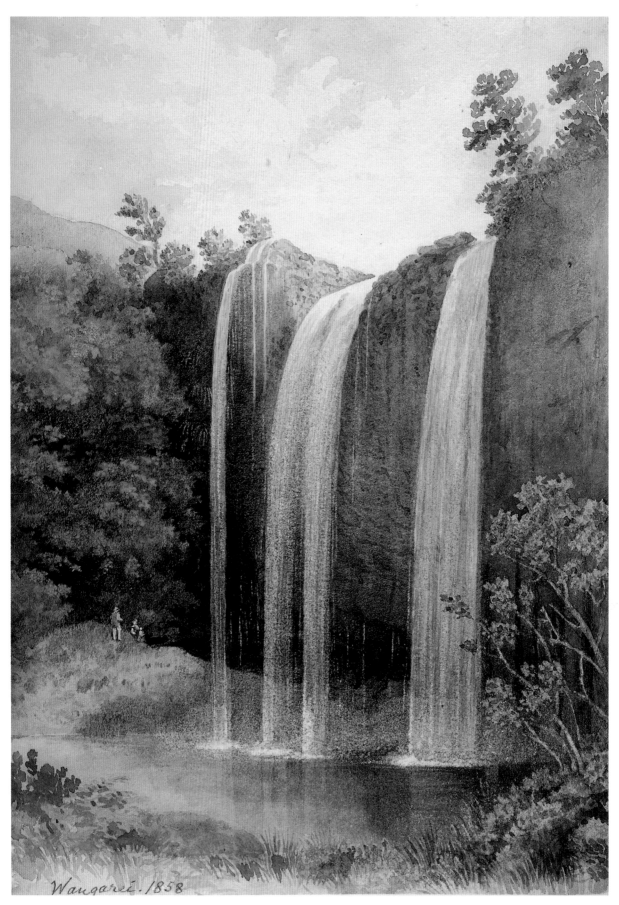

94

John Kinder
Whangarei Falls, 1858.
Watercolor on paper.
294 x 206 mm. (11½ x 8⅛ inches).
Auckland City Art Gallery
Collection. Presented by
Harold A. Kinder, 1937.

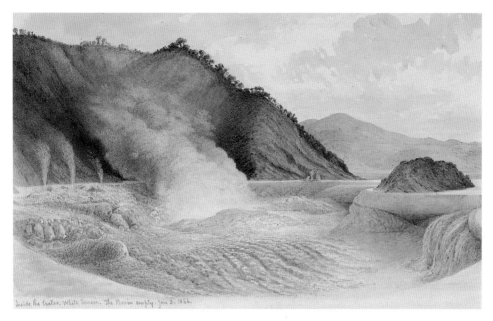

John Kinder
White Terraces: Inside the Crater with the Basin Empty, 1866.
Watercolor on paper,
248 x 354 mm. (9¾ x 14 inches).
Dr. Ferrier-Watson Collection.
Waikato Museum of Art
and History, Hamilton.

John Kinder
*Crater of Pouerua, Pakaraka,
Bay of Islands: View Taken
from the Highest Point,* 1874.
Watercolor on paper,
154 x 344 mm. (6 x 13½ inches).
Auckland City Art Gallery
Collection. Presented by
Harold A. Kinder, 1937.

▼
95

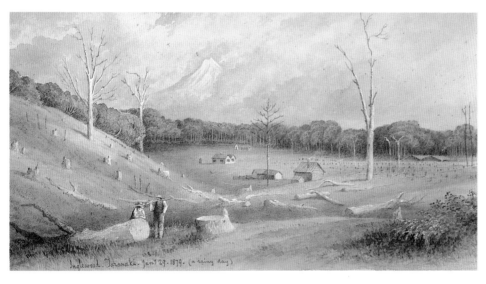

John Kinder
*A Rainy Day, Inglewood,
Taranaki: January 19, 1879.*
Watercolor on paper,
182 x 335 mm. (7⅛ x 13⅛ inches).
Auckland City Art Gallery
Collection. Presented by
Harold A. Kinder, 1937.

John Kinder
The Railway Tunnel under the
Grammar School, Auckland, 1865.
Albumen print, 177 x 216 mm.
(7 x 8½ inches).
Hocken Library, University of
Otago, Dunedin, New Zealand.

John Kinder
Cliffs with Pohutukawa Trees,
Whangaparaoa, near Auckland.
Albumen print, 228 x 188 mm.
(9 x 7⅜ inches).
Hocken Library, University of
Otago, Dunedin, New Zealand.

▼

John Kinder
In Hobson's Gully, Auckland, 1866.
Albumen print, 204 x 276 mm.
(8 x 10⅞ inches).
Hocken Library, University of
Otago, Dunedin, New Zealand.

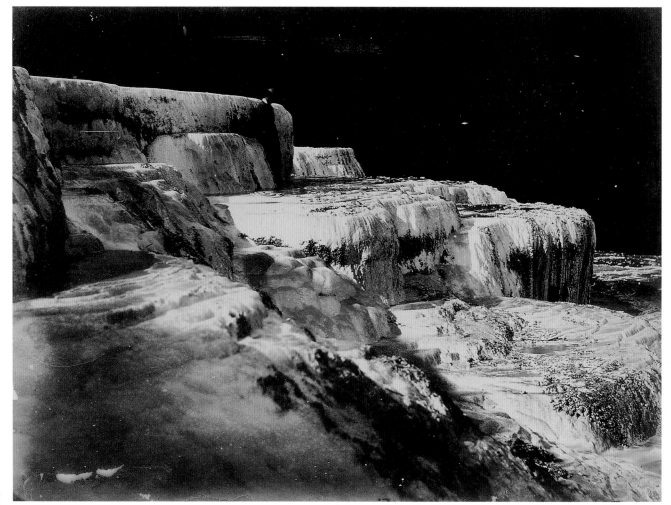

John Kinder
Otukapuarangi, Lake Rotomahana,
1865. Albumen print,
183 x 247 mm. (7¼ x 9¾ inches).
Hocken Library, University of
Otago, Dunedin, New Zealand.

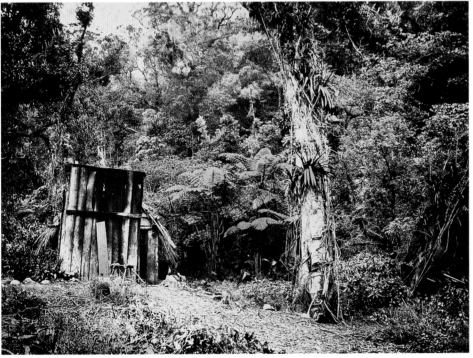

John Kinder
Kohunui Rock (Frenchman's Cap),
Whangaparaoa.
Albumen print, 202 x 290 mm.
(8 x 11⅜ inches).
Hocken Library, University of
Otago, Dunedin, New Zealand.

John Kinder
Bush Scene, Coromandel, 1868-69.
Albumen print, 213 x 277 mm.
(8⅜ x 10⅞ inches).
University of Auckland Art
Collection, The University
of Auckland.

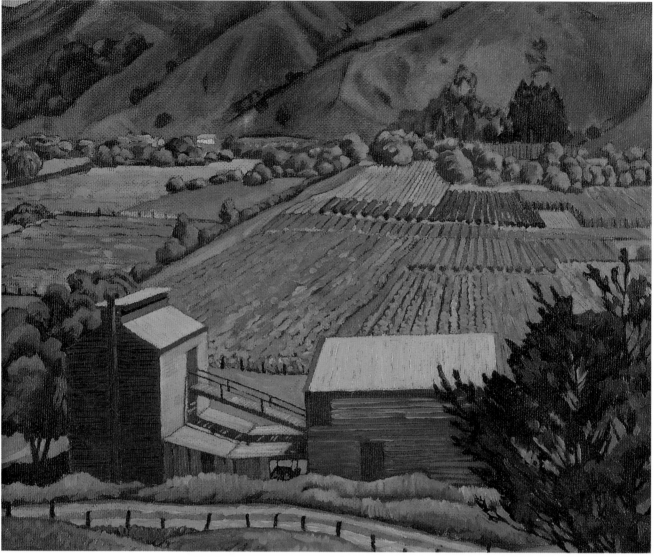

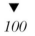
100

Doris Lusk
Tobacco Fields, Nelson, N.Z., 1941.
Oil on board, 509 x 604 mm.
(20 x 23¾ inches).
Hocken Library, University
of Otago, Dunedin, New Zealand.
Given by Charles Brasch, 1963.

Doris Lusk
Gold Dredging, Central Otago, 1938.
Oil on canvas on board,
386 x 455 mm. (15¼ x 18 inches).
Hocken Library, University
of Otago, Dunedin, New Zealand.
Given by the artist, 1979.

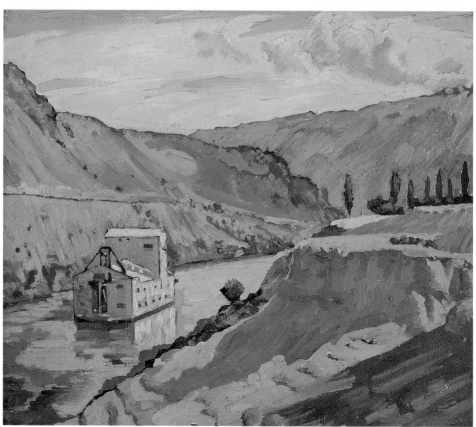

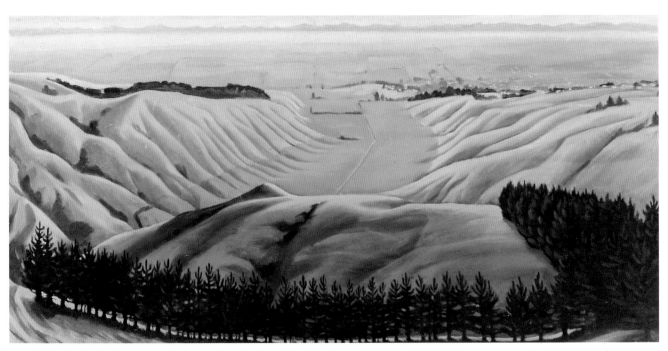

Doris Lusk
Canterbury Plains from the Cashmere Hills, 1952. Oil on textured hardboard, 608 x 1220 mm. (23⅞ x 48 inches).
Robert McDougall Art Gallery, Christchurch.

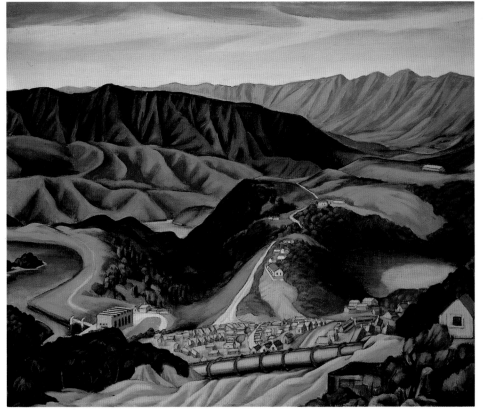

Doris Lusk
Overlooking Kaitawa, Waikaremoana, 1948. Oil on board, 575 x 688 mm. (22⅝ x 27 inches).
Robert McDougall Art Gallery, Christchurch.

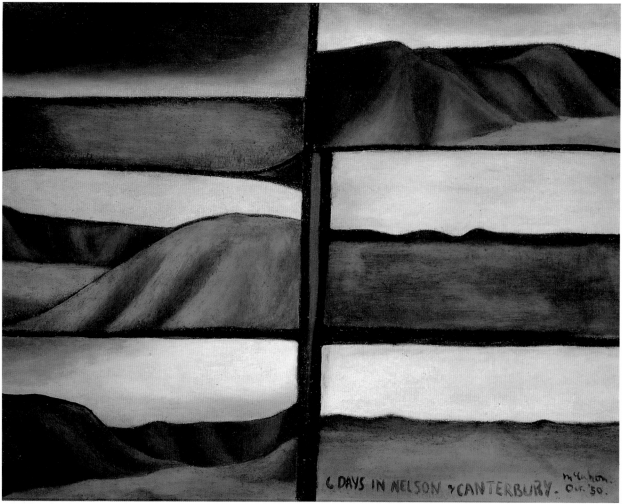

Colin McCahon
Six Days in Nelson and Canterbury, 1950.
Oil on canvas, 885 x 1165 mm.
(34⅞ x 45⅞ inches).
Auckland City Art Gallery Collection.
Presented by the Friends of the
Auckland City Art Gallery as a gift from
the artist, 1978.

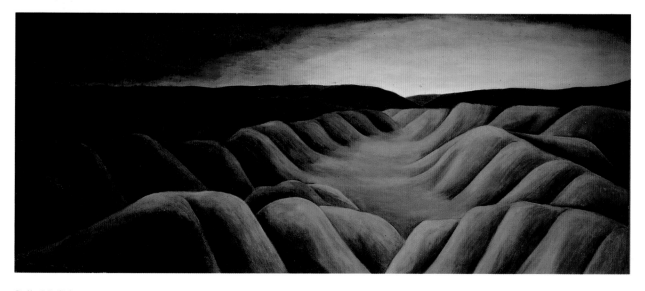

Colin McCahon
Takaka: Night and Day, 1948.
Oil on canvas, 915 x 2130 mm.
(36 x 83⅞ inches).
Auckland City Art Gallery Collection.
Presented by the Rutland Group, 1958.

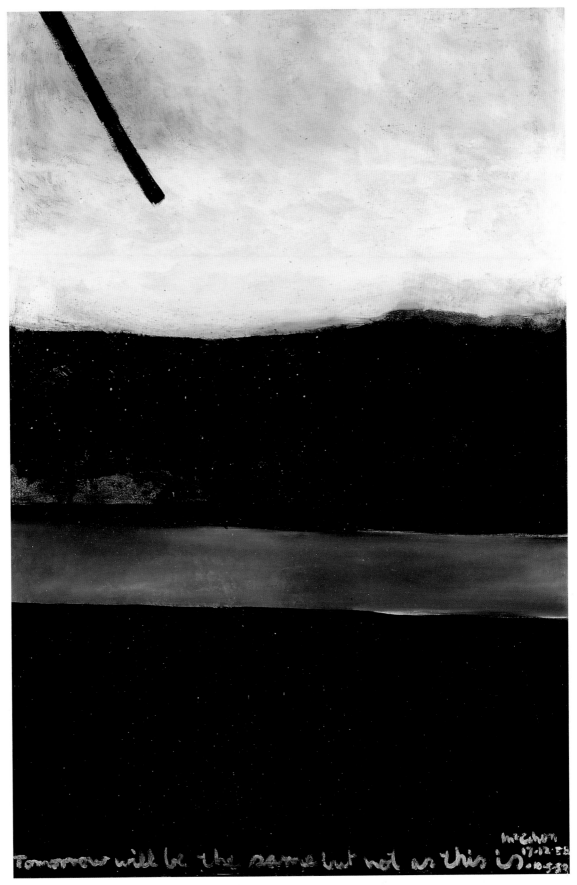

Colin McCahon
*Tomorrow will be the same but not as
this is,* 1958–59.
Solpah and sand on board,
1824 x 1217 mm.
(71¾ x 47⅞ inches).
Robert McDougall Art Gallery,
Christchurch.

COLIN McCAHON

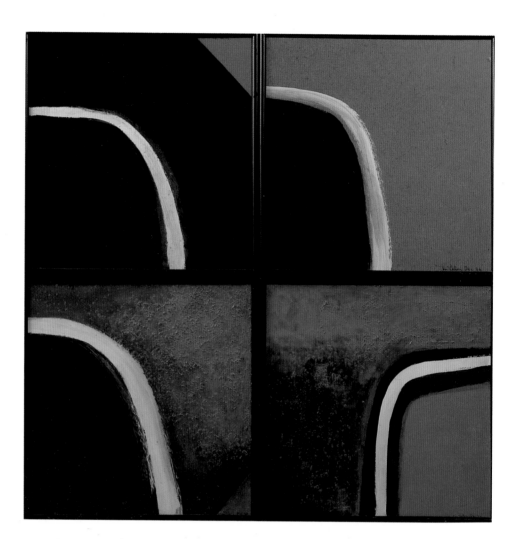

Colin McCahon
Four Waterfalls, 1964.
Acrylic on board, 630 x 630 mm.
(24¾ x 24¾ inches).
Manawatu Art Gallery,
Palmerston North.

Colin McCahon
*As there is a constant flow of light we
are born into the pure land,* 1975.
Enamel on board, 598 x 1800 mm.
(23½ x 70⅞ inches).
Robert McDougall Art Gallery,
Christchurch.

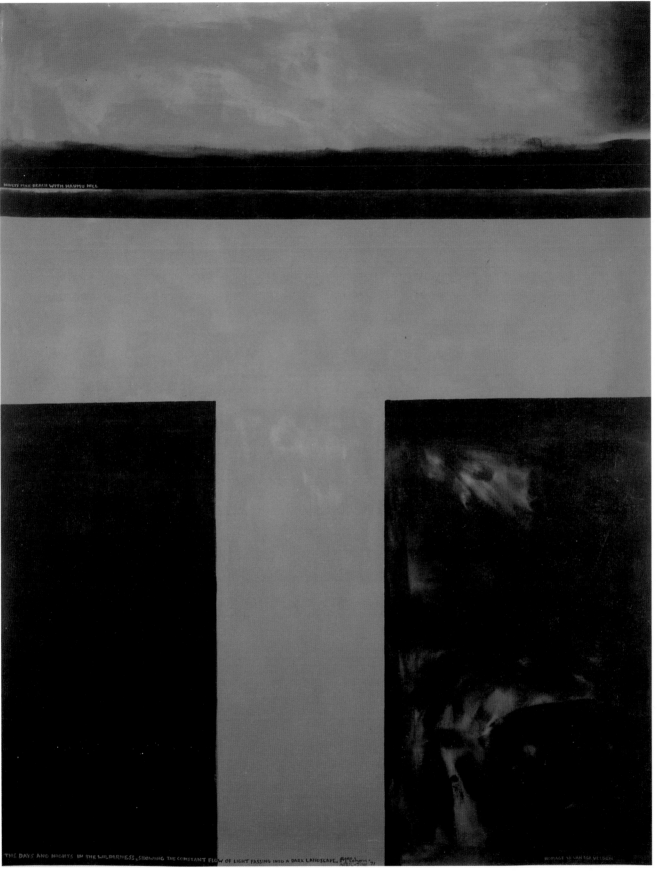

Colin McCahon
The Days and Nights in the Wilderness,
1971.
Acrylic on canvas, 2360 x 1840 mm.
(92⅞ x 72½ inches).
Govett-Brewster Art Gallery,
New Plymouth.

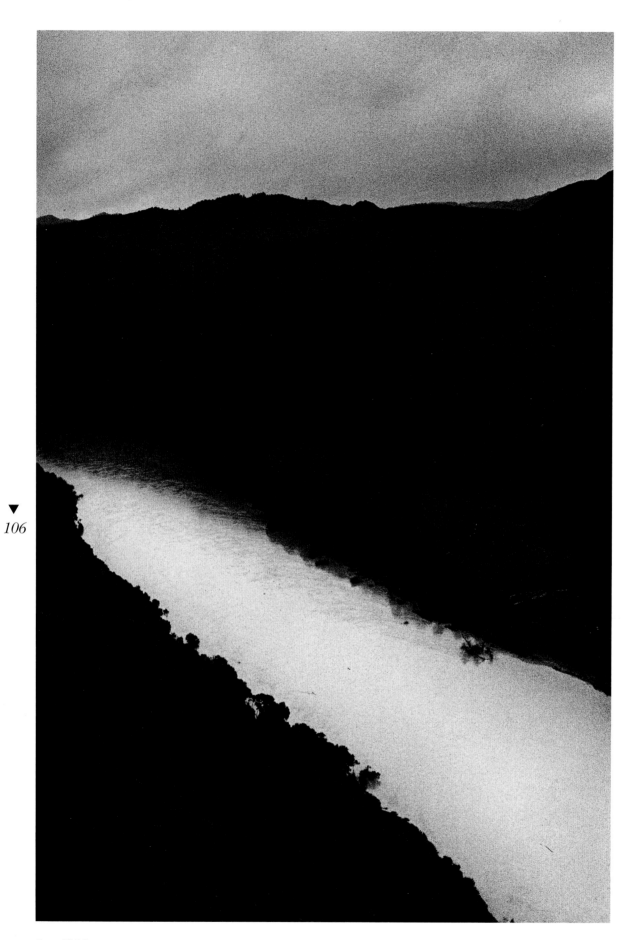

Anne Noble
Wanganui series:
From Gentle Annie, 1980.
Silver print, 290 x 191 mm.
(11⅜ x 7½ inches; sight).
Sarjeant Gallery, Wanganui.

PACIFIC PARALLELS: ARTISTS AND THE LANDSCAPE IN NEW ZEALAND

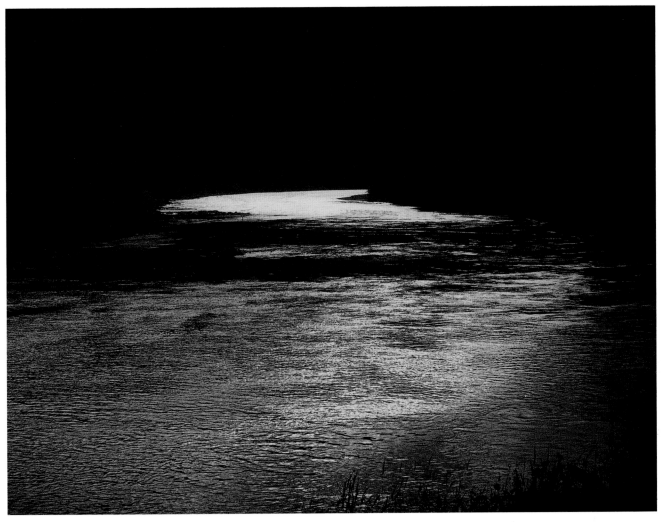

Anne Noble
Wanganui series:
Paparoa Rapid, Pipiriki, 1981.
Silver print, 221 x 327 mm.
(8¾ x 12⅞ inches; sight).
Sarjeant Gallery, Wanganui.

Anne Noble
Wanganui series:
Otukopiri, Koroniti, 1981.
Silver print, 196 x 291 mm.
(7¾ x 11½ inches; sight).
Sarjeant Gallery, Wanganui.

Anne Noble
Wanganui series:
The Road to Tawhata, Upper Reaches,
1982. Silver print, 134 x 318 mm.
(5¼ x 12½ inches).
Sarjeant Gallery, Wanganui.

108

Anne Noble
Wanganui series:
The Bridge to Nowhere,
Mangapurua Valley, 1982.
Silver print, 134 x 317 mm.
(5¼ x 12½ inches).
Sarjeant Gallery, Wanganui.

Anne Noble
SONG ... without Words:
Swan No. 1, 1989–90. Silver print,
257 x 388 mm. (10⅛ x 15¼ inches).
Collection of the artist.

Anne Noble
SONG ... without Words:
Swan No. 2, 1989–90. Silver print,
255 x 1165 mm. (10 x 45⅞ inches).
Collection of the artist.

Anne Noble
SONG ... without Words:
Swan No. 3, 1989–90. Silver print,
248 x 1145 mm. (9¾ x 45 inches).
Collection of the artist.

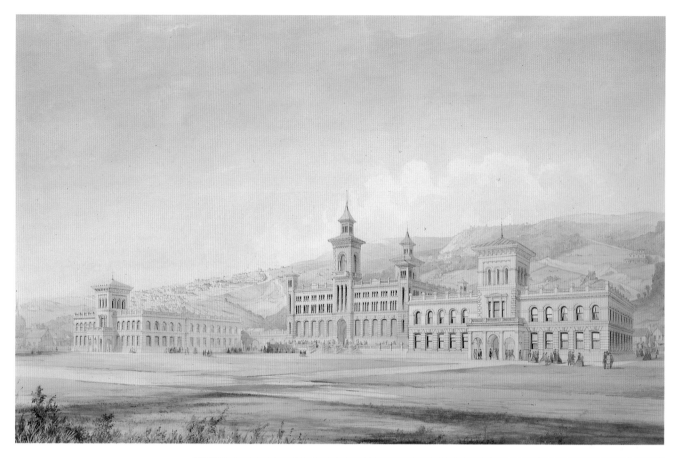

George O'Brien
Dunedin Exhibition Buildings, 1865.
Watercolor on paper,
657 x 1041 mm. (25⅞ x 41 inches).
Otago Early Settlers' Association
Museum, Dunedin.

110

George O'Brien
Water of Leith Brewery, ca. 1865.
Watercolor on paper,
245 x 345 mm.
(9⅝ x 13½ inches; sight).
Otago Early Settlers' Association
Museum, Dunedin.

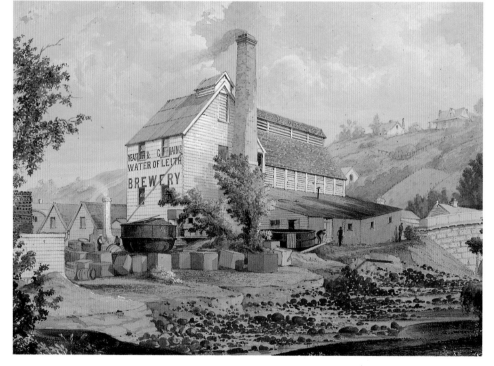

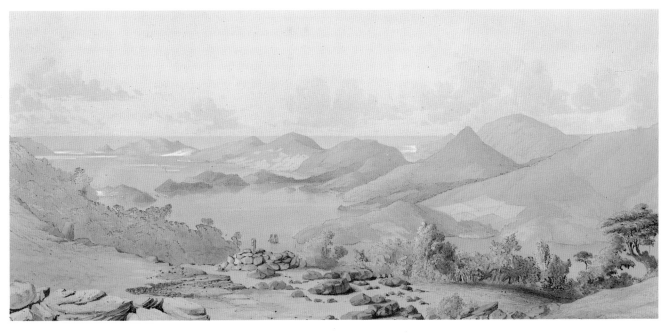

George O'Brien
*View of the Otago Peninsula with
Harbour Cone and Mt. Charles
from the Slopes of Mt. Cargill,* 1866.
Watercolor on paper,
530 x 447 mm. (20⅝ x 17⅝ inches).
(Also known as *Dunedin Harbour
Lower Harbour.*)
Otago Early Settlers' Association
Museum, Dunedin.

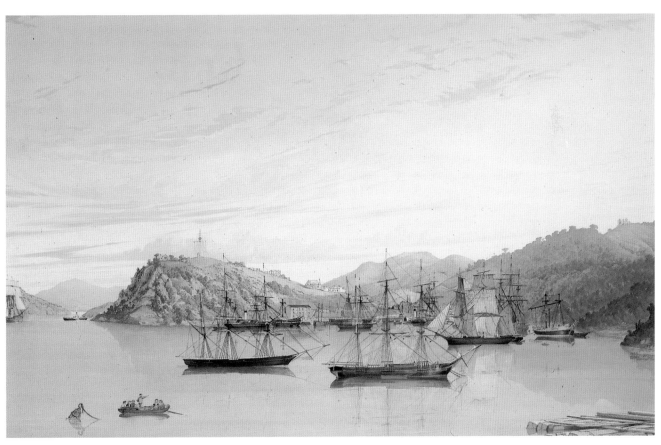

George O'Brien
Port Chalmers, 1868.
Watercolor on paper,
624 x 962 mm. (24½ x 37⅞ inches).
Otago Early Settlers' Association
Museum, Dunedin.

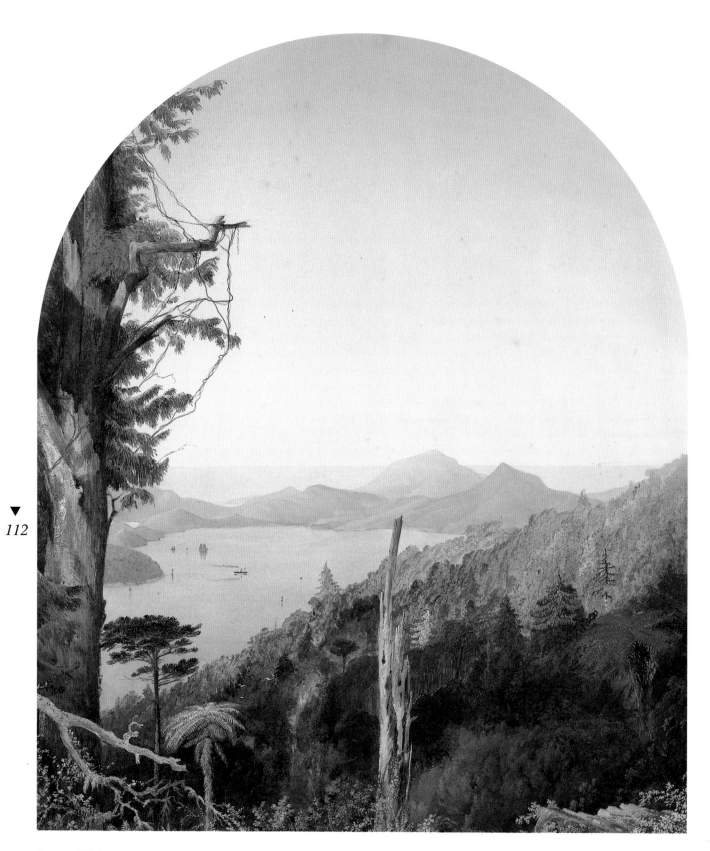


112

George O'Brien
Dunedin Harbour: View of Entrance to
Harbour from Highcliff Road, 1866.
Watercolor on paper,
436 x 600 mm.
(17⅛ x 23⅝ inches).
Otago Early Settlers' Association
Museum, Dunedin.

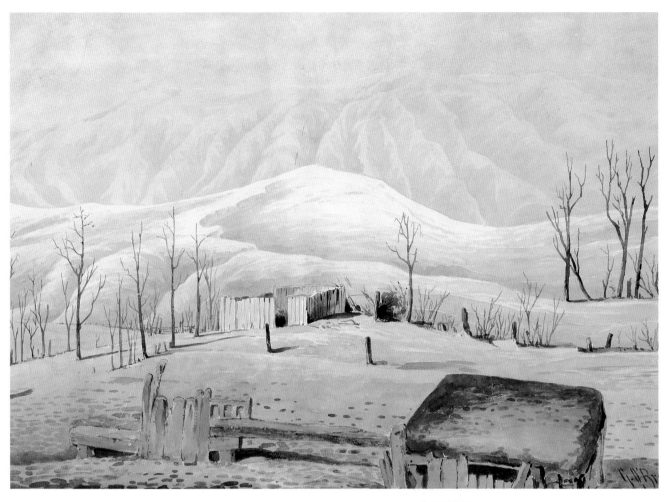

George O'Brien
Mt. Tarawera after Eruption, 1886,
ca. 1886. Watercolor on paper,
568 x 819 mm. (22⅜ x 32¼ inches).
Otago Early Settlers' Association
Museum, Dunedin.

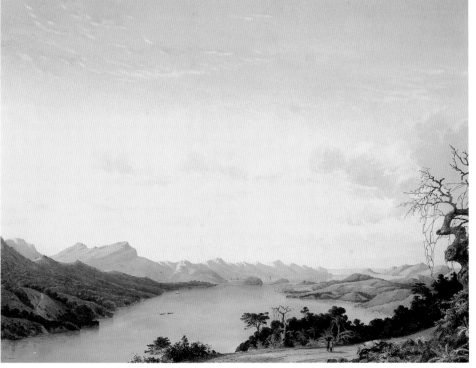

George O'Brien
*View of Otago Heads and
Port Chalmers from Signal Hill
near Dunedin,* ca. 1866.
Watercolor and pencil with china
white on paper, 288 x 634 mm.
(11⅜ x 25 inches).
Dr. T. M. Hocken Collection.
Hocken Library, University of
Otago, Dunedin, New Zealand.

▼
114

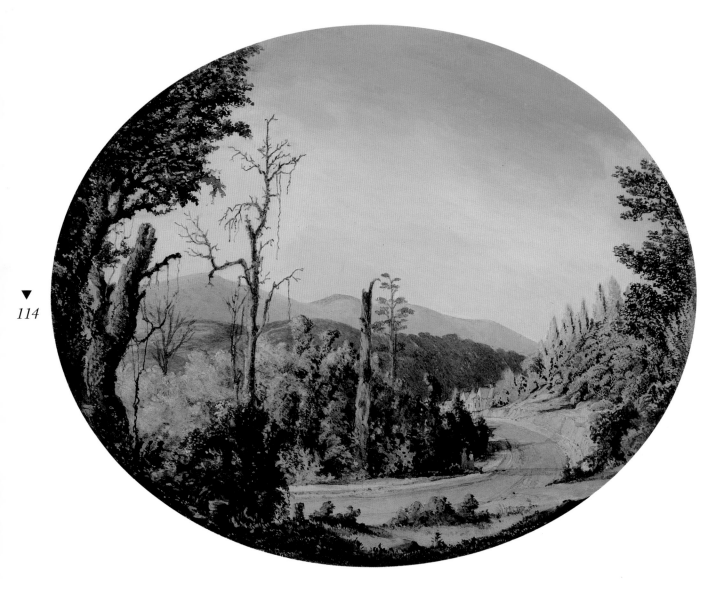

George O'Brien
Leith Valley, Dunedin, ca. 1884–87.
Watercolor on paper,
229 x 278 mm.
(9⅛ x 10⅞ inches; sight).
Sarjeant Gallery, Wanganui.

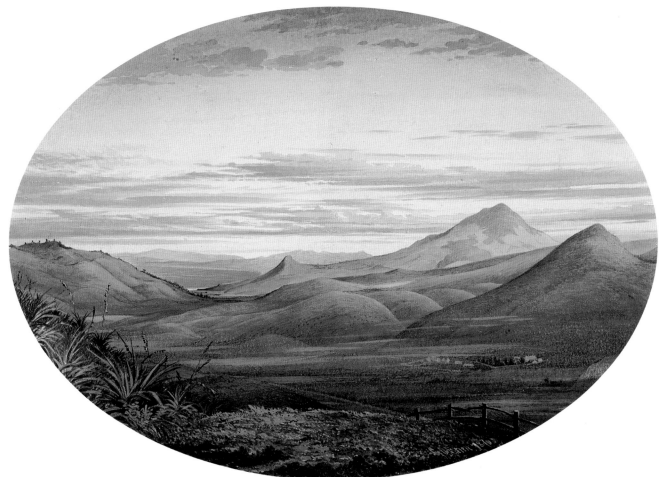

George O'Brien
Otago Landscape [Saddle Hill
and Kaikorai Estuary], 1870.
Watercolor on paper,
241 x 349 mm. (9½ x 13¾ inches).
Collection National Art Gallery,
New Zealand.

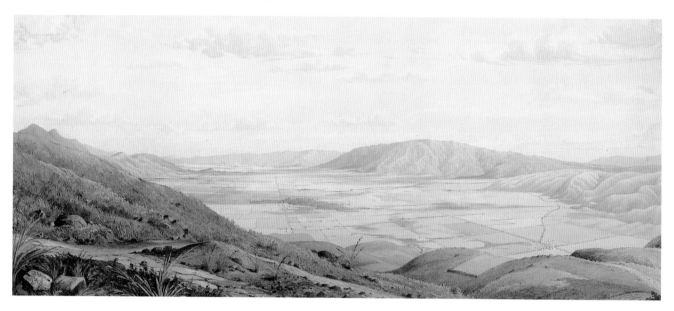

George O'Brien
The Taieri Plains, Taken from the
Upper or Halfway Bush Road Leading
Down to the North Taieri, 1867.
Watercolor on paper,
292 x 704 mm. (11½ x 27¾ inches).
Hocken Library, University of
Otago, Dunedin, New Zealand.

▼
116

George O'Brien
Designs of R. A. Lawson, late 1860s.
Watercolor on paper,
742 x 1300 mm.
(29¼ x 51⅛ inches).
Otago Early Settlers' Association
Museum, Dunedin.

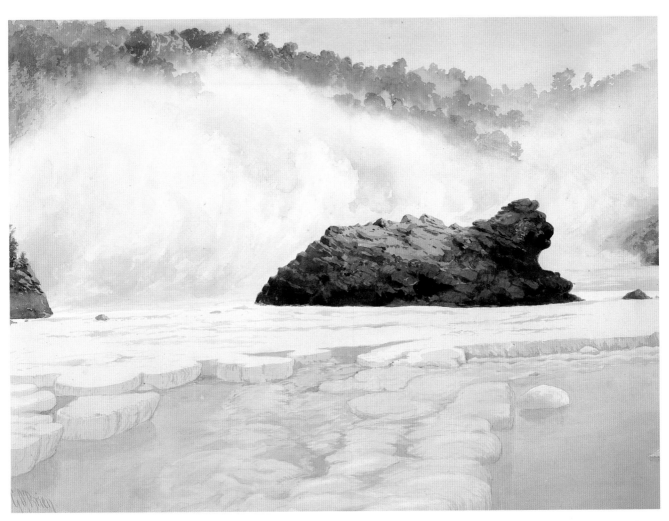

▼
117

George O'Brien
*Mt. Tarawera, Floating Pumice after
Eruption, 1886, at Lion Rock, Lake
Rotomahana,* 1886–88.
Watercolor on paper,
571 x 776 mm.
(22½ x 30½ inches; sight).
Otago Early Settlers' Association
Museum, Dunedin.

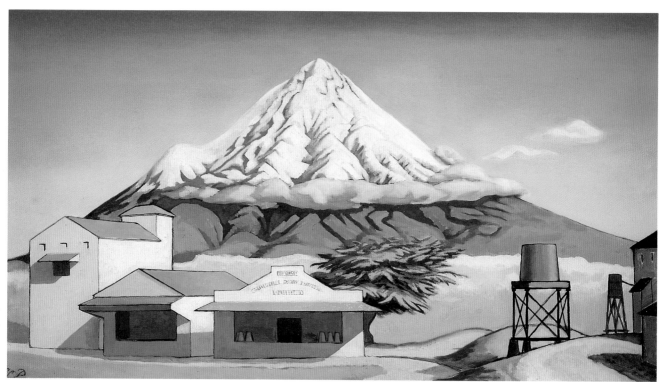

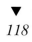

Christopher Perkins
*Taranaki,*1931.
Oil on canvas, 505 x 912 mm.
(19⅞ x 35⅞ inches).
Auckland City Art Gallery
Collection. Purchased 1968.

Christopher Perkins
Frozen Flames, 1931.
Oil on canvas, 690 x 610 mm.
(27⅛ x 24 inches).
Auckland City Art Gallery
Collection. Presented by the
Friends of the Auckland City
Art Gallery, 1962.

CHRISTOPHER PERKINS

Peter Peryer
Frozen Flame, 1982. Silver print,
420 x 280 mm. (16½ x 11 inches).
Collection of the artist.

▼
120

Peter Peryer
Kiokio, 1984. Silver print,
287 x 208 mm. (11¼ x 8¼ inches).
Sarjeant Gallery, Wanganui.

Peter Peryer
Bluff, 1985.
Silver print, 360 x 355 mm.
(14⅛ x 14 inches).
Collection National Art Gallery,
New Zealand.

Peter Peryer
Black Nerita, Buckleton Bay, 1988.
Silver print, 363 x 359 mm.
(14¼ x 14⅛ inches).
Auckland City Art Gallery
Collection. Purchased 1988.

Peter Peryer
Pouerua, 1988. Silver print,
220 x 220 mm. (8⅝ x 8⅝ inches).
Collection of the artist.

Peter Peryer
Moeraki Boulder, 1988. Silver print,
355 x 355 mm. (14 x 14 inches).
Collection of the artist.

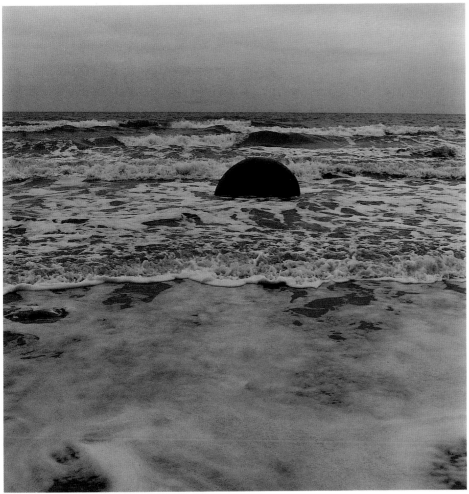

Peter Peryer
Ruapehu, 1988. Silver print,
335 x 335 mm.
(13¼ x 13¼ inches).
Collection of the artist.

▼

124 **Peter Peryer**
Toetoe, 1986. Silver print,
350 x 350 mm.
(13¾ x 13¾ inches).
Collection of the artist.

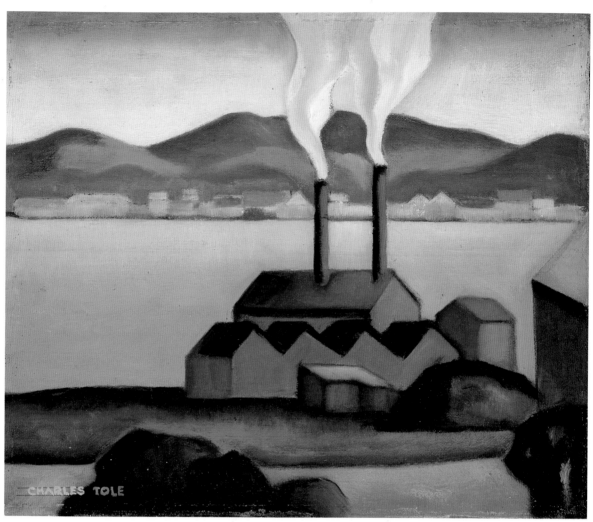

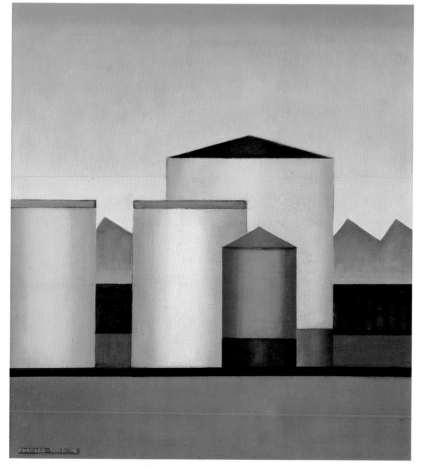

Charles Tole
Industry, 1944. Oil on canvas,
257 x 304 mm. (10⅛ x 12 inches).
Auckland City Art Gallery
Collection. Purchased 1989.

Charles Tole
Oil Tanks, 1976. Oil on board,
502 x 454 mm. (19¾ x 17⅞ inches).
Hocken Library, University of
Otago, Dunedin, New Zealand.
Bought with the assistance of the
Queen Elizabeth II Arts Council of
New Zealand.

Charles Tole
Landscape with Marae, 1983–84.
Oil on board, 422 x 610 mm.
(16⅝ x 24 inches).
Harold R. Jones, Esq.

Charles Tole
Waimangu, Waikato Stream, ca. 1957.
Oil on board, 440 x 550 mm.
(17⅜ x 21⅝ inches).
Ministry of External Relations
and Trade.

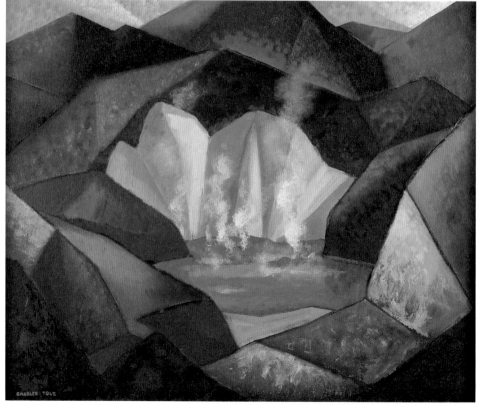

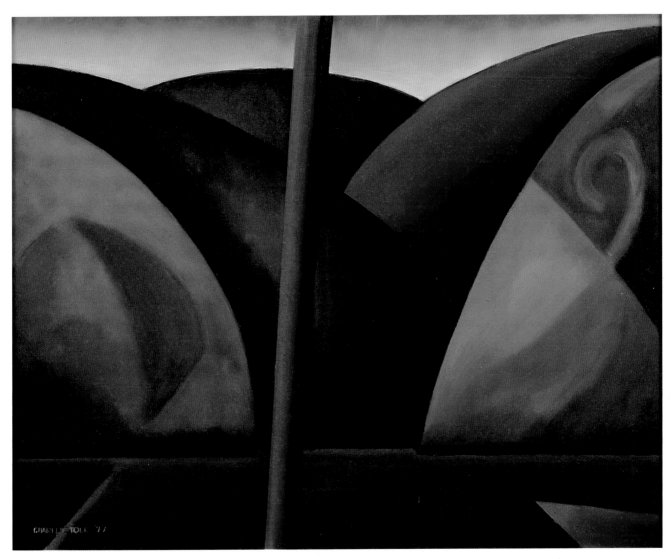

Charles Tole
Landscape with Red Stanchion, 1977.
Oil on board, 445 x 560 mm.
(17½ x 22 inches).
A. T. and J. B. Gibbs collection.

Ruth Watson
Mappa Mundi, 1988–89.
Mixed media; 12 units,
each 2000 x 340 mm.
(78¾ x 13⅜ inches).
Collection of the artist. Courtesy
Sue Crockford Gallery, Auckland.

Ruth Watson
Tour of New Zealand, 1989. Acrylic
and mixed media on canvas on
board, 1300 x 1340 mm.
(51⅛ x 51¾ inches).
Private collection.

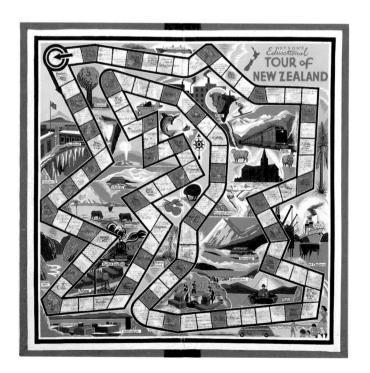

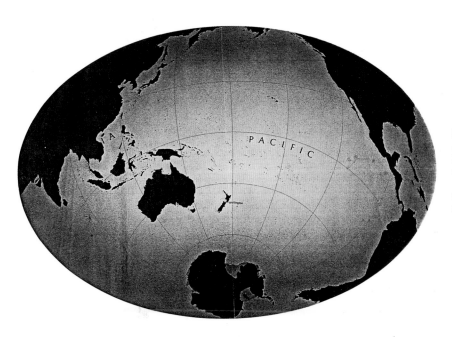

Ruth Watson
Another Map of the World, 1989.
Photocopy of altered "found" map
on paper, 365 x 470 mm.
(14⅜ x 18½ inches).
Collection of the artist. Courtesy
Sue Crockford Gallery, Auckland.

Chronology: Making New Zealand

The Beginning

My mother was the Earth.

My father was the Sky.

They were Rangitane and Papatuanuku, the first parents, who clasped each other so tightly that there was no day. Their children were born into darkness. They lived among the shadows of their mother's breasts and thighs and groped in blindness among the long black strands of her hair.

Until the time of separation and the dawning of the first day.

Witi Ihimaera, *Tangi*
(Auckland: Heinemann, 1973), 204.

▼
130

▼
131

Fig. 1. **Cliff Whiting**, *Te Wehenga o Rangi Raua ko Papa,* 1969–76. Mural. National Library of New Zealand, Wellington.

Locating New Zealand

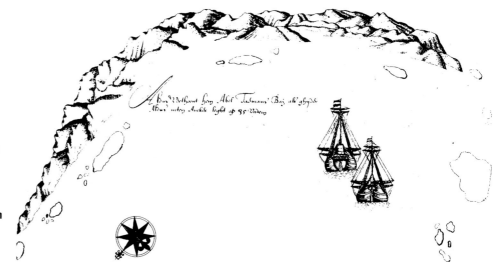

Ca. 800
One or more groups of East Polynesian explorers discover and settle in New Zealand. Over the centuries they evolve a complex and sophisticated Maori culture. Through fires and clearance for agriculture they initiate changes to the landscape that gradually remove parts of the forest and begin erosion.

1642
Two Dutch ships under the command of Abel Tasman anchor in what is now Golden Bay near the northwest tip of the South Island. This, the first recorded contact between Maori and European, ends in violence. The place is named Murderer's Bay.

▼ **1769**
132
The *Endeavour* commanded by the Englishman James Cook arrives off the east coast of the North Island. Through March of the following year he circumnavigates the country and maps its coastline. The artists and scientists on this and his later expeditions, including Sydney Parkinson, record the land and people. He leaves gifts of seeds and animals.

1771
Benjamin Franklin develops a plan to send an expedition to the inhabitants of New Zealand, "not to cheat them, not to rob them, not to seize their lands, or enslave their persons; but merely to do them good." The expedition does not take place.

Towards the middle of the day we saw a great land uplifted high.
Abel Tasman made the first recorded European sighting of New Zealand on December 13, 1642.

I've just taken up my pen again after stopping to ruminate and fill my pipe. When you pause at midnight in this house, the landscape comes in through the windows and sends something exciting down your spinal column. Out there are the plateau, the cincture of mountains, the empty sparkling air. To the north, more mountains, a plain, turbulent straits, another island, thirteen thousand miles of sea and at the far end, you.
Ngaio Marsh, *Died in the Wool* (Auckland: Collins, 1944), 250.

If a girl hit the ball a great distance, when my mother's mother played hockey at school in Norwich during the eighteen-seventies, she was said to have "hit it to New Zealand."
Keith Sinclair, "Life in the Provinces," in his *Distance Looks Our Way: The Effects of Remoteness on New Zealand* (Paul's Book Arcade for the University of Auckland, 1961), 27.

A virgin countryside cannot be restocked; the vicissitudes of its pioneers cannot be re-enacted; its invasion by alien plants, animals, and birds cannot be repeated; its ancient vegetation

Fig. 2. Attributed to **Isaac Gilsemans**, *Thus appears Abel Tasman's Bay when lying at anchor in 35 fathoms,* 1642. Engraving. Alexander Turnbull Library.

cannot be resuscitated – the words terra incognita have been expunged from the map of little New Zealand.
W. H. Guthrie-Smith, *Tutira: The Story of a New Zealand Sheep Station* (Edinburgh and London: William Blackwood & Sons, 1953), vii.

So this is New Zealand was the thought in our minds as our transport glided through busy Waitemata Harbour. This is the "Land Down Under" where the summer comes in winter, and winter in

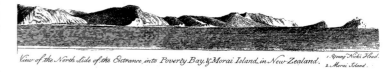

View of the North Side of the Entrance into Poverty Bay, & Morai Island, in New Zealand. 1. Young Nicks Head. 2. Morai Island.

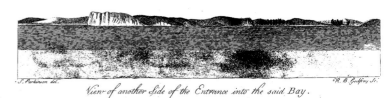

View of another Side of the Entrance into the said Bay.

Fig. 3. After **Sydney Parkinson**, *Views of the Entrance into Poverty Bay,* 1769. Engraving, 1773. Alexander Turnbull Library.

summer, where the sun is in the north at midday and everyone drives on the wrong side of the street.

From "Pacific Diary" privately printed by the 25th Construction Battalion, United States Navy Veterans, in **Henry Bioletti,** *The Yanks Are Coming: The American Invasion of New Zealand, 1942-1944* (Auckland: Century Hutchinson, 1989).

Wellington, our port of debarkation, was a red-roofed city on hills surrounding a splendid bay. It had for me a distinctly foreign look, different from any city I had ever seen before; a clean cold tidy look, severe and substantial.

Zane Grey, *Tales of the Angler's El Dorado* (London: Hodder and Stoughton, 1926), 24.

Take an atlas....

Now turn to the map of the world. Tucked away down in the south, separated from Australia and America by miles upon miles of blue sea water, you'll find three funny little crinkly islands which look as if the waves had been nibbling, mouselike, at their coasts for countless centuries. These three comprise the Dominion of New Zealand, and that is where we live, and where I am going to take you for a while.

Esther Glen, *Six Little New Zealanders* (London: Cassell, 1917), 1.

If it would not look too much like showing off, I would tell the reader where New Zealand is; for he is as I was; he thinks he knows. And he thinks he knows where Herzegovina is; and how to pronounce *pariah*; and how to use the word *unique* without exposing himself to the derision of the dictionary. But in truth he knows none of these things.

Mark Twain, *Mark Twain in Australia and New Zealand* (Harmondsworth, Eng.: Penguin, 1973), 251.

Fig. 5. Map used in an educational booklet about the relations between New Zealand and the United States for the New Zealand armed forces during World War II.

1797
Sealers arrive from the American vessel Mercury. *By 1806 one American vessel alone carries a cargo of 60,000 skins to Port Jackson, Australia.*

1804
Foveaux Strait between the South Island and Stewart Island is discovered by the American sealing captain Owen F. Smith.

1814
Samuel Marsden establishes the first mission station in the Bay of Islands. More missions are set up in the northern North Island in the following years. Traders begin to dominate the European presence.

▼

133

Fig. 4. The world from New Zealand. Ministry of External Relations and Trade.

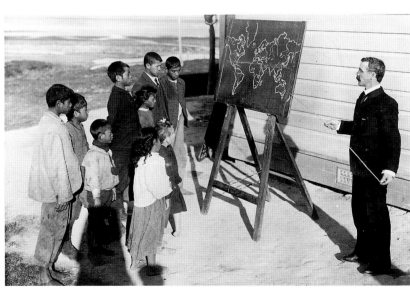

Fig. 6. **Arthur Northwood**, *A Geography Lesson*, ca. 1910. Northwood Collection, Alexander Turnbull Library.

Describing New Zealand

▼
134

The country was the grandest that can be imagined. How often have I sat on the mountain-side and watched the waving downs, with the two white specks of huts in the distance, and the little square of garden behind them; the paddock with a patch of bright green oats above the huts, and the yards and wool-sheds down on the flat below; all seen as through the wrong end of a telescope, so clear and brilliant was the air, or as upon a colossal model or map spread out beneath me.

Samuel Butler, *Erewhon; or, Over the Range* (Auckland: Golden Press, 1973), 20.

In my young day we used to be asked to draw "a map of New Zealand." I always traced mine – inaccurately of course, for somehow this was cheating. But the result only showed a great emptiness within.

Denis Glover, "Thoughts in the Suburban Tram," *Landfall* 20 (December 1951): 267.

Alas that native names should have been replaced by Mount Eden, Wellington, Hobson, Smart! – as if *we* were that smart people who would have changed them to

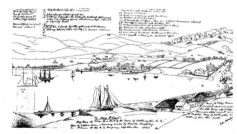

Fig. 7. **T. Allom,** after **Charles Heaphy** (draftsman to the New Zealand Company), A key plan to part of the town of Wellington, 1841. Ink. Hocken Library, University of Otago, Dunedin, New Zealand.

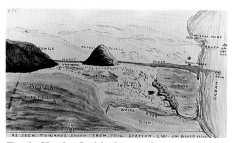

Fig. 8. **Charles Smith,** Survey drawing of part of the lower west coast of the South Island, ca. 1880. Department of Survey and Land Information District Office, Hokitika.

Mount One, Two, and so on. And the islands in and around the harbour had better have been called A, B, C Islands, rather than change Motu Korea to *Brown's* Island. What a blessed thing that Rangitoto has escaped the sacrilege of being named for ever perhaps "Two-Pap Peak Hill"! Had it been smitten with such an indignity the very name would have marred the beauty of that island's lovely outline, and the landscape would not have been the same with such hideous words paining the ear.

J. Logan Campbell, *Poenamo: Sketches of the Early Days of New Zealand, Romance and Reality of Antipodean Life in the Infancy of a New Colony* (London: Williams and Norgate, 1881), 105.

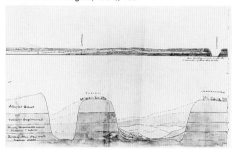

Fig. 9. **Walter Mantell** (surveyor), Geological cross-section in the Wanganui region, ca. 1847. Ink. Alexander Turnbull Library.

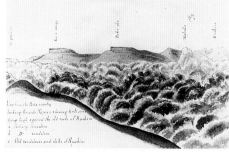

Fig. 10. **James Coutts Crawford**, View from the Patea country, Taranaki, mid-nineteenth century. Alexander Turnbull Library.

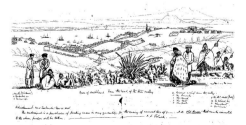

Fig. 11. **Thomas Collinson,** The town of Auckland, 1846. Ink. T. B. Collinson MS Papers, Alexander Turnbull Library.

The jungles of India, or the forest of America, cannot yield a more secure retreat for beasts of prey than these vast woods; yet none are found to exist here; and the ample provision of the mountains, the valleys, the hills, the forests, and the

plains of New Zealand seem reserved by Providence for the use of man or for animals of the biped nature....

Rev. William Yate, *An Account of New Zealand; and of the Formation and Progress of the Church Missionary Society's Mission in the Northern Island* (London: Seeley and Burnside, 1835).

...a landscape of splendour, and order and peace.

Colin McCahon, "Beginnings," *Landfall* 80, no. 2 (December 1966): 364.

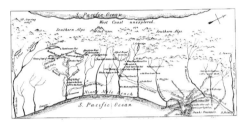

Fig. 12. A map of the Province of Canterbury, 1853. Alexander Turnbull Library.

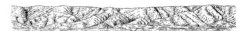

Fig. 13. **C. A. Cotton**, The Hawkdun fault scarp in Otago, in his book *Geomorphology: An Introduction to the Study of Landforms,* 3rd ed. (Wellington: Whitcombe & Tombs, 1942).

Fig. 14. The international signpost at Bluff. Postcard.

1840
William Hobson arrives in Kororareka as the British lieutenant-governor with authority to negotiate with the Maori about their ceding sovereignty to the British crown. A *hui* (meeting) is held at Waitangi at which Hobson explains the treaty's advantages. The Treaty of Waitangi is signed, and British sovereignty is declared. *American traders and captains, as well as the United States Consul James Clendon, are present at the signing. The scientific party from the United States Exploring Expedition, headed by Charles Wilkes, spends six weeks in the Bay of Islands at this time; members of the expedition are also present at the signing of the treaty.*

The New Zealand Company sends the first organized groups of settlers to Port Nicholson, later called Wellington. The company helps establish other settlements in Nelson and New Plymouth.

▼

135

A panorama of the Bay of Islands by Robert Burford, based on the drawings of Augustus Earle, is displayed in New York.

1841
The American ship Black Warrior fires the first foreign salute to the new colony.

Fig. 15. Members of A. H. Bogle's survey party making survey pegs, 1903 or 1904. A. H. Bogle Collection, Alexander Turnbull Library.

Taking the Land

▼
136

I said to them, "God has made this land for us and for our children; – are we the only people that God has created without giving land to live upon?"

Hone Heke to Governor Fitzroy, May 21, 1845, in *I Take up My Pen: An Early Colonial Scrap-book*, ed. Cecil Manson and Celia Manson (Wellington: Pigeon Press, 1971).

I would here observe, that as I would not, even in addressing a New Zealand chief, state or assert any international law or practice, not borne out by some good and admitted authority, I think it as well to quote my authority, and more particularly as you may possibly not have the book at hand to refer to.

Chitty's new edition of the Law of Nations, from the French of de Vattel, published in 1834, page 100: "There is another celebrated question to which the discovery of the New World has principally given rise. It is asked whether a nation may lawfully take possession of some part of a vast country in which there are none but heretic nations, whose scanty population is incapable of occupying the whole. We have already observed in establishing the obligation to cultivate the earth, that those nations cannot exclusively appropriate to themselves more land than they have occasion for, or more than they are able to settle and cultivate. Their unsettled habitation in those immense regions cannot be accounted a true and legal possession; and the people of Europe, too closely pent up at home, finding land of which the savages stood in no particular need, and of which they made no actual and constant use, were lawfully

Fig. 16. The Wesleyan Mission Station at Wangaroa, north of the Bay of Islands, 1827. Alexander Turnbull Library.

Fig. 17. Attributed to **William Gordon,** A sketch of a Maori *pah* with its defenses demolished during the New Zealand Wars, 1860 or 1861, 1920. Drawing. Alexander Turnbull Library.

entitled to take possession of it, and settle it with colonies. The earth, as we have already observed, belongs to mankind in general, and was designed to furnish them with subsistence; if each nation had from the beginning resolved to appropriate to itself a vast country, that the people might live by hunting, fishing and wild fruits, our globe would not be sufficient to maintain a tenth part of its present inhabitants. We do not, therefore, deviate from the views of nature in confining the Indians within narrower limits. However, we cannot help praising the moderation of the English Puritans, who first settled

on New England; who, notwithstanding their being furnished with a charter from the Sovereign, purchased of the Indians the land of which they intended to take possession. This laudable example was followed by William Penn, and the colony of Quakers that he conducted to Pennsylvania."

William Spain, Land Commissioner, to Governor Fitzroy, 1844, in *I Take up My Pen: An Early Colonial Scrap-book*, ed. Cecil Manson and Celia Manson (Wellington: Pigeon Press, 1971), 96.

The missionaries are a holy class; they teach us to join our hands, look up to heaven and pray, and while we are doing so, take the land from under our feet!

A. Hope Blake, *Sixty Years in New Zealand: Stories of Peace and War* (London: Hodder and Stoughton, 1909), 4.

When I speak of the land, the survey, the ploughmen, and such small matters, the pencils of the reporters fly with the speed of the wind, but when I speak of the words of the spirit, they say this is the dream of a madman!

Te Whiti to reporters at Parihaka, June 1879, in Dick Scott, *The Parihaka Story* (Auckland: Southern Cross Books, 1954), 46.

Tukuna mai he kapunga oneone ki au hai tangi.
(Send me a handful of earth to weep over.)

Traditional proverb.

1852

A form of government based on six provinces responsible for local affairs is set up. More provinces are established but they are abolished in 1875 after conflicts with central government arose.

1854

Missionaries for the Church of Jesus Christ of Latter Day Saints arrive from their base in Sydney. A church is set up in Wellington but suffers attrition from the constant migration of members to the United States.

1858

European settlers outnumber Maori for the first time.

George R. West becomes the first American to be officially accredited as United States consul. ▼

Fig. 18. Police surround protesters before removing them from contested land on Bastion Point in Auckland, 1978. *Auckland Star.*

Fig. 19. Fence posts are taken by pack horse into back stations behind Waipiro Bay, early 1900s. F. A. Hargreaves Collection, Alexander Turnbull Library.

Fig. 20. **John Williams,** Fighting at Ohaiawai near the Bay of Islands on the morning of July 1, 1845. Drawing. Rex Nan Kivell Collection, National Library of Australia, Canberra.

1860–1872
Wanting to speed up land purchases and subordinate the Maori, Europeans initiate the New Zealand Wars. Bitter fighting rages across the North Island for a decade, with the Maori finally being narrowly defeated. For the biggest campaign 18,000 British troops are mobilized against the Maori people who do not number more than 60,000 men, women, and children throughout the country. The artist Charles Heaphy wins the Victoria Cross for military valor.

1861
Gold is discovered in Otago, starting a rush of miners, mainly from Australia and California.

▼
138

1862
The second American consulate is opened at Dunedin to handle the demands of the gold-rush miners.

1863
The first regular railway service begins in Canterbury.

1865
The Native Land Court is set up to establish Maori title to land and to limit the number of owners to no more than ten. This process insidiously destroys the traditionally communal land-holding practices of Maori society and does more to alienate land than did the confiscations of the New Zealand Wars.

Wellington replaces Auckland as the capital.

The New Zealand Exhibition in Dunedin attracts more than 800 exhibitors from the colony and abroad. It also hosts the first exhibition of paintings by New Zealand artists.

English version of the treaty's three articles

Article the First

The Chiefs of the Confederation of the United Tribes of New Zealand and the separate and independent Chiefs who have not become members of the Confederation cede to Her Majesty the Queen of England absolutely and without reservation all the rights and powers of Sovereignty which the said Confederation or Individual Chiefs respectively exercise or possess over their respective Territories as the sole sovereigns thereof.

Article the Second

Her Majesty the Queen of England confirms and guarantees to the Chiefs and Tribes of New Zealand and to the respective families and individuals thereof the full and exclusive and undisturbed possession of their Lands and Estates Forests Fisheries and other properties which they may collectively or individually possess so long as it is their wish and desire to retain the same in their possession; but the Chiefs of the United Tribes and the individual Chiefs yield to Her Majesty the exclusive right of Pre-emption over such lands as the proprietors thereof may be disposed to alienate at such prices as may be agreed upon between the respective Proprietors and persons appointed by Her Majesty to treat with them in that behalf.

Article the Third

In consideration therefore Her Majesty the Queen of England extends to the Natives of New Zealand Her royal protection and imparts to them all the Rights and Privileges of British Subjects.

Maori version of the three articles

Ko te tuatahi

Ko nga Rangatira o te wakaminenga me nga Rangatira katoa hoki ki hai i uru ki taua wakaminenga ka tuku rawa atu ki te Kuini o Ingarani ake tonu atu – te Kawanatanga katoa o o ratou wenua.

Ko te tuarua

Ko te Kuini o Ingarani ka wakarite ka wakaae ki nga Rangatira ki nga hapu – ki nga tangata katoa o Nu Tirani te tino Rangatiratanga o o ratou wenua o ratou kainga me o ratou taonga katoa. Otiia ko nga Rangatira o te wakaminenga me nga Rangatira katoa atu ka tuku ki te Kuini te hokonga o era wahi wenua e pai ai te tangata nona te wenua – ki te ritenga o te utu e wakaritea ai e ratou ko te kai hoko e meatia nei e te Kuini hei kai hoko mona.

Ko te tuatoru

Hei wakaritenga mai hoki tenei mo te wakaaetanga ki te Kawanatanga o te Kuini – Ka tiakina e te Kuini o Ingarani nga tangata maori katoa o Nu Tirani ka tukua ki a ratou nga tikanga katoa rite tahi ki ana mea ki nga tangata o Ingarani.

A literal English translation of the Maori text of the Treaty of Waitangi, signed at Waitangi on February 6, 1840.
Translation by Professor Sir Hugh Kawharu

The First

The Chiefs of the Confederation, and all the chiefs who have not joined that Confederation, give absolutely to the Queen of England for ever the complete government over their lands.

The Second

The Queen of England agrees to protect the Chiefs, the Subtribes, and all the people of New Zealand in the unqualified chieftainship over their lands, villages, and all their treasures. But on the other hand the Chiefs of the Confederation and all the Chiefs will sell land to the Queen at a price agreed to by the person owning it and by the person buying it (the latter being) appointed by the Queen as her purchase agent.

The Third

For this agreed arrangement therefore concerning the Government of the Queen, the Queen of England will protect all the ordinary people of New Zealand [i.e., the Maori] and give them the same rights and duties of citizenship as the people of England.

Fig. 21. Whina Cooper and one of her grandchildren on the long march from Northland to Wellington to protest the continuing alienation of Maori land, 1975. *NZ Herald.*

1867
In Taranaki the community of Parihaka is founded by the prophet Te Whiti O Rongomai based on principles of pacifism and a desire for the return of Maori land confiscated during the New Zealand Wars.

1870
Treasurer Julius Vogel announces an ambitious program of public works and immigration. By the end of the decade more than 140,000 immigrants have arrived, most of them state-assisted and of humble origins. Nearly 1,200 miles of railway and some 2,000 miles of graveled roads have been finished.

Prime Minister William Fox begins trade negotiations with the American consul in Dunedin to secure entry of New Zealand wool into the United States. Agreement is not reached.

James Gray invents a double-furrow plough and a swing plough to cultivate the tussock grasslands of the South Island. They are enormously successful, leading him to develop other sophisticated forms of agricultural machinery.

First public art school opens in Dunedin, while Charles Heaphy, John Kinder, and thirteen others form the Society of Artists in Auckland. Their first exhibition is held in March 1871.

▼
139

1876
The Otago Art Society is formed in Dunedin and local societies are soon established in other centers.

1877
Compulsory, free education is introduced.

1881
End of passive resistance to the surveying of land by the Parihaka people. Parihaka is occupied by force and its leaders jailed.

40 percent of the population live in towns.

1882
First shipment of frozen meat to Britain. New Zealand begins its role as Britain's outlying farm.

▼
140
1885
Mrs. Mary Clement Leavitt, an American, establishes the Women's Christian Temperance Union in New Zealand. The union leads the fight for prohibition and is also important in the battle for women's suffrage.

1886
A major eruption of Mt. Tarawera destroys the famed tourist attraction, the Pink and White Terraces, and kills 153 people.

Landscape painting of New Zealand subjects attracts us because we are lovers of nature in New Zealand. It is, we confess, greatly to our dishonour that we, in our greed for gold, despoil this nature.

We have no pride in our inheritance. Our forests, which to their growing took hundreds of years, we wantonly destroy. Our birds, which in their plumage and in their songs are joyously beautiful, we

Fig. 22. Burning the bush, 1908.
Auckland Weekly News.

put to death. Our most glorious gifts we lay upon the altar of Mammon. We hope that our painters may give to posterity a picture of the majesty that might have been ours.

Leonard H. Booth, "The 1939 Exhibition of the Canterbury Society of Arts," *Art in New Zealand* 11, no. 4 (June 1939): 170.

You never saw such a sight; and if the wind hadn't been in our favour, and the house so far back from the road, it must have shrivelled up where it stood. The fence was alight in a dozen places at once, and at last we had simply to let it burn and run for our lives, the heat was so terrible. After that the fire seemed just to leap through the settlement. It crossed back to the riverside and burnt out the Finnertys and Robinsons. Mrs Robinson saved herself and the Finnerty children in the cattle-tank, and now the men are going about the settlement with their arms round one another's neck, the best friends in the world.

William Satchell, *The Toll of the Bush* (Auckland University Press and Oxford University Press, 1985), 212.

1887
New Zealand's first national park, Tongariro, is set aside, a gift of the Maori. The establishment of this park, inspired by the example of Yellowstone, is followed by many others, until by 1990 nearly 19 percent of the nation's total land area is under some form of protection.

1888
Branches of the American Knights of Labor are set up by unemployed groups. The organization spreads rapidly in the early 1890s.

Auckland City Art Gallery is officially opened.

1891
The Liberal Party comes to power and initiates reforms, among which laissez-faire is rejected as an acceptable principle of public policy. *By the end of the decade the Boston reformer Frank Parsons states: "A new civilization has come. A new age has dawned. New Zealand is the birthplace of the twentieth century."* Land development schemes for family farms mean large-scale clearing and burning of indigenous forests.

▼

141

1892
Of the approximately 26.9 million hectares that make up New Zealand, 4 million remain in Maori ownership. Much of it is remote and rugged country in the North Island.

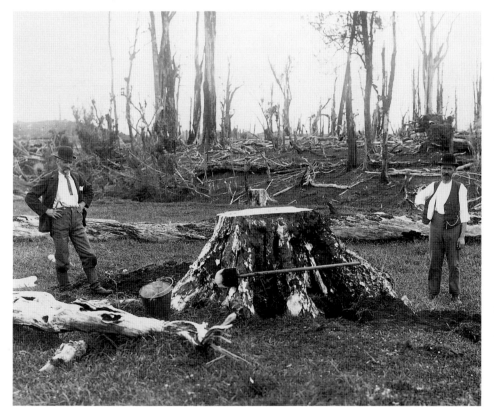

Fig. 23. Preparing to blast a stump, ca. 1900. McAllister Collection, Alexander Turnbull Library.

1893
New Zealand women are the first in the world to vote in national elections.

The first issue of the *Triad* is published in Dunedin and for 36 years judges the arts. Its editor, Charles Baeyertz, asserts that "the public is always wrong in regard to any question of taste, until it is by a slow process converted to the right way of thinking by the educated and thinking minority." *Ezra Pound notes in 1922: "It is something in the nature of a national disgrace that a New Zealand paper, the Triad, should be more alert to, and have better regular criticism of contemporary French publications than any American periodical has yet had."*

1895
The American photographer William Henry Jackson visits New Zealand as part of his ambitious global photographic survey. He writes of Whakarewarewa: "At times I could hardly imagine that instead of the Yellowstone I was at almost exactly its antipodes."

Mark Twain makes a lecture tour and notes: "New Z consists simply of scenery & civilization."

The difference between Tutira of '82 and Tutira of 1939 is the difference between youth and age: the face of the one smooth, that of the other wrinkled and lined. In the early days of the station its surface was unmarked by paths; now it is seamed with tracks. Before the arrival of the European with his domesticated breeds of animals, save for a few Maori footpaths the station was an untrodden wild: it was without path or track – in the language of Scripture, void; its surface is now a network of lines; it is reticulated, like the rind of a cantaloupe melon.

W. H. Guthrie-Smith, *Tutira: The Story of a New Zealand Sheep Station* (Edinburgh and London: William Blackwood & Sons, 1953), 196.

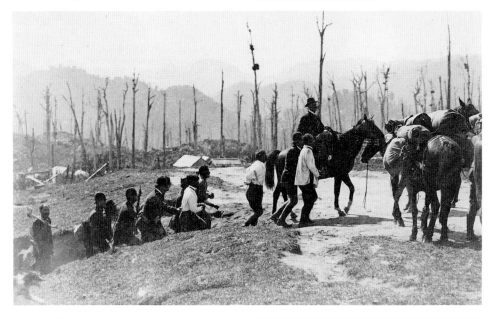

Fig. 24. The prophet Rua Kenana, in torn shirt, is taken from Maungapohatu with his followers by Police Commissioner John Cullen, April 5, 1916. Alexander Turnbull Library.

Fig. 25. **Charles Heaphy**, *Kauri Forest, Wairoa River, Kaipara*, 1839. Watercolor. Alexander Turnbull Library.

I have just travelled an arduous motor journey through hills that it is a pity the Almighty had not used a plane on. One thing that spoils your scenery, too, is the way the bush has been cut and burnt, and dead trees left standing. They spoil the landscape terribly. Of course, I can quite see you have to do that to get pasture as quickly as possible.

George Bernard Shaw, "Talking with Shaw" (1934), in *Verdict on New Zealand*, ed. Desmond Stone (Wellington: A. H. & A. W. Reed, 1959), 136–137.

1898
Old-age pensions are introduced with strict means and residence requirements.

Motorcars are first imported.

The Treaty of Paris is signed, ending the Spanish-American war. It cedes the Philippine Islands to the United States, turning it into a Pacific power.

1902
There is still debate whether the farmer Richard Pearse in fact made a sustained and controlled flight on March 31, 1902, in a flying machine he designed and made. Pearse himself wrote, "as the Wrights were the first to make a successful flight in a motor-driven aeroplane [on December 17, 1903] they will be given the pre-eminence when the history of the aeroplane is written."

▼
143

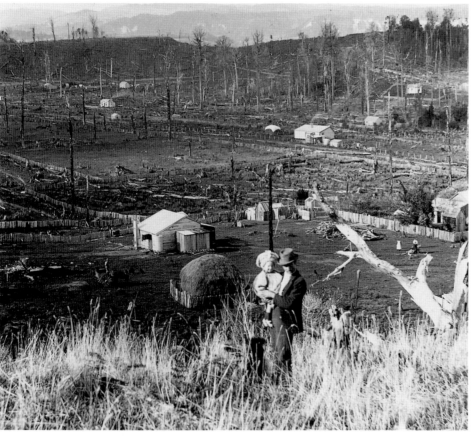

Fig. 26. Land clearance at Mangaonoho, Rangitikei, with Bain's farm in the foreground, early 1900s. Child Collection, Alexander Turnbull Library.

Fig. 27. **Murray Ball**, Wal and His Dog, 1984. From the cartoon *Footrot Flats*. Murray Ball.

Remaking the Landscape

1903
First car journey made between Auckland and Wellington, via Napier.

1906
The Department of Tourist and Health Resorts is established, and the government takes the major responsibility for tourism.

1907
In recognition of its greater independence New Zealand ceases to be called a colony and is declared a dominion.

1908
The main railway line between Auckland and Wellington is completed. *The first train takes VIPs to Auckland to greet the Great White Fleet of the United States that visits in August to demonstrate the strength and mobility of American naval power.*

1911
Vivian Walsh makes the first officially confirmed controlled powered flight in a Howard Wright biplane imported into New Zealand in parts and assembled there.

John Philip Sousa's band tours New Zealand.

1912
A Ford advertisement describes the ubiquitous Ford motorcar as "the car that has captured New Zealand."

▼
144

Here in New Zealand we seize a piece of primeval country whereon no work has been done since the very dawn of time, and in two or three years have it in pasture which rivals the work of centuries in other lands. Then, after a second ploughing and treatment, a result is shown which is the pride of this and the envy of all other countries. In grass-farming New Zealand really leads the world.

E. Earle Vaile, *Pioneering the Pumice* (Christchurch: Whitcombe & Tombs, 1939), n.p.

Whenever I enter the "bush" I am seized with a yearning to tidy it up.

[**E. L. M. White**], *My New Zealand Garden, by a Suffolk Lady* (Wanganui: A. D. Willis, 1902), 58.

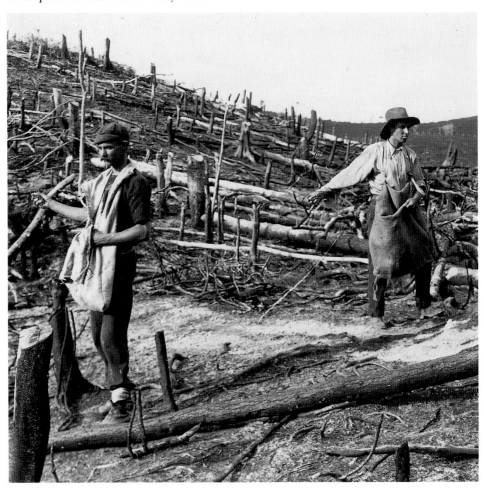

Fig. 28. Sowing grass after burning off in North Auckland, ca. 1910. Northwood Collection, Alexander Turnbull Library.

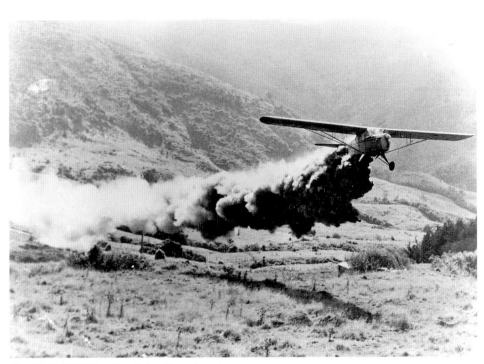

Fig. 29. **D. J. McKay**, Fertilizing from the air, 1950s. Alexander Turnbull Library

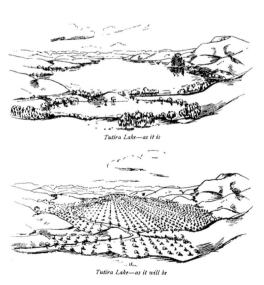

Tutira Lake—as it is

Tutira Lake—as it will be

Fig. 30. Two illustrations from *Tutira: The Story of a New Zealand Sheep Station* by **W. H. Guthrie-Smith** (Edinburgh and London: William Blackwood & Sons, 1953).

Fig. 31. Advertisement for the agricultural services company Wright Stephenson, 1963.

▼ *145*

1914
New Zealand joins Britain in declaring war on Germany.

1915
The Panama-Pacific International Exposition is held in San Francisco to celebrate Balboa's discovery of the Pacific and the completion of the Panama Canal. New Zealand's main contribution is primary produce, but the work of some photographers is also included. The photographer Leslie Hinge attended the exposition and took many photographs of the New Zealand Pavilion.

1916
The Tuhoe prophet Rua Kenana Hepetipa and his followers are arrested and taken from Maungapohatu, an act historians describe as "the last shots of the New Zealand Wars." Men from the community had refused to volunteer for military service but are arrested ostensibly for illegal grog dealing.

1918
The Armistice marks the end of World War I.

The influenza epidemic claims 6,700 lives. It remains New Zealand's worst recorded tragedy. Maori communities are particularly ravaged.

Tahupotiki Wiremu Ratana sees visions and begins to teach. The Ratana church spreads among the Maori. In 1981 it is the largest indigenous faith and is third in the number of adherents after the Anglican and Roman Catholic churches.

The Bountiful Landscape

▼
146

When Christchurch has grown to a pretty town, when the young oak of England stands by the side of the giant trees indigenous to New Zealand, when the avenues to houses are lined by the graceful and beautiful shrubs, when the green grass of England is sprouting in

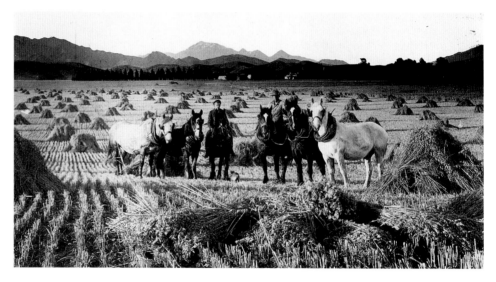

Fig. 32. Harvesting oats, early 1900s. Agriculture Department Collection, Alexander Turnbull Library.

her meadows, fenced by hawthorn hedges, when daisies and butter-cups flower over the land, when the timid hare springs across the field, and the coveys of partridges break from their cover, and the sun of heaven shines brightly through the pure atmosphere, tempered by breezes from the Pacific and the Alpine range, then there will be but one thing wanting to make New Zealand the Eden of the world – the charm of age, the vestiges of the past, the spot endeared by old associations and traditions.

Charles Hursthouse, *New Zealand; or, Zealandia, the Britain of the South* (London: Edward Stanford, 1857), vol. 1, 99.

I met many of the natives employed on the road. I had a little conversation with most of them. I asked some, Who was sent before to prepare the way for it; they said, John. I reminded them of what it was prophesied he should do – every valley shall be made plain, every hill shall be made low, every rough place be made smooth, every crooked place be made

straight. I told them that that was exactly what they were now doing, cutting down trees, rooting them out, filling up hollows, levelling the hills to make a good road for the Governor according to his command, so I said, Was John commanded to make a highway for our God by preaching repentance, that all those inequalities produced by sin may be removed, and it come to take up his abode in our hearts.

Rev. Richard Taylor, typescript journal, vol. 4, July 23, 1844–March 10, 1846, p. 169 (Alexander Turnbull Library), in Paul Shepard, *English Reaction to the New Zealand Landscape before 1850* (Wellington: Department of Geography, Victoria University, 1969).

A track [past Oxford] had to be cut with the axe for the road on which we were travelling, permission being purchased from the Maoris to whom the wood belongs. Thirty feet or so had been cleared on either side of the carriage way, to let in air and light, and the vast trunks lay stretched as they had fallen, one upon another, thousands and tens of thousands of tons of the finest timber left to rot. Nay, not even to rot, for they had set them on fire where they could, and the flames spreading to the forest had seized the trees which were nearest, and there they were standing scorched, blackened, and leafless. We went through absolutely 20 miles of this. Such wanton and lavish destruction I must have seen to have believed.

James Anthony Froude, "A Land to Touch the Imagination" (1885), in *Verdict on New Zealand*, ed. Desmond Stone (Wellington: A. H. & A. W. Reed, 1959), 52–53.

The features of great pastoral districts are seldom rightly imagined by Englishmen, who almost universally form their notion of the grass-lands of a new country from the look of their own meadow-land, taking away the hedges, and filling up the back ground of the picture with groups of graceful trees; in short, the park round some great gentleman's seat is the common farm-servant's *beau idéal* for a new country of this kind…. They never think that our English pasture-lands have attained their present thick carpet of beautiful grass by the constant grazing of cattle, by skilful and long-continued cultivation, and a mixture of grass-seeds.

Thomas Cholmondeley, *Ultima Thule; or, Thoughts Suggested by a Residence in New Zealand* (London: John Chapman, 1854), 133.

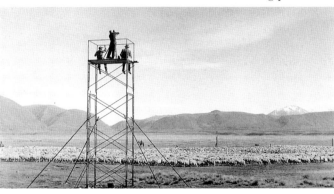

Fig. 33. National Film Unit crew shooting the documentary *The Snow Line Is Their Boundary*, 1955. Broadcasting Corporation of New Zealand.

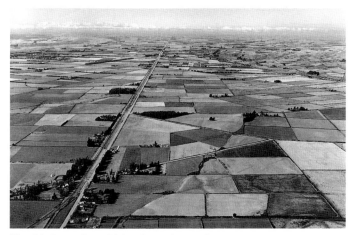

Fig. 34. Canterbury Plains from the air, late 1950s. Air Logistics.

[W]hen the hills are more dotted with sheep, and the valleys more golden with corn; when the pheasant whirs from the brake, and the fox bursts from the cover, New Zealand will offer a thousand views which even a Turner might cross the seas to paint.

Charles Hursthouse, *New Zealand; or, Zealandia, the Britain of the South* (London: Edward Stanford, 1857), vol. 1, 99.

The plains are certainly, at first sight, monotonous, but they improve as you know them. The beautiful views, the magnificent range and files of mountains, can hardly be equalled; and the rapid growth of homesteads over the plains, with their necessary accompaniments – plantations, hedgerows, gardens, and trees of every description, which are being planted universally – will so alter the face of the country, that four years hence it will hardly be known, and will effectually do away with any objection on the score of monotony.

Edward Brown Fitton, *New Zealand: Its Present Condition, Prospects and Resources; Being a Description of the Country and General Mode of Life among New Zealand Colonists, for the Information of Intending Emigrants* (London: Edward Stanford,1856), 272.

In writing this story, I had in my mind the New Zealand of some years ago, with which I first made acquaintance. Since then much is altered. The land which lay waste and desolate is now fenced and under cultivation, and society has become more formal, and conforms more strictly to the rules in vogue in Europe.

C. Evans, *Over the Hills and Far Away: A Story of New Zealand* (London: Sampson, Low, Martson, Low & Searle, 1874).

1926
On the government's invitation, the American writer Zane Grey tries out big-game fishing in New Zealand. His enthusiasm helps promote the sport internationally.

General Motors opens a car assembly plant in Petone outside Wellington. The first vehicle off the line is a Chevrolet sedan.

1928
With the first trans-Tasman flight, the Australian Charles Kingsford Smith ends New Zealand's isolation by air.

The first issue of *Art in New Zealand* is published and promotes the work of New Zealand artists and writers. It ceases publication in 1951 as the *Arts Year Book*.

▼

147

The first sound film screened is Lights of New York *from Warner Brothers.*

The boxer Tom Heeney travels to the United States to fight Gene Tunney for world heavyweight championship; Tunney retains title.

1929
Artists in Christchurch form The Group, which exhibits regularly until 1977.

1930
The worldwide depression begins to affect New Zealand.

Linking the Land

▼
148

People have almost forgotten what roads used to be like. Up north they were notoriously impassable in wet weather. In the winter time vehicles – horse drawn, not automobiles – got bogged down by the dozen and were jacked out and left on the roadside till next summer's dry weather should make the clay track passable again.

E. Earle Vaile, *Pioneering the Pumice* (Christchurch: Whitcombe & Tombs, 1939), 248.

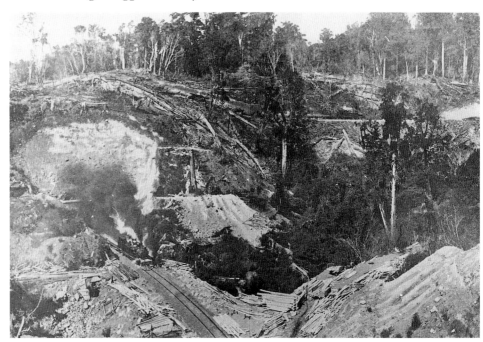

Fig. 35. The Raurimu spiral, a great engineering feat accomplished during the completion of the main trunk line from Wellington to Auckland, photographed in 1908. *Auckland Weekly News.*

Fig. 36. Road construction, mid-1930s. Tyndall Collection, Alexander Turnbull Library.

Fig. 37. A Cadillac, probably on the streets of Nelson, ca. 1907. Jones Collection, Alexander Turnbull Library.

Fig. 38. Aerial view of Auckland, 1987.
Air Logistics.

Fig. 39. **E. P. Christensen**, Road construction,
1954. National Publicity Studios Collection,
Alexander Turnbull Library.

Fig. 40. **Leonard Mitchell**, Design for a 1963
promotional road safety issue postage stamp.
New Zealand Post.

1937
*Softball is introduced by an
American employee of the Ford
Motor Company.*

1938
An exhibition of contemporary
Canadian painting, arranged by the
National Gallery of Canada, tours
the country. *It is supported by the
Carnegie Corporation.*

1939
New Zealand joins Britain in de-
claring war on Germany.

*An exhibition of Pacific cultures at
the Fine Arts Palace in the Golden
Gate International Exposition (San
Francisco) includes Maori carvings
that win lavish praise from the local
critic Alfred Frankenstein.*

▼

149

1940
Despite the outbreak of war,
centennial celebrations continue
with publications, exhibitions,
and competitions organized by the
government. *The National Centennial
Exhibition of New Zealand Art* is the
first major historical survey of its
kind. A very popular pictorial his-
tory, called *Making New Zealand*,
is published in parts.

*Regular air services by Pan-Ameri-
can Airways begin,* and an airmail
service to the United Kingdom is
introduced.

1941
*Following the Japanese attack on
Pearl Harbor the United States
enters the war.*

1942
Full diplomatic relations between New Zealand and the United States are established. The first New Zealand ambassador to the United States is the Honourable Walter Nash, at the time Deputy Prime Minister and Minister of Finance in the War Cabinet.

Following the success of the Japanese in the Pacific, American forces arrive. Over the next two years more than 100,000 American servicemen spend some time in New Zealand.

1943
Street brawls between American and New Zealand servicemen in Wellington are dubbed the "Battle of Manners Street." The cause is attributed to the Americans' being "overpaid, oversexed, and over here." Eleanor Roosevelt visits the troops.

▼
150

1944
United States servicemen leave; 1,400 New Zealand women become war brides.

The more I see of life the more certain I feel that it's the people who live remote from cities who inherit the earth. London, for instance, is an awful place to live in. Not only is the climate abominable but it's a continual chase after distraction. There's no peace of mind – no harvest to be reaped out of it. And another thing is the longer I live the more I turn to New Zealand. I thank God I was born in New Zealand. A young country is a real heritage, though it takes one time to recognise it. But New Zealand is in my very bones. What wouldn't I give to look at it!

Katherine Mansfield to her father, Harold Beauchamp, March 18, 1922. Mansfield wrote this letter from Paris. She had left New Zealand in July 1907 when she was eighteen. She never went back.

Fig. 41. Homestead at Ohura in the King Country, 1919. *Auckland Weekly News.*

I grew to awareness rejecting as alien our scrubby backblocks farm, the thick bush of tall kauri, rimu and kaihikatea strung with creeper and supplejack, the mangroved tidal creek, the dusty wooden schoolhouse, the cabbage trees in the playground, the bare coastline where wild surf creamed the rocks. And not only as alien; as somehow unwholesome too. England – the narrow street, the red pillar-box, the green and common, the lilacs, and the tall-towered church – was home. It was tamed, known, and entirely wholesome. New Zealand was a burden to be shouldered, like her marriage to father.

Maurice Shadbolt, *The New Zealanders* (Christchurch: Whitcoulls, 1976), 10.

It is natural that we who were born in New Zealand should look to English (and to a lesser extent, Continental) models when we wish to express ourselves in the arts of writing and painting. We are of British seed, planted not so very long ago. We have, as we are never tired of pointing out, no tradition of our own. In a word, we are Englishmen, born in exile.

A. R. D. Fairburn, "Some Aspects of N.Z. Art and Letters," *Art in New Zealand* 6, no. 4 (June 1934): 213.

Those years between the First World War and the depression were indeed a wasteland. Meanwhile the land lay waiting and its people, in Gothic fear, cultivated their

Fig. 42. Cover of the sixth edition of the pamphlet *Aid for Britain*, published by the Britain National Council in New Zealand, ca. 1942.

English gardens; secure within the palings of their quarter-acres from the pagan wilderness of hills and native bush.

P. A. Tomory, "The Visual Arts," in *Distance Looks Our Way: The Effects of Remoteness on New Zealand,* ed. Keith Sinclair (Paul's Book Arcade for the University of Auckland, 1961), 72.

Sitting here in my little bay-windowed sitting room with English trees in the

Noah's Ark did not more completely treasure up specimens of the creature world, then did the ships bound for Canterbury preserve casts from all the old moulds left behind them in the old country."

C. L. Innes, *Canterbury Sketches; or, Life from the Early Days* (Christchurch: Lyttelton Times, 1879), 8–9.

1946
The first successful experiments in the aerial application of fertilizer are held.

1947
New Zealand finally adopts the Statute of Westminster and becomes fully independent from Britain.

The word "native" is dropped from all official use and is replaced by "Maori."

The literary journal *Landfall* is founded.

The American Field Scholarship program is established to arrange exchanges of high school students from New Zealand and the United States. By the late 1970s its orientation has become multinational and the organization is renamed the AFS Intercultural Programs.

1948
The American legation in Wellington gains embassy status. The Fulbright program to foster educational and cultural exchanges between New Zealand and the United States is set up.

▼
151

Fig. 43. **Steffano Webb,** Students from the Canterbury College School of Fine Arts, 1907. Steffano Webb Collection, Alexander Turnbull Library.

garden, and those precious ducks of ours on the pond in front, and everything about me feeling so English and home-like, it is almost impossible to believe that we are so far away from you. One feels far more a stranger twenty miles away from England on the French coast than you can possibly do, at this great distance, in an English colony.

Alice Mary Lees, in *I Take up My Pen: An Early Colonial Scrap-book,* ed. Cecil Manson and Celia Manson (Wellington: Pigeon Press, 1971), 33.

I find that the London *Times* of July 5th, 1851, thus noted its small contemporary:

"A slice of England, cut from top to bottom, was despatched in September last, to the Antipodes. A complete sample of civilization, weary of the fight for bread within the compass of these narrow isles, took ship at Gravesend in search of less crowded markets in New Zealand...."

Those who love the highly cultivated scenes of their native land, to ramble through leafy lanes, and to gather the sweet primrose and violet – those who love to gaze upon the stately mansion, the charming homestead, the rustic cottage or the ruins of antiquity, should not come here!

"Hopeful," "Taken in"; Being a Sketch of New Zealand Life (London: W. H. Allen, 1887; Christchurch: Capper Press, 1974), 176.

Fig. 44. Outside Longbeach sheep station, Canterbury, 1920s. Alexander Turnbull Library.

Selling New Zealand

152

New Zealand has rightly been described as "the world's most exciting travel package." With features such as the amazing thermal areas, magnificent lakes and fiords, glaciers, alpine regions, and unrivalled hunting, fishing, and other sporting opportunities, New Zealand combines in a comparatively small area a host of attractions, each one of which has made some other country famous.

New Zealand Official Yearbook (Wellington: Government Printer, 1962), 1061.

Few regions in the world exhibit such a variety of geographical features in so small an area. It is possible in New Zealand to be swimming in the Tasman Sea in the morning and skiing on some of the North Island's snow-covered volcanic peaks in the afternoon.

United States Antarctic Research Program, *Personnel Manual* (Washington, D.C.: National Science Foundation, ca. 1966).

Fig. 45. **C. Spencer**, Tourists on the famous Pink and White Terraces at Lake Rotomahana, which were destroyed in a volcanic eruption in 1886. R. F. Keam Collection, Alexander Turnbull Library.

Fig. 46. Decorative border from a 1957 *New Zealand Holiday* advertisement selling New Zealand as "seven countries in one."

Fig. 47. Decorative heading from *New Zealand Today*, published to celebrate the Dunedin Exhibition of 1925.

No Bledisloe Medal

"For the benefit of painters south, the medal can at present only be awarded to a painting of natural landscape of an uncultivated nature, and the A.S.A.'s [Auckland Society of Arts] rigid interpretation of these conditions apparently leaves only bush-clad hills covered with first growth as legitimate subject matter. No evidence whatever of human activity must be visible. No dead trees, please. No lively red sheds; no ploughed fields; no roads, no nothing."

The Arts in New Zealand 17, no. 4 (June–July 1945): 48.

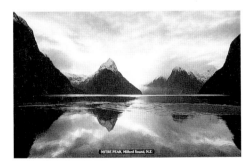

Fig. 48. Mitre Peak, Milford Sound, 1980s. Postcard.

Fig. 49. Promotional brochure, 1990.

1952
Population passes two million.

1953
Edmund Hillary and the Sherpa Tenzing Norkay are the first people to reach the summit of the world's tallest mountain, Mt. Everest.

1954
The first exhibition of abstract art in a public art gallery, *Object and Image,* is held at the Auckland City Art Gallery.

▼
153

1956
The United States Navy establishes a base in Christchurch for its Antarctic operations.

Coca-Cola becomes available.

1957
The last person is hanged in New Zealand; capital punishment is abolished.

1959
Modern surfing and the Malibu board are introduced by two Americans at Piha, near Auckland.

The American evangelist Billy Graham attracts large crowds to his meetings.

1960s
▼ *Large-scale migration from the Pacific islands begins.*

1960
Television broadcasts begin in black and white, with Lassie as one of the first programs.

New Zealand's first computer is installed, an IBM 650 for the Treasury in Wellington.

154

Several eminent writers have declared that the beauties of the Swiss lakes, the grandeur of the Rocky Mountains, and the glacier-clothed peaks of the Himalaya mountains are as nothing when compared with the deep blue waters of the Wakatipu, the grandeur of the Remarkables, and the glacier-covered Earnslaw.

William Fox to Robert Godley, December 31, 1858, in Gordon H. Brown, *Visions of New Zealand: Artists in a New Land* (Auckland: David Bateman, 1988), 180.

We feel the image of sheep, mudpools, and green grass has been a tad overdone lately," we said. "We'd like to see you play with some of New Zealand's other attributes, even the very ones which have always been held against it. Our loneliness, our lack of night life, our intrinsically boring qualities, can be seen as positive attributes these days, not to mention the absence of nuclear power stations and terrorists ... well, most of the time!

Editorial brief to advertising agencies for a competition on Selling New Zealand, *More Magazine* (October 1986): 37.

Fig. 50. A trip up the Wanganui River, 1907. Alexander Turnbull Library.

One finds, for example, that New Zealanders are not really living in their country, and that they are blind to many of its most characteristic beauties. They mainly admire its excesses, its glaciers, geysers, caves and other "sublime" and "awe-inspiring" spectacles. In its quieter aspects they are aware principally of resemblance to Sussex Downs, Scottish lochs, and other exotic scenic features.

J. N. Findlay, "An Infantile Idealism" (1937), in *Verdict on New Zealand*, ed. Desmond Stone (Wellington: A. H. & A. W. Reed, 1959): 139.

Fig. 51. Logo for promoting New Zealand tourism, 1989. New Zealand Tourist and Publicity Department.

Fig. 52. Children's board game, 1950s.

1961
The exhibition *Paintings from the Pacific,* organized by the Auckland City Art Gallery, shows work from Japan, the United States, Australia, and New Zealand in an attempt to assert common Pacific Basin cultural concerns.

1964
Queen Elizabeth II Arts Council is set up to support individual artists and organizations in all areas of the arts.

1965
New Zealand troops are sent to Vietnam. They are pulled out in 1972. *President Lyndon B. Johnson visits to bolster support for the American effort in Vietnam.*

1967
Six o'clock closing of hotel bars ends after a referendum.

Decimal currency is introduced, changing pounds to dollars and pennies to cents.

▼
155

Fig. 53. Advertisment for Toyota vehicles, 1990. Colenso Communications.

1968
The American art critic Clement Greenberg makes a lecture tour.

1970
Anti-Vietnam demonstrators greet Vice President Spiro T. Agnew on his arrival in Auckland.

1971
65 percent of the 223,000 Maori population live in urban areas, compared with 3 percent in 1936.

Metric weights and measures are adopted.

The Auckland City Art Gallery organizes an exhibition of the work of Morris Louis.

▼
156
1972
The government sends two frigates into the French nuclear testing zone around Mururoa to protest continuing testing.

The exhibition The State of California Painting *is shown at the Govett-Brewster Art Gallery in New Plymouth. It includes the work of Richard Diebenkorn, Robert Irwin, John McLaughlin, and Wayne Thiebaud.*

New Zealand in the past has suckled men who have photographed barrels of lush pastureland dominated by posterish Egmont, trainloads of pseudo-Maori dances, while Mount Cook from the bathroom window of the Hermitage has sadly slunk through lots of lenses.

John Pascoe, "Photography in New Zealand," *Landfall* 1, no. 4 (December 1947): 302.

Fig. 54. **Charles Heaphy,** *Mt. Egmont Viewed from the Southward*, ca. 1840. Watercolor. Alexander Turnbull Library.

It is perhaps not altogether a matter of surprise that the most striking natural object in the New Zealand landscape should have been so inadequately handled by our artists. The exotic and very thrilling beauty of Mt Egmont, in which a perfection of geometric form has been achieved by some exceptional refinement of nature, may be compared with the Japanese Fujiyama, which has accepted the homage of poets and artists for centuries.

P. W. Robertson, "The Art of Christopher Perkins," *Art in New Zealand* 4, no. 13 (September 1931): 20.

A more striking or magnificent object in creation than this mountain, I have never beheld.

William Barrett Marshall, *A Personal Narrative of Two Visits to New Zealand, in His Majesty's Ship Alligator, A.D. 1834* (London: James Nisbet), 175.

Yesterday we saw the great Taranaki, the King of Australasian mountains. Rising in a regular cone, almost straight from the sea, with no rival near it, it gave me the impression of being the loftiest mountain I had ever seen, tho' it is said not to exceed 9000 feet.

Thomas Arnold to J. C. Shairp, December 6, 1849, in *New Zealand Letters of Thomas Arnold the Younger*, ed. James Bertram (Auckland University Press and Oxford University Press, 1966), 164–165.

Fig. 55. **Walter Mantell,** *Taranaki from Orokohai Road*, 1840s. Ink and pencil. Alexander Turnbull Library.

Fig. 56. Taranaki–Mt. Egmont used in advertising.

Fig. 57. Aerial view of Taranaki–Mt. Egmont. *Weekly News Annual* (1963).

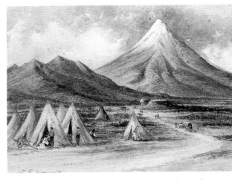

Fig. 60. **Henry Warre,** *Mt. Egmont from the Camp near Stony River,* ca. 1862. Watercolor. Rex Nan Kivell Collection, National Library of Australia, Canberra.

1973
Britain formally joins the European Economic Community (EEC), and New Zealand begins its protracted fight for special access to the community market.

The exhibition Some Recent American Art *is shown at the Auckland City Art Gallery. It introduces to the New Zealand public many of the substantial artists of the 1960s and 1970s, including Carl Andre, John Baldessari, Eva Hesse, Brice Marden, Agnes Martin, and Richard Serra. It has a great impact on New Zealand artists.*

First broadcasts of color television.

▼
157

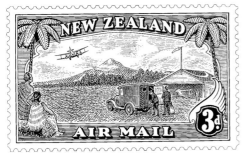

Fig. 58. **James Berry,** Airmail issue stamp, 1935. Drawing. New Zealand Post.

Fig. 61. View of New Plymouth, 1843. *Illustrated London News.*

Fig. 59. **Michael Smither**, *Taranaki*, ca. 1975. Silkscreen. Private collection.

Fig. 62. Taranaki–Mt. Egmont, with a cooperative milk factory in the foreground, ca. 1940. Alexander Turnbull Library.

A National Landscape

1975
Whina Cooper leads the Maori Land March from Northland to Wellington to win support for Maori demands for land rights. She states: "I wanted to draw attention to the plight of Maori who were landless. I wanted to point out that the people who were landless would eventually be without culture. I wanted to stop any further land passing out of Maori ownership, and I wanted the Crown to give back to Maori land it owned that was of traditional significance to Maori."

1976
The first McDonalds opens at Porirua, near Wellington.

The first issue of *Art New Zealand* is published.

1977
The Waitangi Tribunal begins to operate, investigating Maori claims against the loss of land and resources going back to the signing of the Treaty of Waitangi. Crown land on Bastion Point, Auckland, is occupied by Maori activists who want it returned to Ngati Whatua, the original owners. The next year they are removed by police after 504 days of occupation.

1978
Graphic works by Edward Ruscha are shown at the Auckland City Art Gallery.

There is nothing soft about New Zealand, the country. It is very hard and sinewy, and will outlast many of those who try to alter it.

John Mulgan, *Report on Experience* (Auckland: Blackwood and Janet Paul, 1967), 3.

There is no golden mist in the air, no Merlin in our woods, no soft warm colour to breed a school of painters from the stock of Turner, Crome, Cotman and Wilson Steer. Hard, clear light reveals the bones, the sheer form, of hills, trees, stones and scrub. We must draw rather than paint, even if we are using a brush, or we shall not be perfectly truthful.

A. R. D. Fairburn, "Some Aspects of N.Z. Art and Letters," *Art in New Zealand* 6, no. 4 (June 1934): 215.

Fig. 63. Annual cover, 1935. *Otago Daily Times and Witness Christmas Annual.*

I am convinced that the fact that the population of New Zealand has been to all intents and purposes a selected one, the circumstances and spirit which are inseparable from colonizing labours, the effects of education and of climate, and the influences of the striking scenery of the colony, all must in time combine to give to the people so distinct a type that it will not be necessary, in order to recognize a New Zealander when he travels in other parts of the world, that he should wear a piece of greenstone on his watch-chain. I was much struck on returning to the colony, to notice what appears to me the palpably characteristic type already taken on by the colonist.

Julius Vogel, *Parliamentary Debates, 1887,* in Keith Sinclair, *A Destiny Apart* (Wellington: Allen and Unwin, 1986), 80.

Until recently the New Zealander spoke of Great Britain as home and looked upon himself as a temporary sojourner in a strange land. He looked with awe and wonder on its scenic grandeur and painted it in the spirit of one paying a visit of inspection. He painted it as strange and curious, but not as the land that belonged to him. How great is the change can be seen from these pictures.

Edward C. Simpson, "The Year's Painting in Perspective," in *1945: First Year Book of the Arts in New Zealand,* ed. Howard Wadman (Wellington: H. H. Tombs Ltd, 1945), 10.

Fig. 64. **Marcus King**, Entry for pictorial stamp issue competition, 1935. New Zealand Post.

Fig. 65. **Leonard Mitchell**, *The Great Franz Joseph Glacier*. Photogravure. *New Zealand, Scenic Playground of the Pacific*, 1936.

I don't think it is possible to look out the window of even the ordinary suburban house in New Zealand without coming to some sort of terms with the landscape. It's present everywhere; even in the middle of our dingy cities one is continually being confronted, tormented, or stimulated, by landscape forms. I would say it's the most characteristic thing about New Zealand, apart from its emptiness; the living presence of quite large landscapes, to say nothing of enormous expanses of ocean.

Les Cleveland, in Athol McCredie, "The Social Landscape," in *Witness to Change: Life in New Zealand* (Wellington: PhotoForum, 1985), 49.

Man Alone

Title of a novel by **John Mulgan** published in 1939.

1979
Following a year of protests the Raglan golf course is returned to its Maori owners.

An Air New Zealand DC-10 crashes on the slopes of Mt. Erebus in Antarctica during a round-trip sightseeing trip; all 257 people on board die.

A severe landslide at Abbotsford, a suburb of Dunedin, destroys 69 houses and damages many others.

1980
Saturday retail trading is legalized.

1981
The tour of the South African Springbok rugby team leads to a storm of sustained and violent protest nationwide.

1983
The New Zealand and Australian governments sign the CER (Closer Economic Relations) Agreement, setting forth a staged reduction in duties between the two countries.

1984
Te Maori *opens in New York at The Metropolitan Museum of Art and travels to St. Louis, San Francisco, and Chicago before making an influential return tour of New Zealand. The feature film* Utu, *directed by Geoff Murphy, opens in New York. Pauline Kael is enthusiastic in the* New Yorker: *"and some of the pleasure [of this film] has to do with the quality of the light and the uncanny splendor of the New Zealand landscapes."*

Vincent Ward's feature film *Vigil* is screened in competition at the Cannes Film Festival.

▼

159

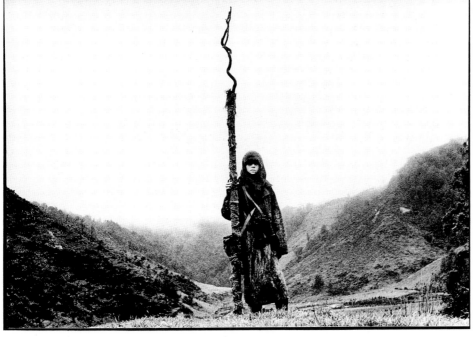

A FILM BY VINCENT WARD
VIGIL

Fig. 66. **Miles Hargest**, Toss (Fiona Kay) stands guard over her valley in the film *Vigil*, directed by Vincent Ward, 1984. Courtesy: John Maynard Productions Ltd.

Toward a Suburban Landscape

1985
Agents of the French government blow up the Greenpeace ship *Rainbow Warrior* in Auckland Harbour, killing a member of the crew. The vessel was on its way to lead a protest at the French nuclear testing site at Mururoa in the Pacific.

New Zealand drops out of the ANZUS alliance when legislation is passed banning the visits of nuclear ships.

The Archbishop Paul Reeves is appointed Governor-General, the representative of the monarchy. He is the first person of Maori descent to hold the position.

1987
The Maori Language Act makes Maori an official language and establishes the Maori Language Commission.

The New Zealand yacht *KZ-7* wins the World Championship in Sardinia. It had been beaten the previous year by the American yacht that went on to win back the America's Cup from Australia. New Zealand competed for the America's Cup the next year but was beaten by the Americans in a catamaran. The result was unsuccessfully challenged in the American courts.

1988
Exhibitions of the work of Barbara Kruger and Richard Misrach are shown at the National Art Gallery in Wellington, followed the next year by one of Cindy Sherman and a touring show of Duane Hanson.

160

Don't leave home till you've seen the country.
New Zealand Tourist Corporation campaign, 1980s.

Ask a New Zealander for a word picture of New Zealand and he will tell you – with some brusque diffidence, for he is essentially a modest chap and even a little inarticulate on such matters – about mountains and trout-streams, about lakes and bush, about beaches and the ever-present ocean.

Ask him for some typical photographs and you will get Mitre Peak, a mud pool, Lake Matheson gloriously reflecting the alps, a kauri forest, a glade of ferns, perhaps a bit of rolling out-back sheep country, all empty of human life, all virtually untouched by civilisation.

"But aren't there any people?" you may ask, puzzled by such emptiness.

"People? Sure!" he retorts. "We've got our big cities. Wellington's the capital, Dunedin is the Scottish city, Christchurch is the English city, Auckland has a harbour bridge."

"But where do you live?" you may persist. "In a kauri tree? On a harbour bridge? Under a Burns monument?"

"Cut it out, mate," he will splutter, suspicious that he is being got at. "I live in a house in a suburb, just like anyone else."
Susan Graham, "Our Very Own Suburbia," *Weekly News Annual* (1963).

Fig. 67. **George Stevens**, *Auckland from One Thousand Feet*, 1886. Color lithograph. Alexander Turnbull Library.

Fig. 68. Aerial view of the Auckland suburb of Oranga, 1947. Alexander Turnbull Library.

The landscape, then, becomes a form of compensation for all that our society lacks; and in this sense there has been a real antipathy in New Zealand between landscape and community. A form of romanticism has been bred, in which topography becomes a substitute for human society.

C. K. Stead, "'For the Hulk of the World's Between': New Zealand Writing," in *Distance Looks Our Way: The Effects of Remoteness on New Zealand*, ed. Keith Sinclair (Paul's Book Arcade for the University of Auckland, 1961), 84.

Fig. 69. **Dennis Beytagh**, Cover of the novel *Owls Do Cry* by Janet Frame. Christchurch: Pegasus Press, 1957.

Now, while I am convinced that society in such a colony as New Zealand must daily Americanise, I am also persuaded that no New Zealander will retain more of the Briton, than any other colonist, for the following reasons. We have no other colony which so much resembles England in climate, size, and position. It is not too much to say, that New Zealand will become an exact copy of England. Churches, houses, roads, inns, hedges, trees, will be almost entirely English, and, to judge from the temper of the present inhabitants, the conservative principle is likely to be very strong there. Again, the very nature of the country will be found to be anti-American. It is small, detached from others, mountainous, and intensely local.

Thomas Cholmondeley, *Ultima Thule; or, Thoughts Suggested by a Residence in New Zealand* (London: John Chapman, 1854), 324.

1990
To mark the 150th anniversary of the Treaty of Waitangi, many celebrations are held. Among the most memorable are the gathering of more than twenty *waka taua* (canoes) at Waitangi to greet Queen Elizabeth II, a historical pageant opening the Commonwealth Games in Auckland, and the outdoor concerts of soprano Dame Kiri Te Kanawa.

Dame Cath Tizard, Mayor of Auckland, is appointed the first woman Governor-General.

▼
161

Fig. 70. Farmers' Trading Company catalogue cover, 1925. Alexander Turnbull Library.

Fig. 71. **Geoff Short**, Rata (Vanessa Rare) and Willie (Lee Mete-Kingi) in the film *Ruby and Rata*, directed by Gaylene Preston, 1990. Photograph. Courtesy: Preston Laing Productions.

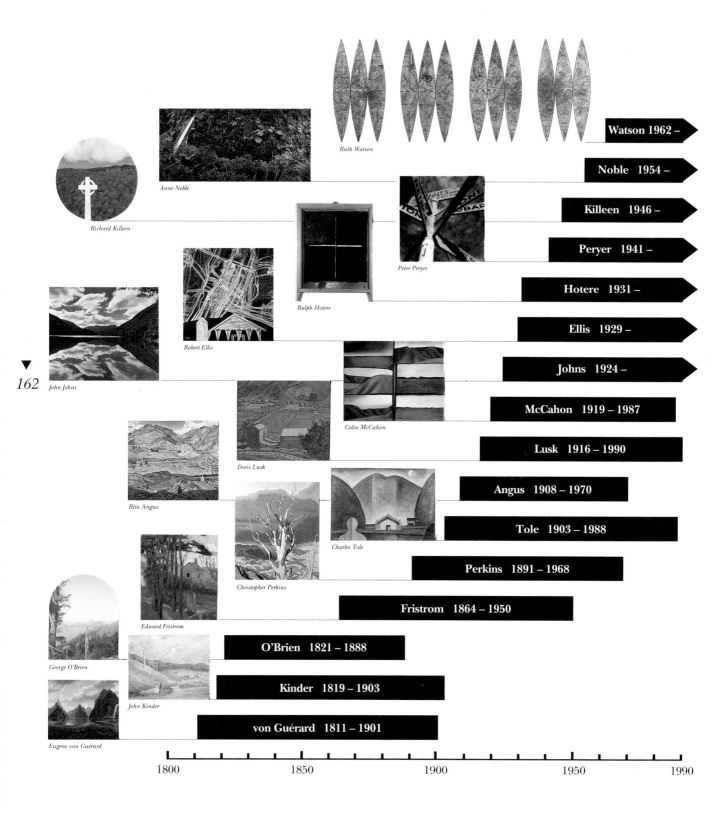

Ruth Watson

Anne Noble

Richard Killeen

Peter Peryer

Ralph Hotere

Robert Ellis

John Johns

Doris Lusk

Colin McCahon

Rita Angus

Charles Tole

Christopher Perkins

Edward Fristrom

George O'Brien

John Kinder

Eugene von Guérard

162

Watson 1962 –

Noble 1954 –

Killeen 1946 –

Peryer 1941 –

Hotere 1931 –

Ellis 1929 –

Johns 1924 –

McCahon 1919 – 1987

Lusk 1916 – 1990

Angus 1908 – 1970

Tole 1903 – 1988

Perkins 1891 – 1968

Fristrom 1864 – 1950

O'Brien 1821 – 1888

Kinder 1819 – 1903

von Guérard 1811 – 1901

| 1800 | 1850 | 1900 | 1950 | 1990 |

Rita Angus

Born Hastings, 1908
Died Wellington, 1970

Rita Angus was a second-generation New Zealander of Scottish descent. During her childhood her father, a self-made man, built up one of the country's leading contracting firms, causing the family to move often. Angus was able to study art, with some interruptions, at the Canterbury College School of Art in Christchurch from 1927 to 1933.

Angus married fellow artist Alfred Cook in 1930, but the couple separated after four years, and she worked as both an illustrator and a teacher as well as continuing with her own painting, primarily portraiture. Angus was impressed by the work of Emily Carr and the Group of Seven, which she saw in the *Exhibition of Contemporary Canadian Painting* in 1938.

Throughout the 1930s and 1940s Angus moved about the country painting and doing a variety of short-term jobs. Her pacifist convictions did not allow her to work to support the war effort, for which she was prosecuted. In 1947 she wrote: "As a woman painter, I work to represent love of humanity and faith in mankind in a world, which is to me, richly variable and infinitely beautiful."[1]

In addition to her portraiture, she continued to observe and paint the landscape, particularly in Central Otago and Hawke's Bay. "I like to paint with the seasons, and devote time to the observation of the skies, country, sea and peoples."[2] In 1949 she suffered a breakdown and finally settled in Wellington with support from her family in 1955.

Angus traveled to England and Europe in 1958 on a fellowship and stayed for a year. On her return her life continued its pattern of sketching expeditions with friends, the constant exploration of the landscape, and consistent painting. Her symbolic vocabulary was developed and enriched by her ongoing interest in Pacific and Asian cultures and the cyclical patterns of growth and decay.

Although she gained increasing recognition she fiercely rejected categorization. "You have been trying to make me into a legend. I am a painter, and paintings are paintings – line, tone, form and colour, mass, light. You cannot make a legend out of a painting."[3]

1. *Year Book of the Arts* 3 (1947): 68.

2. Ibid., 67.

3. Notes, Rita Angus to Gordon Brown, in Janet Paul, *Rita Angus* (Wellington: National Art Gallery, 1982), 39.

▼

163

Robert Ellis

Born Northampton, England, 1929
Lives in Auckland

Robert Ellis took full advantage of the experiences and diversity of the cultures available to him in Europe. His study at the Royal College of Art was delayed by two years in the Royal Air Force, where he served as an aerial photographer. His formal study at the Royal College was completed in 1949, after which time he worked as a designer and exhibited widely. He continued to travel extensively in Europe and was fascinated by Spanish culture, and in particular by the flamenco guitar on which he excelled.

However, as he approached thirty, Ellis began to find Europe claustrophobic. As he had relatives in New Zealand, he looked for a teaching position there and was appointed senior lecturer in design at the University of Auckland. He began to teach in 1957 and is now professor of painting at the University of Auckland.

He held his first one-person show of cityscapes in New Zealand two years later. Obvious sources for the development of his distinctive perspective have been his training as an aerial photographer and his interest in street maps, in which he found "all that information reduced to comprehensible symbols!"[1] Ellis continued to develop his imagery based on motorways, but by 1974 he was increasingly introducing other elements.

He has also drawn on the approach to imagery of the indigenous Maori culture. "They used symbols taken from the landscape, the physical landscape, and I tried to do the same in my urban way.... It [the symbolism] was evolved by people who had observed New Zealand and I was tying my paintings very much into a New Zealand context."[2] Ellis married into a Maori family and has come to understand the "conflict between rural Maori and urban Anglo Saxon."[3]

Recently he has moved out of the urban environment entirely and based a large series of works on Rakaumangamanga, an impressive geological outcrop in the Bay of Islands that is a spiritual home of the Maori side of his family. "It [is] not intended that [these] paintings should be regarded particularly as observations about conservation or political issues, but rather as 'portraits' of a unique and special landscape seen from one person's viewpoint."[4]

1. *Vogue Australia*, November 1964.

2. Jim Barr and Mary Barr, *Contemporary New Zealand Painters* (Martinborough: Alister Taylor, 1980), 68.

3. Ibid., 68.

4. Artist's statement, Hamilton Arts Centre, 1984.

Edward Fristrom

Born Sweden, 1864
Died San Anselmo, California, 1950

Christened Claus Edvard Fristrom, the artist anglicized the spelling of his middle name and dropped his first name after emigrating to Australia in 1888. He and his brother Oscar (1856–1917), both largely self-taught as painters, settled in Brisbane, where they helped establish the Queensland Art Society. Although naturalized as an Australian, Edward moved again in 1903 to New Zealand, where he stayed until 1909.

Fristrom traveled extensively in New Zealand, painting landscapes in both islands. His plein-air approach was modified by his exploration of the decorative possibilities of the landscape. The majority of his works are small-scale scenes, although he also made portrait studies of the Maori.

In 1911, after an absence that included at least one visit to the United States,[1] Fristrom returned to New Zealand and for several years exhibited regularly in Auckland and in the network of art society shows throughout the country. He also took up a teaching position at the School of Art in Auckland and quickly became a popular instructor. When he resigned in 1915 over a pay dispute with the director, a deputation of students requested the board to reinstate him. It declined to do so, and Fristrom quit Auckland, sailing for California later that year.

In the United States Fristrom was active in Carmel and the San Francisco area, continuing his interest in landscape subjects. In 1925 he wrote: "I did quite a lot of sketching in Carmel. Since I came back [to San Anselmo] I have fixed up my studio but the light is poor in the afternoon. It is such an awful long time since I did any painting from my sketches indoors that I feel like a fish out of water at it. I prefer the out of doors."[2]

In 1939 Fristrom helped establish the San Francisco chapter of the National Society for Sanity in Art (founded to encourage rationalism in art and "the expression of true beauty")[3] and served on its artist's council for six years; he participated in the society's annual exhibitions from 1939 to 1947. Although he was generally represented by pastoral views of northern California, at least once (1943) his subject was a New Zealand beach scene.

1. E. W. Payton, director of the Auckland School of Art, recorded that Fristrom "has recently visited America in the interests of Art"; Letter, January 10, 1912, in Elizabeth S. Wilson, "Edward Fristrom" (M.A. thesis, University of Auckland, 1981), 179. A student later recalled that Fristrom had traveled to Australia and California "two or three times" before his final move and that "all the time I knew him there was this business of travelling to and fro across the Pacific"; Interview with Marcus King, December 13, 1979, in ibid., 219–220.

2. Cited in Elizabeth S. Wilson, "Edward Fristrom: Interpretations of the Landscape," *Art New Zealand* 19 (Autumn 1981): 43.

3. *Exhibition by Members of the San Francisco Branch of the National Society for Sanity in Art, Inc.* (San Francisco: California Palace of the Legion of Honor, 1939), n.p.

Eugene von Guérard

Born Vienna, 1811
Died London, 1901

Eugene von Guérard never lived in New Zealand but briefly visited as a tourist in 1876. His father, Bernhard, specialized in miniatures and landscapes, and the son was thoroughly trained in Italy and Germany. The two men also toured extensively, setting a pattern of searching for new experiences that von Guérard followed throughout his life.

When he reached his forties he was drawn to ever more exotic destinations. Gold had recently been discovered in Victoria, Australia, and von Guérard arrived there in 1852 to try his luck. He met with no success over the next two years and returned to his career as a landscape painter in Melbourne.

There, he began to exhibit works he had made based on his explorations of the Australian wilderness. Von Guérard, who was knowledgeable in the natural sciences, had accompanied expeditions to rugged and unexplored areas of the country, making a systematic study of the landscape. His paintings in Australasia were of two kinds: views of homesteads, which depicted the settlers' pride in their pioneering achievements, and scenes of primeval landscape, which glorified nature.

In 1870 von Guérard obtained an official position as a teacher and curator at the newly established National Gallery of Victoria. It was probably this newfound financial security that enabled him to join a tourist party and see for himself the famous Milford Sound in New Zealand in 1876. A newspaper of the time reported: "M. von Guérard at once had himself conveyed to an island, upon which, with rapid artistic instinct he had promptly fixed as the point of vision of his forthcoming picture."[1]

The two large paintings of New Zealand subjects that were exhibited the next year were received enthusiastically and shown in Paris as well as around Australia. In 1882 the seventy-one-year-old von Guérard returned to Europe with his family, finally settling in England in 1891.

1. *Otago Daily Times,* January 28, 1876, in Candice Bruce et al., *Eugene von Guérard: A German Romantic in the Antipodes* (Martinborough: Alister Taylor, 1982).

Ralph Hotere

Born Mitimiti, Tai Tokerau, 1931
(tribal affiliation: Te Aupouri)
Lives in Port Chalmers, Dunedin

For most of the 1960s and 1970s Hotere was one of the few Maori consistently included in contemporary New Zealand art exhibitions and publications, where he was always acknowledged as a Maori artist. He represented New Zealand at the São Paulo Biennale (1970) and at the Sydney Biennale (1984). Parallel to this success in the European-dominated art world, Hotere has also been part of a powerful cultural reassertion by contemporary Maori artists. This has occurred in the traditional community setting as well as in the broader art world.

Hotere was a specialist school art advisor during the 1950s, receiving some of his training in art at the King Edward Technical College, Dunedin. In 1961 Hotere was awarded a New Zealand Art Societies Fellowship and, like most other New Zealand artists of the time, headed for England. He studied at the Central School of Art in London and the following year was able to travel through Europe thanks to a Karolyi International Fellowship. He returned to Auckland in 1965.

In 1969 Hotere was awarded the Frances Hodgkins Fellowship and moved to Dunedin, where he has remained. "In Dunedin they accept that I am a painter and leave me to go about my work. In Auckland it's not like that."[1] In 1978 he traveled again in Europe and has continued to do so regularly.

Although Hotere was usually accepted as a painter in the minimalist mode during the late 1960s and 1970s, his subject matter has been increasingly recognized as directly political. Series of paintings have confronted the futility of war, the horror of nuclear weaponry, and, since the early 1970s, the protection of the land. Hotere was intensely engaged in the battle to stop an aluminum smelter being built at Aramoana on the Otago coast and more recently has been fighting to protect the area around his own home from expansion by the nearby port.

1. *Waikato Art Gallery Bulletin* 4 (1973): n.p.

▼

John Johns

Born Devonshire, England, 1924
Lives in Stokes Valley, outside Wellington

After events in World War II took him to Southeast Asia and India, Johns decided that forestry was the way of the future and joined the British Forestry Commission as a trainee. He received his diploma in forestry at Dartington Hall, where there was a special interest in photography. It was here that Johns's lifelong interests in forestry and photography were set.

In 1951, his professional education complete, Johns went to New Zealand and was quickly appointed the offical photographer for the New Zealand Forest Service. His response to his new country was immediate: "It was a great landscape and I felt at home in it."[1] Most of his first assignments were for illustrations, in the course of which he traveled around New Zealand.

Forests were the source of New Zealand's first major export, timber. Then, as settlers cleared land for their farms, huge areas of native forests were logged and burnt and forestry declined. Large-scale commercial planting of exotic trees began in the 1890s, and one of the most common conifers used was the *Pinus radiata,* a native of California although now little known there.

Johns was in the Forest Service during another surge in the planting of exotic trees in the 1960s, but he also had a profound personal commitment to the conservation of native forests. His book *Westland's Wealth* is evidence of his concern. It was commissioned by the Minister of Forests, the Honourable Sir Eruera Tirikatene, and documents the ravages of clear-felling native trees and the urgent need for forest management. "Dare we look the next generation in the eye as we hand to them the heritage that we have made, and are making for them – a ravaged countryside?"[2]

More publications followed, and in the course of these Johns increased his technical skills. In 1978 and 1980 he attended Ansel Adams workshops in California. He usually developed and made the master prints himself and began to work increasingly in color.

Johns retired from the Forest Service in 1984. In 1990 the two strands of his achievements were acknowledged: he was made an honorary member of the Institute of Forestry and was included in the major exhibition *Two Centuries of New Zealand Landscape Art* at the Auckland City Art Gallery.

1. Interview with Jim Barr, 1990.

2. John Johns, *Westland's Wealth* (Wellington: Government Printer, 1959), n.p.

Richard Killeen

Born Auckand, 1946
Lives in Auckland

Richard Killeen is one of many recent New Zealand artists to extend their careers beyond their own country. Earlier in the century artists with these ambitions were compelled to leave New Zealand for extended periods or even forever, but more recently it has become possible for them to work in New Zealand and to travel and show frequently elsewhere.

Killeen's exhibition history illustrates the possibilities of such an approach. He has shown in large contemporary exhibitions overseas, including the Sydney Biennale (1982 and 1986) and the Edinburgh Festival (1984), as well as in commercial galleries in Sydney, New York, and London.

His work is diverse. At art school in Auckland (where he studied with Colin McCahon) he was one of a group of students who looked at realism as a way to escape the dominance of expressive landscape. He also experimented with arbitrary and random imagery and in 1978 moved on to cutting out shapes from sheet aluminum and hanging them directly on the wall.

This change of technique brought with it a reorientation. Killeen commented at the time, "Usually with painting, the painting is a negative process in that you are reducing the space. This is different. I'm adding, not subtracting."[1] The elements of the cutouts could be hung in any order and were often based on images he had found while researching in the Auckland museum library.

In 1986 Killeen started working on a computer with graphic capability, so that he could more efficiently raid images from many sources. He has also looked at cultural and social issues, such as New Zealand's place in the Pacific and in the world, his own role as a member of an island nation, the impact of feminism, and the challenge to authorship. In all these areas he has been keen to empower the spectator. "Some images are more important than others because of the viewer's subjective relationship to those images."[2]

1. Jim Barr and Mary Barr, *Contemporary New Zealand Painters* (Martinborough: Alister Taylor, 1980), 122.

2. *Splash* 1, no. 2 (December 1984): 102.

▼

166

John Kinder

Born London, 1819
Died Auckland, 1903

John Kinder was the son of a London merchant. He studied mathematics at Cambridge University and then, despite the decline in his father's fortunes, decided to enter the Anglican priesthood. He gained his first appointment in 1846 in a poor district of London's East End.

The next year Kinder was appointed headmaster of a school in the Midlands, where he taught for about eight years. His insistence on Anglican religious instruction made him increasingly unpopular, so he accepted an appointment as master of an Anglican school to be established in Auckland in the new colony of New Zealand. He sailed in July 1855.

Kinder already had a sister and brother living in Auckland, and he rapidly established himself there. His first years were very busy setting up the school and serving as an Anglican priest as well as improving the fortunes of his family through shrewd investments.

Although always an amateur, Kinder had been interested in sketching since his student days. He had crossed to the Continent a number of times, walking and sketching Gothic churches and ruined abbeys. Although the subject matter was of a different kind, Kinder continued this practice in New Zealand. He spent his holidays on extended sketching tours, carefully recording the progress of the colony and exploring the new landscape with its fascinating geological formations.

In the early 1860s Kinder began to take photographs and used them as the basis for many of his paintings. In 1871 he exhibited watercolors in the first exhibition of the newly formed Society of Artists in Auckland. This was the first of only two occasions that his work was publicly displayed during his lifetime. On the second of these occasions Kinder included photographs with his watercolors.[1]

Kinder continued to teach and took an active part in church affairs. He was highly respected for his theological learning. He expressed his enduring commitment to ecclesiastical architecture in his recording of churches and missions visited during his frequent travels as well as practical fund raising for building them. He even designed a church in Auckland. Wherever he went, "sketching from nature became my favourite amusement, and was kept up till my old age as my numerous books and portfolios will testify."[2]

1. Gordon H. Brown, *The Ferrier-Watson Collection of Watercolours by John Kinder* (Hamilton: Waikato Art Gallery, 1970), 11.

2. Cited in ibid., 13.

Doris Lusk

Born Dunedin, 1916
Died Christchurch, 1990

Doris Lusk, the daughter of an architect, was born in Dunedin in 1916. In the mid-thirties Dunedin was a center of New Zealand culture at a time when isolation had made knowledge of most contemporary developments in Europe and America difficult. Dunedin boasted a lively literary and theater scene and was also home to the important poet, publisher, and patron Charles Brasch.

The Dunedin Art School, where Lusk studied from 1934 to 1939, was an exciting place for a young artist. It had been revitalized by teachers brought to New Zealand who had studied in Great Britain, such as Charlton Edgar and R. N. Field. They introduced new ideas about creativity and the modern movement and attracted a lively group of students. Lusk became great friends with the artists

Anne Hamblett and Colin McCahon, who were later to marry, and also with Tosswill Woollaston.

As with the writers of the time, in her early works Lusk portrayed the New Zealand landscape as a hostile presence, revealing the uncertainty of the recent colonist. Lusk tried to strip the land of its menace and reveal what she described as the "breadth and unique structure of these hill forms."[1] She also became fascinated by the intrusion of fabricated structures into the landscape, a theme that was to dominate much of her painting.

In 1941 she married and in the next year moved to Christchurch. Although slowed down by family commitments over the next twenty or so years, Lusk steadily produced work and exhibited regularly.

In 1966 she joined the staff of the Ilam School of Fine Art at the University of Canterbury where she taught painting for the next fifteen years.

From the mid-1960s Lusk worked increasingly in watercolor, both traditionally, on paper, and, in the 1970s, using a stain technique she developed using acrylic paint on dampened canvas. She continued to explore as personal symbols her earlier concerns through intensive studies of land uses like dam construction and building sites.

1. Interview with Doris Lusk, 1987, in Lisa Beaven, "Doris Lusk: Attitudes to the Land, 1934–1984" (M.A. thesis, University of Canterbury, 1988).

▼

167

Colin McCahon

Born Timaru, 1919
Died Auckland, 1987

Colin McCahon is now regarded as New Zealand's most significant artist. He has been the subject of major national and international exhibitions, a steady stream of articles and publications, and even official political recognition when one of his large works was given by the New Zealand government to "the government and people of Australia" in 1978.

McCahon spent most of his childhood in Dunedin and later attended the King Edward Technical College Art School there from 1937 to 1939. Most of the next decade he spent painting and doing seasonal jobs in Nelson and Otago. His work at this time often depicted the land pared down to its geological bones, introducing a symbolism based on Christian imagery.

In 1948 he settled in Christchurch in Canterbury and made his first visit out of New Zealand to Australia in 1951. What he wrote of one work of that period is suggestive for much of his oeuvre: "[I]t states my interest in landscape as a symbol of place and also of the human condition.

It is not so much a portrait of place as such but is a memory of a time and an experience of a particular place."[1] He moved north to Auckland in 1953, where he worked at the Auckland City Art Gallery; he was appointed to a curatorial position in 1956.

McCahon visited the United States in 1958 in his capacity as a museum professional but viewed what he saw as a painter. He wrote of his overseas impressions later: "[I]n the States I was mucked up by the open land round Ox Bow & the nothing, endless land around Salt Lake & out of Colorado. I don't trust myself with new land. But here I know what I'm on about and don't have to wonder where I belong.... I belong with the wild side of New Zealand."[2]

He left the gallery in 1964 to teach at the University of Auckland School of Fine Arts, where his life and career as an artist profoundly influenced many students and friends. He began painting full-time in 1970.

In 1984 an exhibition focusing on the use of words in his later work was organized for the Sydney Biennale and was also shown at the Edinburgh Festival. It was appropriately titled *I Will Need Words*. International interest in his work has grown, particularly among artists. Painters like John Walker from Britain and Julian Schnabel from the United States have been impressed by McCahon and have fed back into the international culture what is often seen as his distinctive and provincial vision.

McCahon's death has meant a necessary readjustment for many New Zealand artists who have related themselves to his powerful presence. Coming to terms with his contribution will be a continuing ambition.

1. *Colin McCahon: A Survey Exhibition* (Auckland City Art Gallery, 1972), 19.

2. Letter to Kees Hos, December 15, 1978, in *Colin McCahon: Gates and Journeys* (Auckland City Art Gallery, 1988), 77.

Anne Noble

Born Wanganui, 1954
Lives in Wanganui

Anne Noble was born and raised beside the Wanganui River, a region that has attracted photographers and painters since the middle of the nineteenth century. Alfred Burton, for example, traveled for a month on the river in 1885 in its heyday as a major tourist attraction and produced more than one hundred photographs. The tourist routes changed, but the river remained. Almost a century later Noble spent two years researching and photographing the Wanganui River in her major portfolio of sixty-five photographs.

Local Maori tribes have been a continuing human presence in Wanganui. Noble values their relation with the river and the land and expresses this in her work: "They have been here far longer than we have to develop a relationship with the land. I am very interested in the way the Maori names the landscape – names that convey the feeling of a place."[1]

Noble first began to photograph intensively in Wellington when she was training as a teacher in 1974. She went on to art school in Auckland, graduating in 1980. It was then she began her exploration of the river. She was very clear about her aims: "I want to offer my pictures as an experience of this landscape, to make people love it very deeply."[2]

Anne Noble worked and traveled in Europe and Britain from 1985 to 1989. In London and Dorset she began to make the photographs of swans which grew into the series *SONG … without Words*. In 1989 she returned to Wanganui, where she now lives, and completed the swan series.

1. Anne Noble, "The Wanganui," *PhotoForum* (September 1982): 51–52.

2. Ibid.

168

George O'Brien

Born County Clare, Ireland, 1821
Died Dunedin, 1888

George O'Brien was born into a distinguished and well-connected family in County Clare, Ireland. His father, an admiral in the Royal Navy, had taken up land grants in Canada in the early 1830s where other members of the family had settled. He was back in England in 1836, but the colonial adventure lured his fifth son, George.

O'Brien arrived in Melbourne, Australia, by 1850. Little is known of his early years, but he worked as a draftsman and surveyor and with architects. A few works from this period have survived (State Library of Victoria, La Trobe Library, and National Gallery of Victoria, Melbourne). He also painted and played an active part in the developing Melbourne art world.

O'Brien moved to Dunedin, New Zealand, in 1863, at the time of the Otago gold rushes and great economic development and pioneering confidence. First employed by the Engineer's Department of the local city council, he made fine architectural renditions of local buildings. Some of these were displayed in the great New Zealand Exhibition of 1865, which celebrated the progress of the colony. He also became well known in Dunedin for his large townscapes and landscapes, which idealized the impact of colonization.

As his biographer Peter Entwisle points out, O'Brien's work should be seen in the context of the Victorian ideal of progress. "They imagined that soon New Zealand would look like the man-made countryside of Europe…. They didn't foresee how protracted and painful the remaking of New Zealand would be."[1]

In contrast to the optimism and order of his images, O'Brien himself suffered first from financial difficulties and then from ill health. His work met with some success, and he continued to make perspective drawings for architects, but he died in poverty on August 30, 1888.

1. Roger Collins and Peter Entwisle, *Pavilioned in Splendour: George O'Brien's Vision of Colonial New Zealand* (Dunedin Public Art Gallery, 1986), 11.

Christopher Perkins

Born Peterborough, England, 1891
Died Ipswich, England, 1968

Christopher Perkins arrived in New Zealand in 1929 when he was already thirty-seven and remained for less than five years. Despite the brevity of his stay, his impact on what he termed "a strip of Victorian England" has proved significant through his desire to participate in, as he termed it, "the birth of the New Zealand idiom."[1]

Self-aware nationalism was in its infancy, for the close bonds with Britain were still a source of great pride. Although Perkins himself had been trained in England at the prestigious Slade School of Fine Art, he had traveled extensively in Europe and had thrown in his lot with the modern, represented by such artists as Walter Sickert, Paul Nash, and John Nash. He had also lived in France after serving in World War I but had met with little success. The need for a new start drew him to the distant Pacific to teach life drawing and painting at the Wellington Technical College.

Although it was his wide knowledge of contemporary developments in European art that attracted attention to him on his arrival in New Zealand in 1929, he did not see himself as a missionary, for he "had come to New Zealand to get away from Europe."[2]

He warmly embraced the isolation and distance from the centers of world art, which were usually seen as stultifying, as the conditions necessary for a national art. Perkins taught in Wellington for the next three years but found it increasingly difficult to find time for his own work. When his contract expired he moved to Rotorua. From the time of his arrival he had responded strongly to the vitality of Maori culture.

His idealism was worn away by poor sales and indifference from all but a small group in the depths of the Great Depression. He ventured to Australia briefly but was back in England by January 1934, where he continued to paint steadily. Of New Zealand he recalled: "A grand country of bush, scrub and mountains, it made me feel lonely."[3]

1. Jane Garrett, *An Artist's Daughter: With Christopher Perkins in New Zealand, 1929–1934* (Auckland: Shoal Bay Press, 1986), 101.

2. *Evening Post* [Wellington], March 1929.

3. *Daily Mail* [London], February 25, 1934.

▼

169

Peter Peryer

Born Auckland, 1941
Lives in Auckland

Peter Peryer spent much of his childhood in settlements to the north of Auckland in the Hokianga and Bay of Islands where his parents were hotel keepers. His involvement with photography did not begin until he was in his early thirties. He was by that time an experienced teacher with a master's degree in education.

Peryer began photographing in 1973. The next year he attended a workshop led by John B. Turner, who was one of the founders of PhotoForum, an important organization in the development of expressive photography in New Zealand. Founded in 1974, it published a significant magazine that set forth the history of the medium in New Zealand, which provided a context for photographers. Workshops, lectures, and discussions were also arranged, and skills were shared so that a photographic community developed.

Peryer began producing many images with a cheap plastic camera in this stimulating environment. These blurred, evocative photographs were presented in two portfolios, *Mars Hotel* and *Going Home* and were also published in the PhotoForum magazine in 1976. Peryer said of *Mars Hotel:* "I look at these photographs and I think of two lines from Allen Curnow's 'Landfall in Unknown Seas': 'Always to islanders danger / Is what comes over the sea.'"[1]

In 1978 he traveled extensively through Europe and the United States. By 1982, when he was represented in the Sydney Biennale, his work had become more concerned with structure and pattern. His approach has become more overtly objective with studies of native New Zealand flora and geological landmarks.

In 1985 Peryer was awarded a Fulbright scholarship to go to the United States, and he regularly visits Australia. Over the almost two decades Peryer has been working, photography has been increasingly accepted in the art world and has often been included in exhibitions and publications. The group support offered by organizations like PhotoForum devoted specifically to the medium has become less necessary.

1. *PhotoForum* 33 (August–September 1976): 16.

Charles Tole

Born Auckland, 1903
Died Auckland, 1988

Charles Tole was a third-generation New Zealander who lived in Auckland virtually all his life. He had no formal art training and did not begin to paint until he was in his mid-thirties. His older brother John, who was also a painter, gave him some instruction, and Charles's interest developed rapidly.

Since Tole worked as a public servant, for most of his life painting was a weekend and holiday avocation. Speaking on behalf of himself and his brother he stated, "We are not painters by profession, consequently as weekend and vacation painters only, our output has been restricted."[1] On his retirement in the late 1960s he was able to paint more intensively.

▼
170

Despite the restriction on his output, by the 1950s Charles Tole was a respected painter active in the Auckland art world and included in major touring exhibitions overseas. One of the most significant of these was *The Land and the People*, which toured the Soviet Union in 1958.

The painter John Weeks was a major influence on Tole, especially through his knowledge of Cubism, which was a powerful source for art in New Zealand throughout the 1940s and 1950s. In developing his approach to landscape, Tole adapted his understanding of Cubism to the information he gathered from sketching trips all over the country.[2] He was also interested in expressions of modernity as New Zealand slowly moved toward urbanization and industrialization following World War II.

He said of himself and his brother: "We have always been intensely interested in modern developments, both in style and technique, yet we think these elements should not be arbitrarily or consciously striven for but should emerge and flow freely from the subject matter and from the artists' 'creative intuition' towards the expression of his message."[3]

1. Letter to Kurt von Meier, May 28, 1965, Alexander Turnbull Library.

2. Interview with Jim and Mary Barr, 1980.

3. Letter to von Meier. May 28, 1965.

Ruth Watson

Born in Canterbury, 1962
Lives in Wellington

Ruth Watson grew up on a Canterbury farm, moving into Christchurch with her family at the age of eight. She attended art school there, graduating in 1984. It was here that she began working with maps. Her fifth-generation rural background continues to provide her with a perspective different from much of the landscape tradition in New Zealand art.

Beginning in the early 1980s a growing group of artists and writers in New Zealand were influenced by postmodern theory from the United States, Britain, and France. Watson became part of this group when she moved to Wellington in 1986 and rapidly found a stimulating context for her work.

The 1988 exhibition *Drawing Analogies* placed her work alongside that of other artists exploring parallel issues of representation, language, and the feminine. Since then there have been a number of further exhibitions and publications elaborating these issues. Of her own position Watson says:

Once, there were Journeys. Where I had been was a wrinkled, faded map. Sometimes I still fall into its omissions, or through the moth-eaten holes. Even failing to recognize them....

More recently, I bought a car, and drive it over the surface of a fresher, greener map. In the glove-box there are others inviting me to a variety of possible transactions, each vying for credibility. (Some of them more user friendly than others).[1]

Watson has continued to work with mapping as a way to intervene in conventional means of representation, but she has also extended her vocabulary. Printmaking, photography, and sculpture, as well critical writing, are all used, depending on how useful they are to her particular objectives. This multimedia approach is common among younger artists working in New Zealand.

1. Artist's statement for *Heart + Land* exhibition (New Zealand Art Gallery Directors' Council, 1990).

ANNOTATED BIBLIOGRAPHY

The literature on the visual arts in New Zealand is not large, although the pace of publication has increased considerably beginning in the 1970s. There are many specialized publications dealing with individual artists, prepared mainly to accompany museum exhibitions or as graduate theses. The notes to *Pacific Parallels* refer to a large number of them, but as their availability outside New Zealand is limited, they are not included here. More general commentaries are listed below, with an emphasis on recent and more accessible publications.

Barr, Jim, and Mary Barr. *Contemporary New Zealand Painters (A–M)*. Martinborough: Alister Taylor, 1980.

A popular introduction based on interviews with the artists, with many photographs.

Blackley, Roger. *Two Centuries of New Zealand Landscape Art*. Auckland City Art Gallery, 1990.

A well-illustrated exhibition catalogue with brief comments and a useful bibliography.

Brown, Gordon H., and Hamish Keith. *An Introduction to New Zealand Painting, 1839–1980*. Revised and enlarged ed. Auckland: Collins, 1982.

The most influential interpretation of New Zealand art history, highlighting nine painters, with coverage extended to 1980 in the new edition.

Docking, Gil. *Two Hundred Years of New Zealand Painting*. Wellington: A. H. & A. W. Reed, 1971.

An introduction based on brief biographies of many artists linked by some general interpretive comment. (A revision is in preparation.)

Easdale, Nola. *Kairuri, the Measurer of Land: The Life of the Nineteenth-Century Surveyor Pictured in His Art and Writings*. Petone, N.Z.: Highgate/Price Milburn, 1988.

Using the words and images of early surveyors, the exploration and settlement of New Zealand are described.

Keith, Hamish. *Images of Early New Zealand*. Auckland: David Bateman, 1983.

Juxtaposes illustrations of colonial artworks with texts from contemporary sources.

Kirker, Anne. *New Zealand Women Artists*. Auckland: Reed Methuen, 1986.

Traces the lives and careers of seventy women artists and groups them according to general themes.

Knight, Hardwicke. *Photography in New Zealand: A Social and Technical History*. Dunedin: John McIndoe, 1971.

A pioneering introduction to the field, which has been followed by monographs on individual artists.

McCormick, E. H. *Letters and Art in New Zealand*. Wellington: Department of Internal Affairs, 1940.

An insightful and elegant first attempt to evaluate New Zealand's artistic achievements, with a special focus on the literary.

Minson, Marian. *Encounter with Eden: New Zealand, 1770–1870: Paintings & Drawings from the Rex Nan Kivell Collection, National Library of Australia*. Wellington: Alexander Turnbull Library, 1990.

A well-illustrated and meticulously documented selection of works from a major collection of early Australasian art.

Platts, Una. *Nineteenth-Century New Zealand Artists: A Guide and Handbook*. Christchurch: Avon Fine Prints, 1980.

A useful biographical listing.

Pound, Francis. *Frames on the Land: Early Landscape Painting in New Zealand*. Auckland: Collins, 1983.

A provocative analysis emphasizing how European theories of the landscape determined the way the new country was seen and depicted.

Shepard, Paul. *English Reaction to the New Zealand Landscape before 1850*. Wellington: Department of Geography, Victoria University, 1969.

An excellent compendium (by an American Fulbright scholar) of early commentary that established themes and attitudes of enduring import.

Smith, Bernard. *European Vision and the South Pacific, 1768–1850: A Study of the History of Art and Ideas*. Oxford: Oxford University Press, 1960.

The essential study of the European interpretation of the Pacific.

Bibliographic aids to the literature about New Zealand are substantial in general but not extensive for the visual arts. The five indexed volumes of *New Zealand National Bibliography to the Year 1960*, compiled by Graham Bagnall, are indispensable. Covering printed books and pamphlets, they are now supplemented by the cumulative *New Zealand National Bibliography*.

With the small number of monographs available, the periodical publication is of considerable interest. The long-running *Art in New Zealand* (1928–1946) was followed by the *Year Book of the Arts in New Zealand* (1945–1951) and more recently by *Art New Zealand* (1976–present). There are also general arts journals, from the wide-ranging *Triad* (1893–1929) to primarily literary publications that included some visual arts coverage, such as *Landfall* (1947–present) and *Islands. Bulletin of New Zealand Art History* (1972–present, intermittent) has hosted more specialized research. In photography, the major journal *PhotoForum* (1970–1982) dealt with contemporary and historical photographers.

The number of publications on the history of New Zealand has accelerated over the last two decades, and the relationship of the land to the people has been a continuing issue. *Te Whenua, Te Iwi: The Land and the People*, edited by Jock Phillips (Wellington: Allen & Unwin/Port Nicholson Press, 1987), was the title of a significant conference and its subsequent publication. It was also the theme of *The People and the Land: Te Tangata Me Te Whenua: An Illustrated History of New Zealand, 1820–1920*, by Judith Binney, Judith Bassett, and Erik Olssen (Wellington: Allen & Unwin, 1990). Two general histories of value are *The Oxford History of New Zealand*, edited by W. H. Oliver with B. R. Williams (1981; Auckland: Oxford University Press, 1990), and *The Oxford Illustrated History of New Zealand*, edited by Keith Sinclair (Auckland: Oxford University Press, 1990). The Maori approach to land and all its meanings is powerfully represented in *Te Maori: Maori Art from New Zealand Collections*, edited by Sidney Moko Mead (New York: Harry N. Abrams/The American Federation of Arts, 1984).

M. B.

▼

171

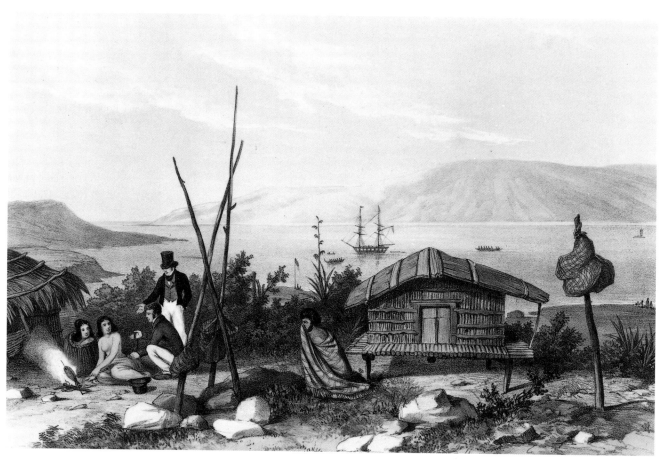

After **Augustus Earle,**
Village of Parkuni, River Hokianga,
from *Sketches Illustrative of the*
Native Inhabitants of New Zealand
(London, 1838).
Hand-colored lithograph,
238 x 370 mm. (9⅜ x 14½ inches).
Rex Nan Kivell Collection,
National Library of Australia,
Canberra.

INDEX

▼

173

PHOTOGRAPH CREDITS

Except as noted below, all color plates are from transparencies newly made for this purpose by Les Maiden of the National Art Gallery, Wellington, New Zealand. Photographs of works from the collections of the Auckland City Art Gallery and Robert McDougall Art Gallery, Christchurch, were kindly provided by the owners. Color plates on pages 69, 80 (left), and 126 (both) were made from transparencies provided by the lenders, and that on page 105, by the Auckland City Art Gallery.

Reproductions of photographs by John Johns, Anne Noble, and Peter Peryer were made from prints supplied by the artists. Otherwise, photographs are credited to the individuals, institutions, or firms cited in the captions, except in the following cases:

p. 17, Fig. 1, Alexander Turnbull Library; p. 19, Fig. 3, Jon Blumb; p. 24, Fig. 7, Les Maiden; p. 26, Fig. 8, A. Mewbourn, Bellaire, Texas; p. 28, Fig. 10, National Art Gallery, Wellington, N.Z.; p. 29, Fig. 13, Thomas Feist; p. 30, Fig. 14, Marian Bowater; p. 33, Fig. 19, and p. 37, Fig. 21, Jon Blumb; p. 134, Figs. 7 and 8, Alexander Turnbull Library; p. 137, Fig. 18, Auckland Institute and Museum; p. 161, Fig. 69, Alexander Turnbull Library.

▼

175

Colophon

This catalogue design was electronically produced with Aldus PageMaker 4.0 software on an Apple Macintosh IIx computer at David Alcorn Museum Publications, Mill Valley, California, and output on Linotronic's L300 at Central Graphics, San Diego, California.

Two typeface families were used for the text of the catalogue: ITC New Baskerville and Univers (with Univers Condensed). The cover and title pages also include Garamond Condensed.

The catalogue was printed at Dai Nippon Printing Co., Ltd., Tokyo, Japan.